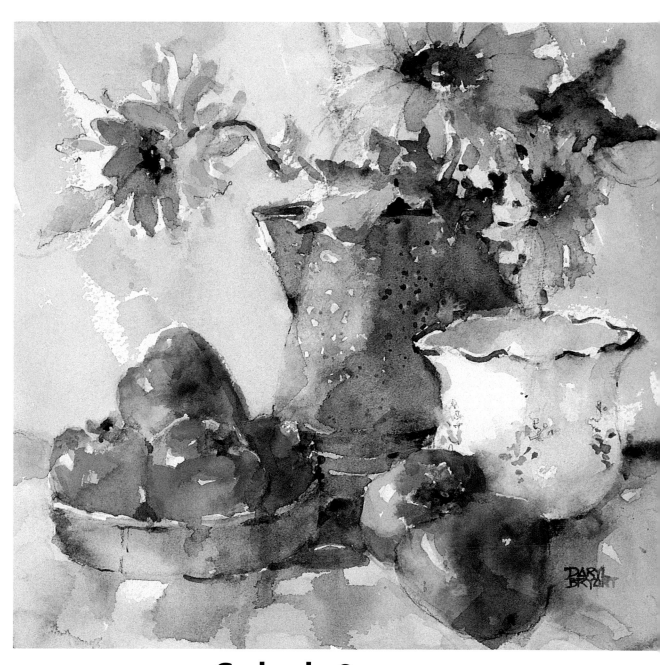

Splash 9

THE BEST OF WATERCOLOR

Watercolor Secrets

Sunny Flowers Daryl Bryant
15" × 15" (38cm × 38cm)

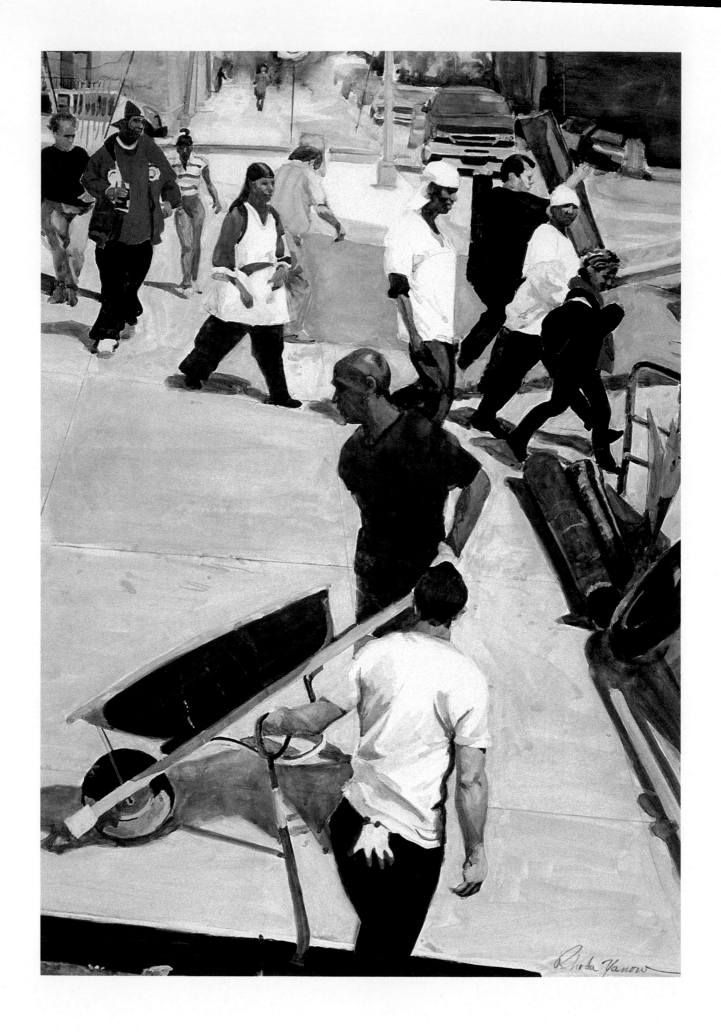

Splash 9

THE BEST OF WATERCOLOR

Edited by Rachel Rubin Wolf

watercolor secrets

Go Your Own Way

In this painting I was going after the "beat," or rhythm, of the street. When I am looking for a subject to paint—and I am always looking for something that excites me until the right moment—I sometimes find a subject that's banal, but I consider it up to me, as the "artist," to give it. One afternoon, I looked down the street and saw a lot of movement, men were working, children were coming home from school. I did some rapid sketching and started to do a paste-up of the composition when I got home.

I exaggerate movement by exaggerating diagonals. The wheelbarrow's shape leads the eye to the dynamic worker. In another diagonal, the children coming home from a day at school, there is such rhythm in their bodies. The street, again another diagonal, keeps it from being boring. Everyone has a purpose, going in different directions.

NORTH LIGHT BOOKS
Cincinnati, Ohio
www.artistsnetwork.com

Street Scene Rhoda Yanow
38" × 32" (97cm × 81cm)

ABOUT THE EDITOR

Rachel Rubin Wolf is a freelance editor and artist. She edits and writes fine art books for North Light Books, including the Splash series (Best of Watercolor); *The Best of Wildlife Art* (editions 1 & 2); *The Best of Portrait Painting*; *The Best of Flower Painting 2*; *The Acrylic Painter's Book of Styles and Techniques*; *Painting Ships, Shores and the Sea*; and *Painting the Many Moods of Light*. She also has acquired numerous new fine art book projects and authors for North Light Books, and is the contributing writer for *Fine Art Connoisseur Magazine*.

ACKNOWLEDGMENTS

Thank you to the editors, designers and staff at North Light Books who have made this into the beautiful final product it is, including Jamie Markle, Mark Griffin, Mona Michael, Guy Kelly and Amanda Metcalf. A special thanks to Vanessa Lyman who has been the foreman on the job, keeping it all together.

A special thanks also to the contributing artists. As I have said in my introduction, you have been great! You have been so willing to share and revise and send me more. I honestly count a number of you as friends, though the finite limits of space and time restrict the expression of that friendship. I long, as many of you do, for the fullness of the beauty we appreciate on this earth to come to fruition. For now, we can only imitate the wonder we see; one day we shall truly enter into it.

Other fine North Light Books are available from your local bookstore, art supply store or direct from the publisher.

10 09 08 07 06 5 4 3 2 1

DISTRIBUTED IN CANADA BY FRASER DIRECT
100 Armstrong Avenue
Georgetown, ON, Canada L7G 5S4
Tel: (905) 877-4411

F+W PUBLICATIONS, INC

DISTRIBUTED IN THE U.K. AND EUROPE BY DAVID & CHARLES
Brunel House, Newton Abbot, Devon, TQ12 4PU, England
Tel: (+44) 1626 323200, Fax: (+44) 1626 323319
Email: mail@davidandcharles.co.uk

DISTRIBUTED IN AUSTRALIA BY CAPRICORN LINK
P.O. Box 704, S. Windsor NSW, 2756 Australia
Tel: (02) 4577-3555

Library of Congress Cataloging in Publication Data---updated to come
Rubin Wolf, Rachel
 Splash 9 watercolor scenes : the best of watercolor / Rachel Rubin Wolf.
 p. cm.
 Includes index.
 ISBN-13: 978-1-58180-694-6 (hardcover : alk. paper)
 ISBN-10: 1-58180-694-9 (hardcover : alk. paper)
 1. Watercolor painting--Technique. I. Title: Splash nine watercolor secrets. II. Title.
 ND2420.R83 2006
 751.42'2--dc22 2006002778

Production edited by Vanessa Lyman
Designed by Guy Kelly
Production art by Lisa Holstein
Production coordinated by Matt Wagner

Reflect on Reflections

When painting water, remember that you actually are painting reflections. My general rule is to start by wetting a blue sky reflection with water. Then, starting at the farthest point, I apply a graded wash of more cobalt and less cerulean that has a touch of burnt sienna to tone down the brightness. When dry, I repeat—perhaps several times—to get the desired depth of color. You can enhance a "solitary boat" scene with reflections of unseen objects. You can place such reflections with an artist's purpose, aiming to add balance to the painting. Use a long, thick reflection on one side balanced with a few short, thin reflections on the other, for example. Then use a rigger brush to design ropes and lines in an undulating fashion to act as pathways through the reflection. If the reflected object also appears in the painting, get the placement right by painting the reflections with your eye level exactly even with the object itself. It is also a great idea to add a touch of the complementary color in the center of interest; in this case the burnt orange of the crab basket helps balance all the blue and acts as a magnet for the eye.

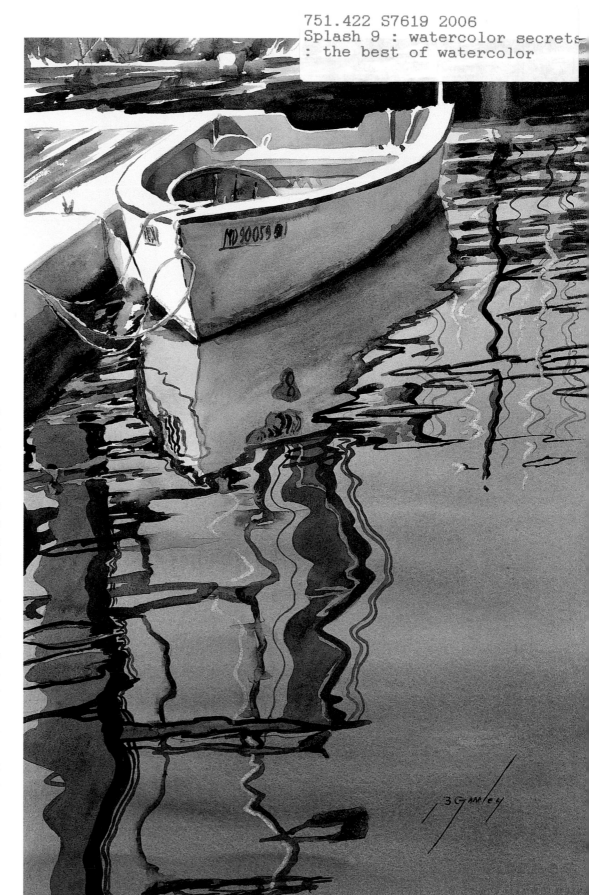

The Crab Basket Betty Ganley
20½" × 14½" (52cm × 37cm)

Table of Contents

INTRODUCTION
page 7

1 PAINTIN' IN THE STREETS
Whether traveling the world or walking to your own city's beat, there is action and beauty to be found in the streets, lanes and plazas of village and city alike.

page 8

SATURATED WITH LIGHT
AND COLOR
There are no more "watercolory" qualities than these. They are what make watercolors sing.

page 28

2

3 PAINTING RICH TEXTURE AND INTRICATE DETAIL
Watercolor lends itself to the broad wash, but also can be the unrivaled master of fine detail.

page 48

DARE TO BE DARING
There shouldn't be any stop signs in your studio. Have fun; it's just paper!

page 72

4

5 FINDING A POINT OF VIEW
Give life and freshness to overpainted or ordinary subjects by finding a new angle.

page 84

CREATING GLOWING MOOD
AND ATMOSPHERE
I think that I shall never see a painting lovely as a tree. But don't stop trying!

page 102

6

7 BREATHING LIFE INTO PEOPLE AND ANIMALS
Since human culture began, artists have sought to capture the unique gesture and personality of living souls—whether on a cave wall or canvas.

page 118

CONTRIBUTOR INFORMATION
page 137

INDEX
page 142

WHY DO YOU PAINT?

"Art has always been a part of my life. I paint because I can't stop."
—Judy Morris

"I paint because more often than not it speaks louder than any words I could say."
—Cathy Hegman

"I paint to capture the light, to freeze in time that which is always in motion."
—Robert O'Brien

WHY DO YOU PAINT?

"I paint because it brings me great joy and a feeling of accomplishment, starting with a blank sheet and giving it life."
—Rhoda Yanow

"Painting is my obsession, my passion and my greatest pleasure!"
—Sandy Delehanty

"I paint as a way to celebrate and express the unspeakable beauty that surrounds me."
—Jane Freeman

"When I paint, I am engaged with joy in all that is most beautiful and radiant to me— with my own creative spirit."
—Robin Berry

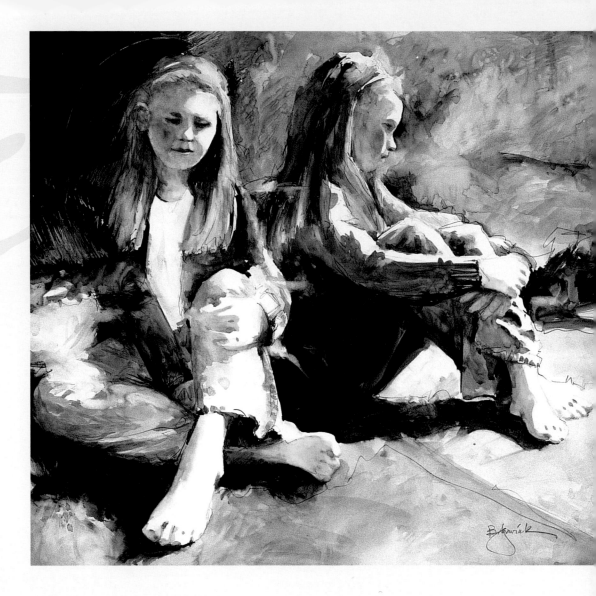

INTRODUCTION

Splash is well on its way to becoming an institution.
I have had the uncommon privilege over the years of viewing a large volume of exceptional artwork from a distinct body of artists. Some of the characteristics I have come to associate with "our" Splash artists—watercolor painters all—are sincerity, friendliness, eagerness to please, willingness to share and a general lack of that stereotypical vice of the creative artist: the inflated ego. What I have encountered over these fifteen years is an overwhelming sense of humility and gratitude for the gift of art.

For this ninth volume we asked the artists to share their tips and techniques so the rest of us can benefit from their experience. Again, they were more than willing to openly share their dearest art secrets. But while I was editing the captions I found I wanted to know something deeper, something a little less tangible, a little more personal. I decided to e-mail all the artists and ask them, "Why do you paint?" Responding was optional, yet about two-thirds answered. We have scattered the responses throughout the book, but I wanted to share here a poem sent by contributing artist Donna Phillips Roberts. I thought it summed up both the thought of many of the artists, as well as the open, giving spirit that has become for me the hallmark of the Splash artist. Please receive the wonderful gifts presented here, in the artwork and in the shared secrets.

I paint to share that part of me that marvels
 at mountain lilies
 drenched by morning yellow light

I paint to share that part of me that gasps
 at giant cedars
 glittered by filtered lace-like light

I paint to share that part of me that sings
 at pristine waters
 shimmered turquoise by skies reflected light

I paint to share that part of me that jubilates
 at jumping trout
 jeweled, gilded gold by day's late light

I paint to share that part of me that awes
 at earth abundant
 filled with feeling, pure delight

Unspoken Friendship Bev Jozwiak
33" × 32" (84cm × 81cm)
Collection of Mary Hurley

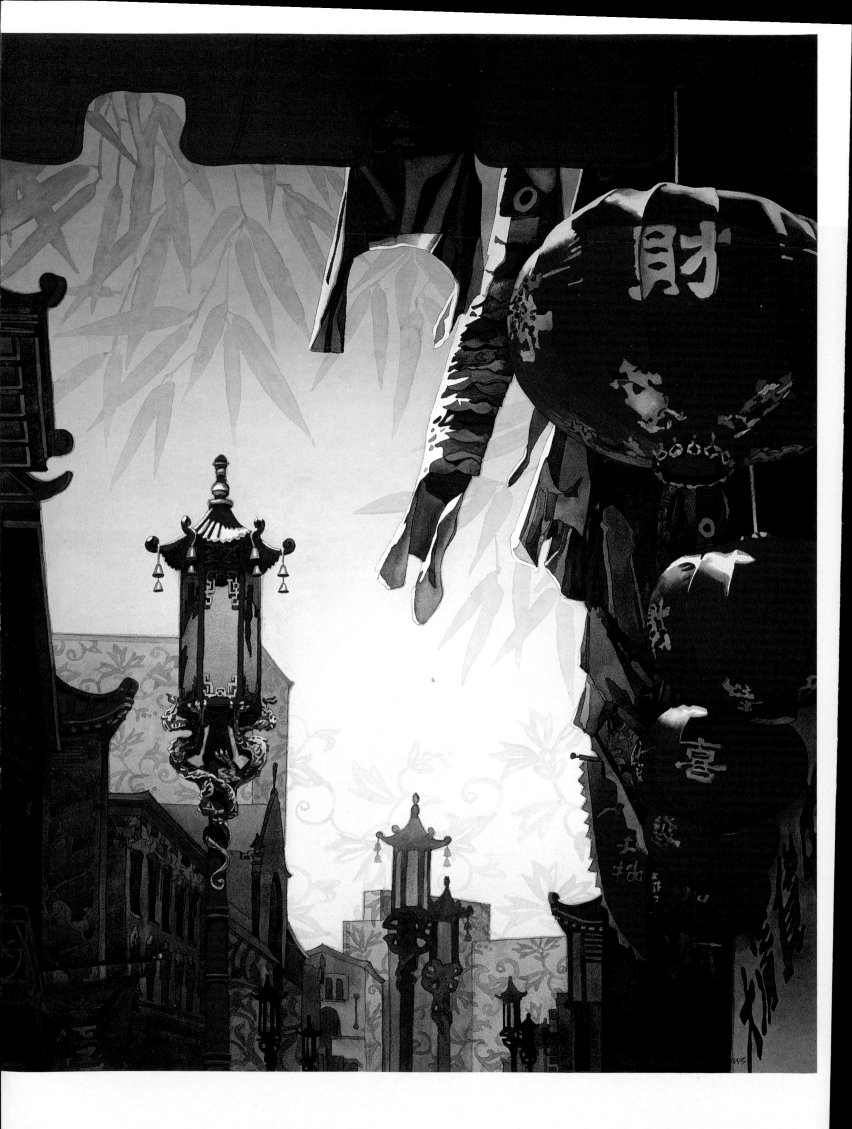

PAINTIN' IN THE STREETS

So many of us try to capture in paint the sights we see while traveling, or perhaps just record the sights and sounds of

our own city. But it is all so confusing most of the time. I asked these artists to tell me what it is they look for

in a scene when they travel and how they record their impressions.

Rachel

Focus and Frame

Chinatown: San Francisco was painted from photographs, as are most of my watercolor paintings. Still, I always say, "My camera doesn't know anything about design. It's a good thing I do!" For that reason I edit and rearrange as many as twenty different photographs of a subject to create my compositions. As I take photo references, I look for two specific things as the backbone for a composition: a focus and a frame.

The focus is the thing that catches my eye—the original inspiration for the painting. Here, the focus is the red lanterns and colorful wind kites hanging in front of one of the Chinatown stores. The frame is the piece of red awning that became the horizontal attachment at the top of the painting along with the shapes of the dark buildings around the perimeter of the composition. One job of the frame is to keep the viewer's eye inside the painting so it doesn't wander over to the painting hanging next to it! A horizontal or vertical attachment often becomes the frame. My focus and frame technique enables me to create a personal interpretation of the location rather than just painting a postcard view.

Chinatown: San Francisco Judy Morris
34" × 28" (86cm × 71cm)

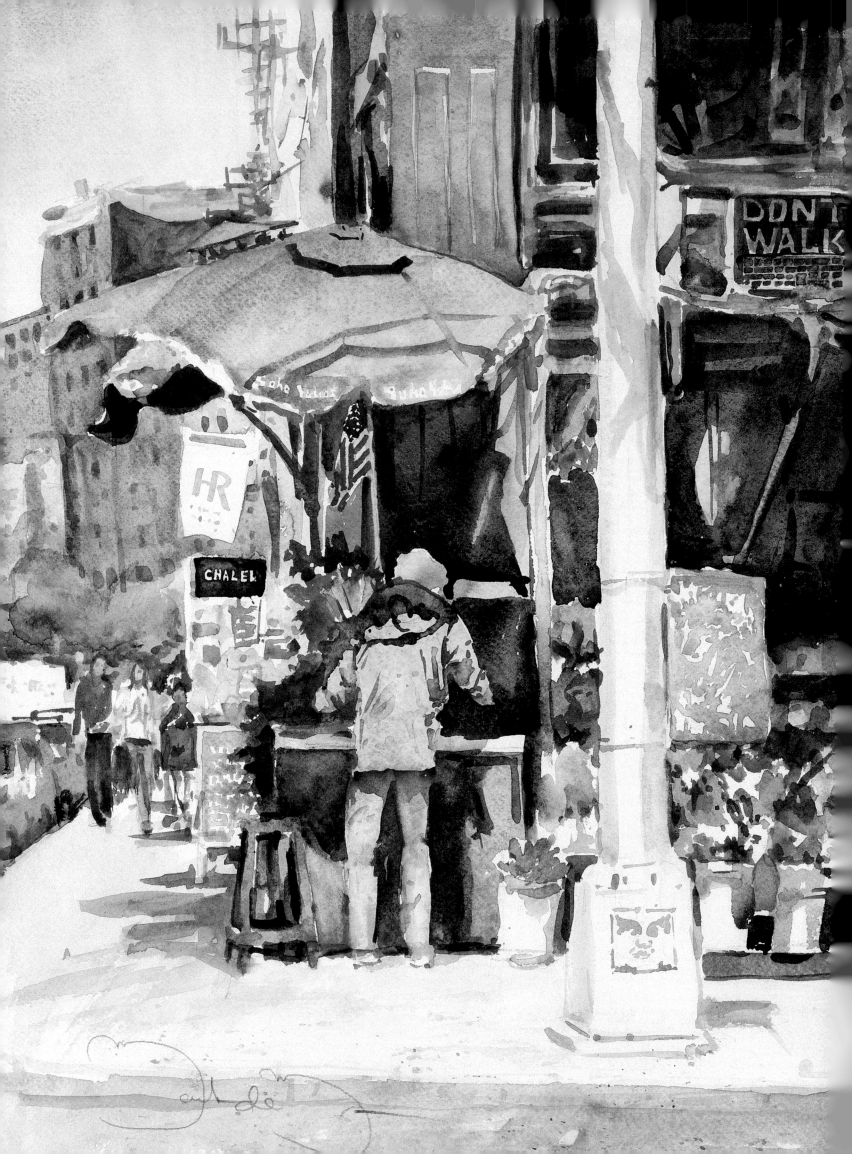

Elicit the Mood

Since retiring as an architect, I have become an avid student of history, architecture, painting and sculpture. The Palazzo Vendramin in Venice is an excellent example of fifteenth-century Italian Renaissance architecture. It is a facade, a stage set, yet it adheres to classical Greek and Roman proportions with a Byzantium influence. I drew the building facade in pencil to its proper scale and proportions, then masked out the building and selected details to save white paper. I painted the water and sky with mixed colors, saving some to be used later in the building. I pressed three or four layers of plastic wrap into the wet paint and weighted it overnight. After removing the masking, I applied graded washes to the buildings and the details, leaving most of the pencil lines showing. I tried to capture both the mood of Venice and the concept of man's persistence to place objects into our natural environment.

Create a Pictorial Narrative

To create art from city life, exploit the play of light and shadow while finding related or conflicting elements, all to create a pictorial narrative, a sense of place. I created the bright bustling atmosphere of *Green Grocer*, set in Soho in New York City, using loose brushstrokes, contrasting sedimentary versus dye colors, and alternating areas of bright sunlight and deep shadows. The allure and unifying factor is the interconnected greens. To create complex, variegated washes, I allow the water and paint to mix through gravity. A wet-in-wet underpainting establishes light colors and warm accents while richer secondary washes laid side-by-side mingle to unify contiguous parts. I then create form by adding shadows and detail.

Green Grocer Mark de Mos
19" × 13¾" (48cm × 35 cm) (LEFT)

Palazzo Vendramin Tom White
15½" × 10½" (39cm × 27cm) (ABOVE)

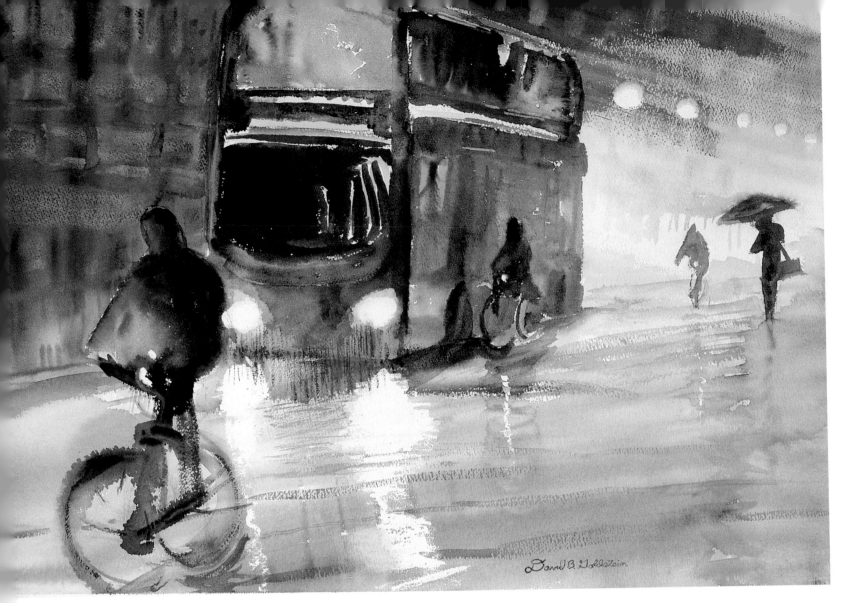

Capture a Moment

When painting a scene, I let myself escape to a time and place to recapture a moment and strive to express through watercolor how it felt. For *Red Bus*, my mind was back in London, and I was again walking alone on a rainy night through the city streets. I am attracted to light and reflections, especially in water, and in this case was interested in both rain and motion. I spend more time planning than painting. I start with a goal and a vision and decide in advance the big picture elements, including large shapes, choosing colors and values. I don't plan the details, which frees me while painting. To create work that is both deliberate and spontaneous, I work from a minimal sketch, drawing with my brush in quick bold strokes, applying color wet-in-wet one shape at a time to maintain control. I expressed the rainy night by tipping the paper at a 30-degree angle to allow the paint to drip. I show objects in motion with soft edges and dry brushstrokes, and I use hard, controlled edges for high contrast to emphasize a focal area.

Simplify a Chaotic Scene

I was inspired to paint this cityscape after attending the American Watercolor Society show in New York City. My biggest challenge was making sense out of a chaotic street scene. My only photos were blurry because of the rainy weather. I realized I needed to simplify and pay close attention to the shapes. The people became shapes that indicate motion; the policeman is at the center of interest because the flow of traffic revolved around him. The reflections on the wet pavement excited me most. To create the illusion of shine, I masked the vehicles' headlights and some of the road below them to save that all important white paper.

Red Bus David B. Goldstein
22" × 30" (56 cm × 76 cm) (ABOVE)

47th and Broadway Dianne Hickerson
27" × 22" (69cm × 56cm) (RIGHT)

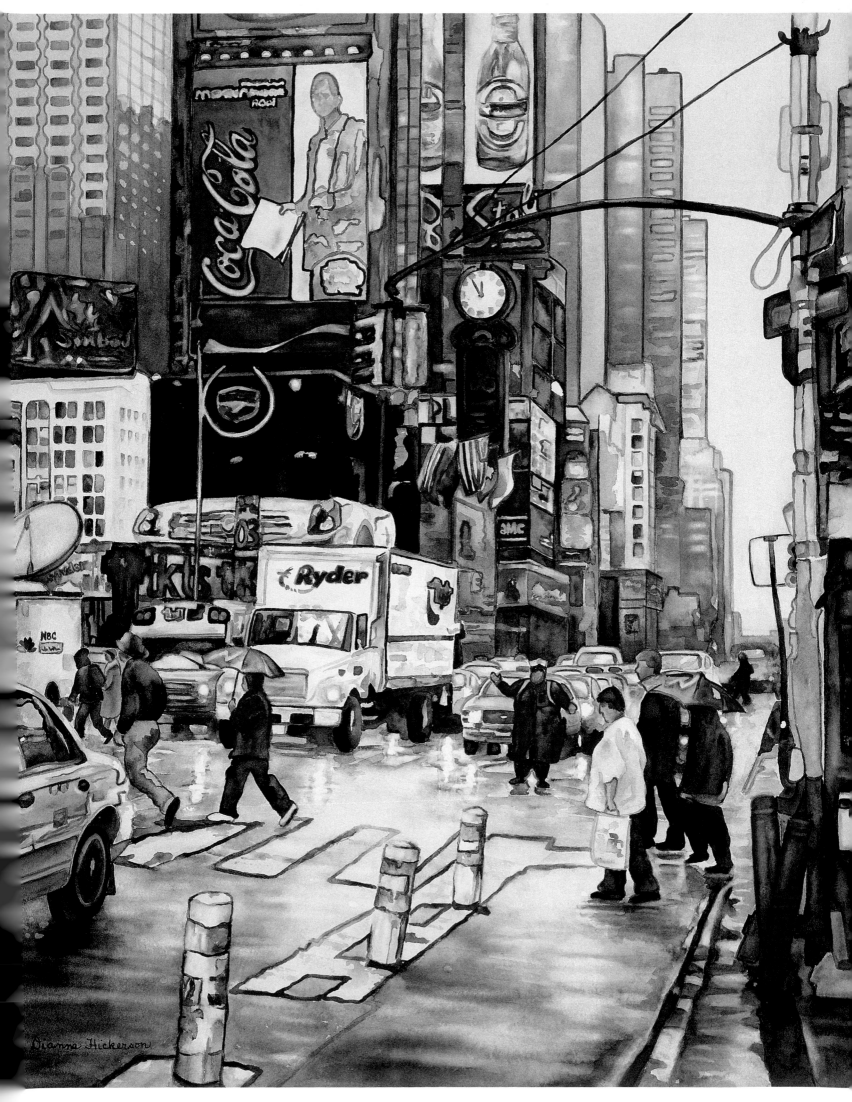

Dianna Hickerson

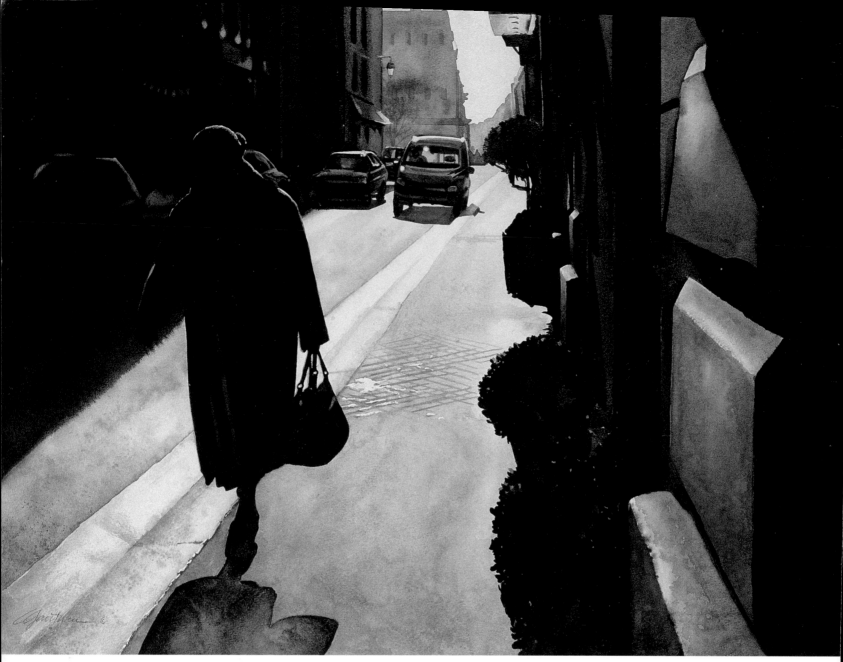

Trust Your Instincts

Late one afternoon, on a street in Paris, with my camera in my hand, I heard a passerby blurt out that I'd never get a good picture shooting into the light. *Click.* The strong contrast and backlit details that originally caught my eye translated into a successful painting. I started with a limited palette of primary colors to unify the work and a good sable brush to make the variations in the large, dark wash easier to manage. An underpainting, rich in both texture and color, laid the groundwork. When this first layer dried, I laid the darkest values down, pushing the range from deep green to dark blues and purples. This process produced the extreme contrast I wanted. Highlights on the figure and parked cars, and outlines of the architecture in simple perspective give enough detail to carry the dark values yet create the sense of mystery that first caught my attention.

WHY DO YOU PAINT?

"I paint for the joy of being able to create a picture than can be enjoyed by others and myself, now and in the future."

—Jean Smith

Start With an Excellent Drawing

Venice possesses a unique ambiance. It is a city that seems to glow with eternal grandeur. The sharp contrasts of the buildings, bridge and water in this scene drew my attention. I started with a detailed sketch of the subjects. I used the first five or six layers of the painting to produce strong colors and sharp contrasts. I used watercolor pencils for the detailed railing and grid work on the bridge. I painted the reflections on the water one small area at a time.

Returning Home Carla Gauthier
20" × 26" (51cm × 66cm) (ABOVE)
Collection of Michael Cheney and Penny Vance

Venice—Bridge Jean Smith
17" × 13" (43cm × 33cm) (RIGHT)

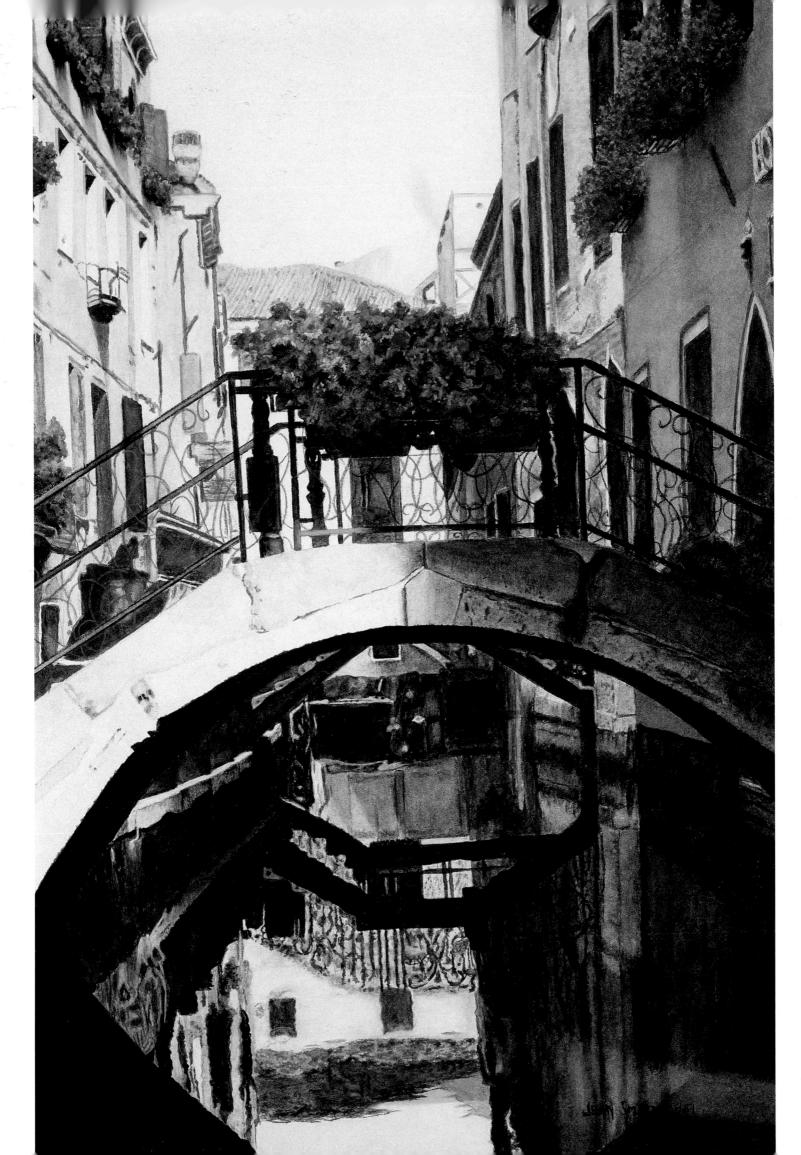

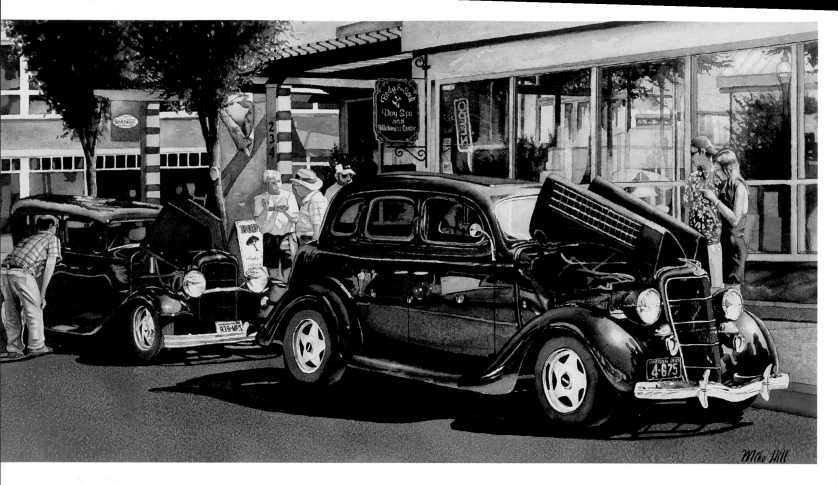

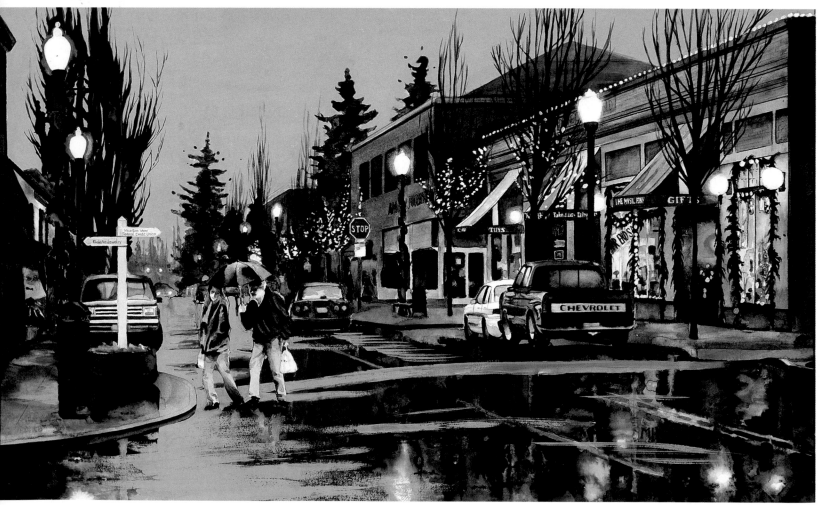

Bodies and Souls Mike Hill
14¼" × 27½" (36cm × 70cm) (TOP)

Christmas on Main St. Mike Hill
15¼" × 26½" (39cm × 67cm) (BOTTOM)
Collection of Mike and Kathy Henton

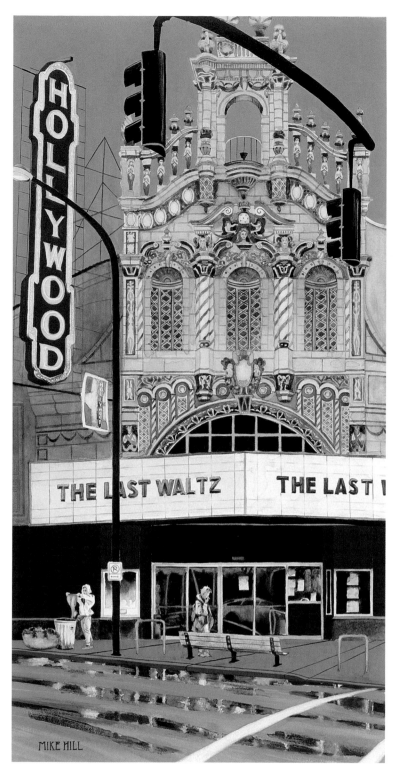

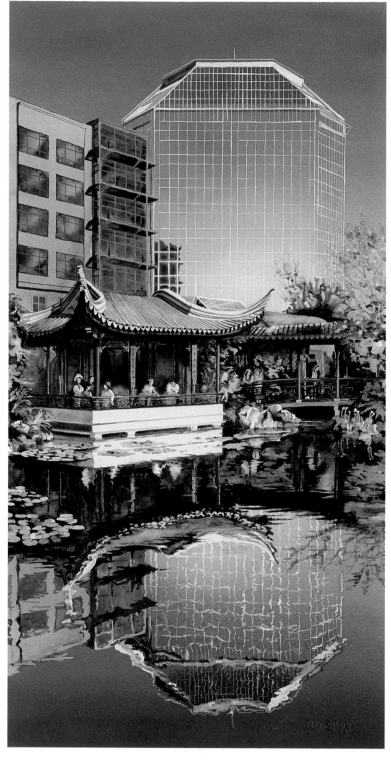

Paint Realism With Attitude

Some say seeing is believing. I believe seeing is even more than that. We, as artists each see, believe and experience the world around us in our own unique way. Seeing city buildings as wonderful, architectural creations is fine, but it takes an artist to see the majesty in their glow and reflections. I find cars and people on the street to exhibit similar personality characteristics. The essence of a car or the gestures of people on the street can express mood better than words. I call my style of painting "Realism With Attitude." The realism is obvious; the attitude comes with the technique. I've learned not to be afraid of using opaque watercolor (gouache). I love the luminescence when you drop in a touch of Chinese White on a wet, transparent wash. I apply gouache with a fine rigger over an airbrushed sky as in *Occidental Oasis* or with a dry brush over a reflective street as in *Christmas on Main St.* and *Last Waltz*. Salt with transparent watercolor and gouache convey a realistic pavement texture. Use whatever tools and materials you need to capture the spirit and essence of each cityscape.

WHY DO YOU PAINT?

"I paint because I cannot do otherwise. I like to think of my work as realism with an attitude, understanding that life is precious—and even more precious when you can re-create it on paper."

—Mike Hill

The Last Waltz Mike Hill
33¼" × 16½" (85cm × 42cm) (LEFT)

Occidental Oasis Mike Hill
29½" × 15¼" (75cm × 39cm) (RIGHT)

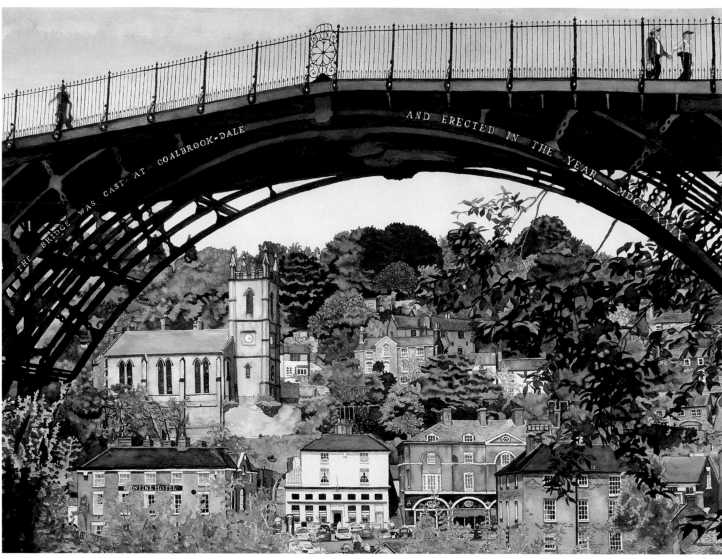

Record Travel Photos

My husband and I make frequent Spring trips to England, where I photograph buildings, flowers and gardens. I keep two kinds of records of these photos. On a small notepad, I record a letter for the roll of film and a number for each picture alongside to any on-site notes to refresh my memory. Each evening, I record the events of that day: highways, buildings, museums, gardens, pubs, food, weather, etc. Back in the studio, these records help me recall my feeling for the time and place. At the top of our 2003 "wanna see" list was the Iron Bridge, built in 1779 across the Severn River valley gorge. The United Nations has declared this area, where the Industrial Revolution began, a World Heritage Site. As I contemplated painting the Iron Bridge, it became obvious that no individual photograph showed all I wanted to tell about this modern wonder. By incorporating bridge, people and village into one composite scene, the *Valley of Invention* emerged as both the theme and the title of the painting.

WHY DO YOU PAINT?
"Watercolor painting was a gift from God, a second career that changed my life. At the age of 71, I can look back on 15 fantastic years of painting, competing, traveling to England and the excitement of waking up each morning to see if what I painted the day before still looks good."

—Tommie Hollingsworth-Williams

Create Depth of Field for Deep Distances

Beware the Dog is the portrayal of an isolated hill town nestled among the mountains in Italy. I achieved depth of field, an essential part of the painting, through three types of contrast. I used warmer colors in the foreground and cooler colors in the background. Even in the distant hills, the greens become paler and cooler toward the horizon. The sky is a darker blue at the upper part of the painting (that part of the sky being closer to you) and becomes lighter as it recedes toward the horizon. Detail is accurate and complex in the foreground, becoming softer and diminished in the distance. You should have contrast between warm and cool, between light and dark and between detail and looseness.

Valley of Invention
Tommie Hollingsworth-Williams
23" × 30" (58cm × 76cm) (ABOVE)
Collection of Dr. and Mrs. Forrest Wood

Beware the Dog Estelle Lavin
40½" × 26" (103cm × 66cm) (RIGHT)

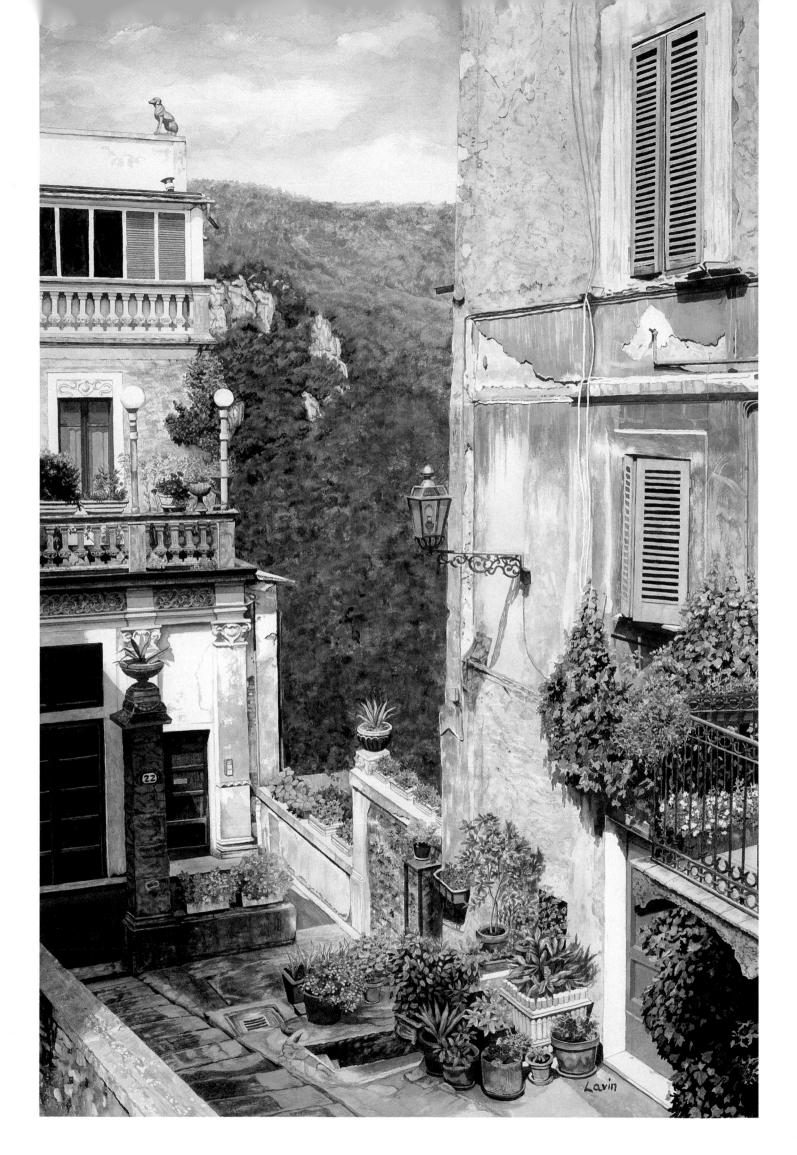

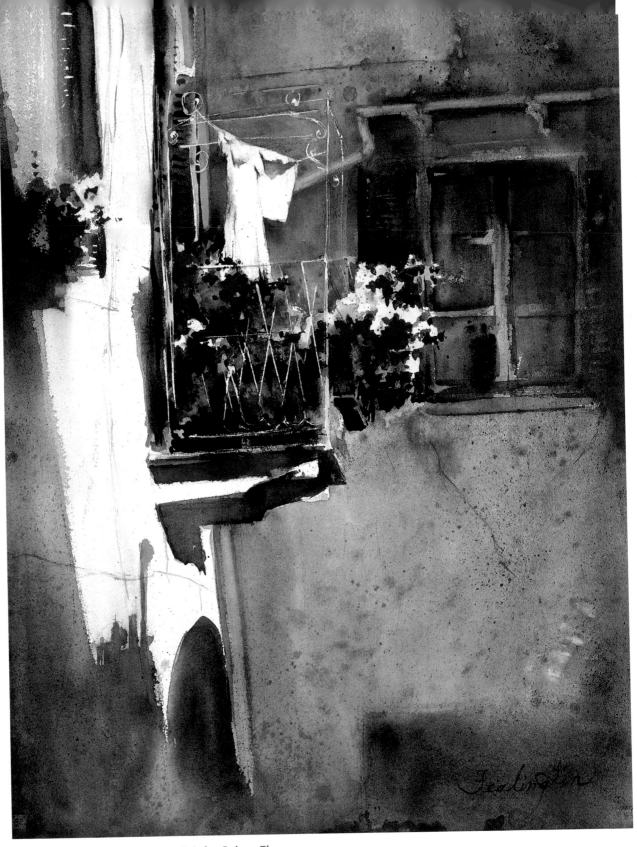

Let Bright Colors Flow

My first trip to Northern Italy inspired both of these paintings. I was drawn inescapably to the marvelous tapestry of light and shadow patterns that artfully defined the narrow streets and buildings in that region. On 300-lb. (640 gsm) watercolor paper I used a flat brush to apply light washes of Alizarin Crimson, Ultramarine Blue and Burnt Sienna wet-into-wet over the entire paper, making sure to save my white areas. After the paper dried, I used masking fluid to mask the people going upstairs in *Lady in Red* and the thin lines on the balcony in *Corner of the Alley*. After the masking fluid dried, I used big brushes to paint large strokes of medium and dark values. I added details last, using a dry brush for the buildings and a razor blade to prick some light on the plants in the center of *Corner of the Alley*.

WHY DO YOU PAINT?

"Painting revived my life and set me free. During a very difficult time in my life about 20 years ago, I decided to give myself one final chance to do my favorite thing, painting. It was a major turning point, and now my painting is in Splash 9."

—Reiko Hervin

Corner of the Alley Fealing Lin
30" × 22" (76cm × 56cm)

Lady in Red Fealing Lin
30" × 22" (76cm × 56cm) (RIGHT)

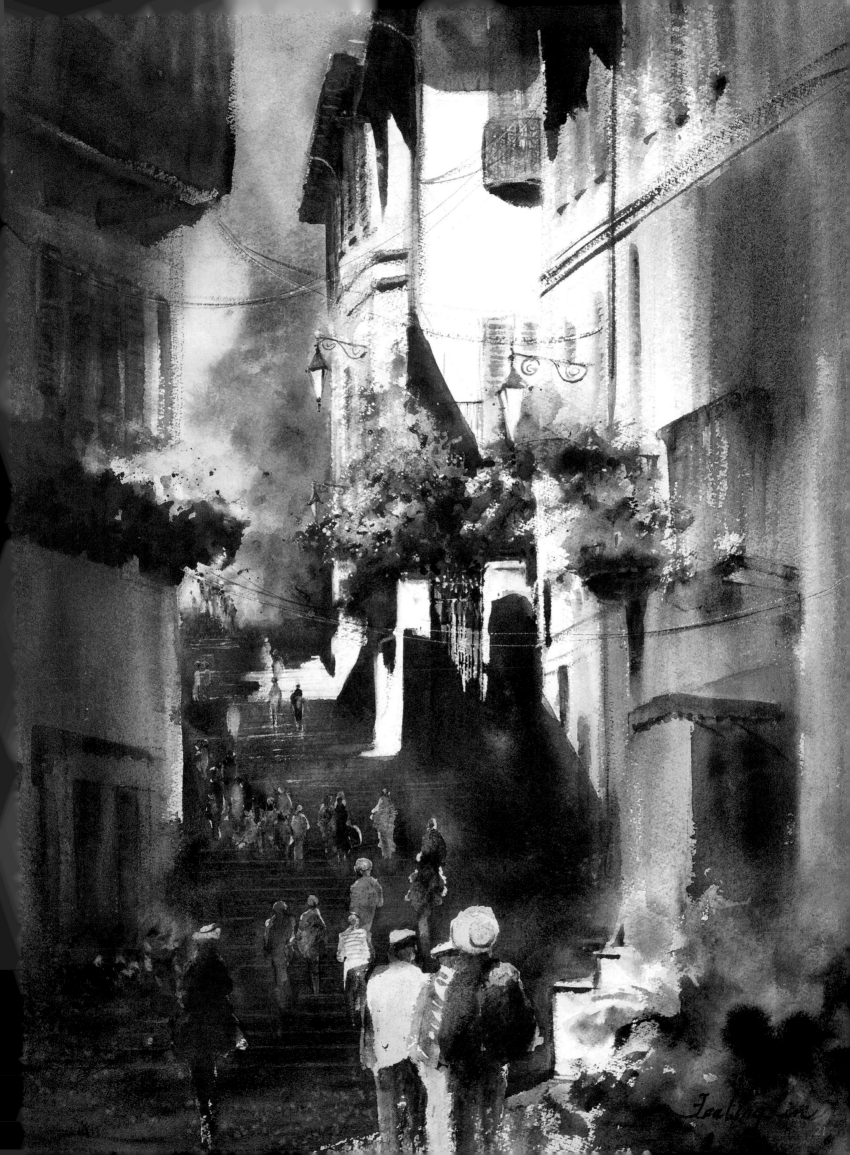

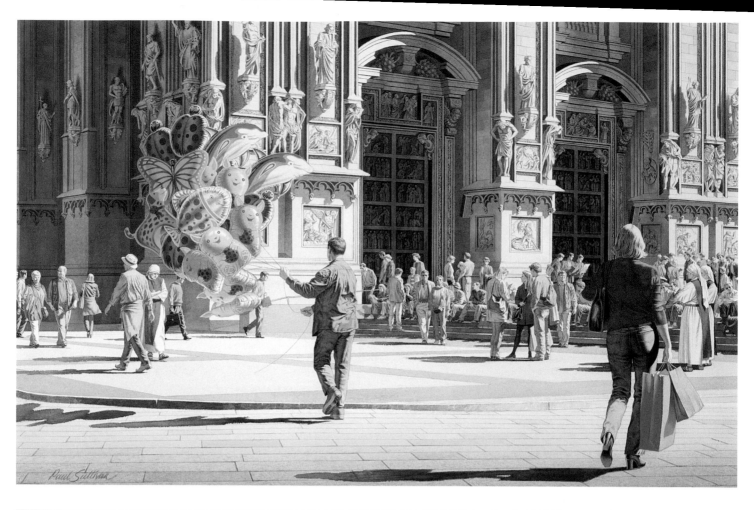

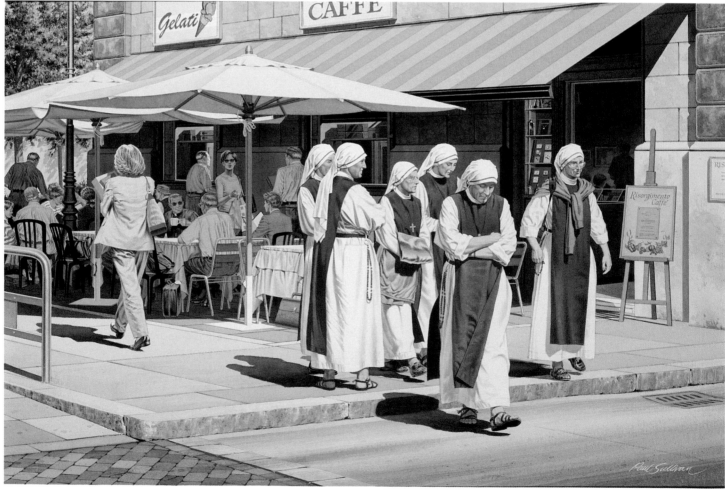

Piazza del Duomo, Milan Paul Sullivan
18" × 28" (46cm × 71cm) (TOP)

Risorgimento Caffé, Rome Paul Sullivan
19" × 28" (48cm × 71cm) (BOTTOM)

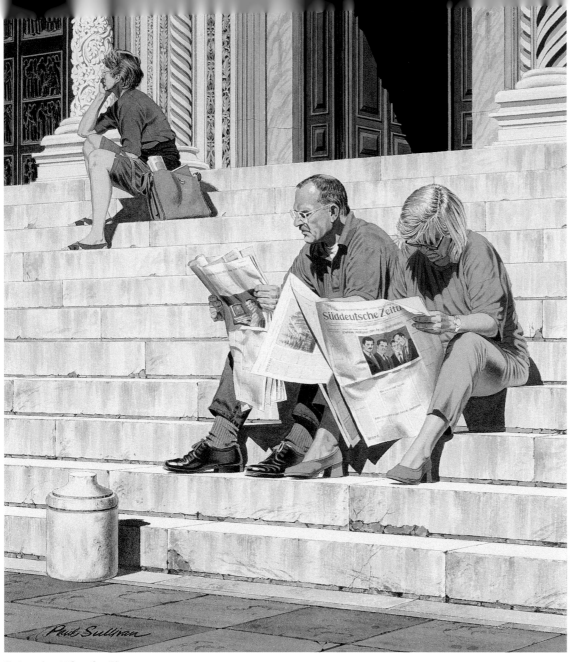

Paint the Life of a Place

Wherever I travel, I paint the people—the life of the place. When I walk around the streets of a new city, I can feel a little of its soul from being out among the people who are engaged in everyday activities. I look for a scene that can put the viewer on the streets of Milan or Sienna or New York City with me. I usually shy away from landmarks as subjects. However, the Milan cathedral in the Piazza del Duomo is connected to the life of the place. I had studied the cathedral of Milan in classes on church architecture. When I actually saw it, I was taking a short cut across the crowded piazza on my way to the mall. My first reaction was, "Good Heavens, there it is!" The place was alive with people and had all the elements that I look for in a subject. A picture like this calls for a lot of preliminary drawing, but the drawing can be lost after the initial washes of color, so I painted a lot of the darker details (lightly and on smaller areas only) with transparent acrylic before applying any watercolor.

I was walking down a side street near the Vatican when I saw several nuns at a busy cafe. *Risorgimento Caffé* began with a perspective drawing of the entire scene without the figures. After I established the perspective, I added the figures in correct proportion. People sitting in the sun crowded the steps of Sienna's Renaissance Cathedral. They reminded me of an audience waiting for a play to begin. For some reason my attention focused on a couple reading a German newspaper. While sketching, I decided to eliminate all the other figures except one for balance. I used a type of dry-brush technique, dragging a loaded brush across an old file folder to paint the steps.

WHY DO YOU PAINT?

"I paint for the challenge and excitement of making ideas and impressions into a tangible image. The challenge is always there, several paces ahead of me, and the excitement never fades."

—Paul Sullivan

Cathedral Steps, Sienna Paul Sullivan
24" × 20" (61cm × 51cm)

23

WHY DO YOU PAINT?

"I was born into an artist's family and was brought up thinking that drawing or painting is as natural as speaking or writing. Now, though, art is my profession and not just a hobby or therapeutic practice. It is my life."

—Milind Mulick

Design With White

I use a photo reference only if I have seen and felt the place. For *Cycle in the Puddle* I kept a very direct approach. Only once or twice did I glaze or apply a second layer. This is a street in an old part of Pune, India—a sure place to find lot of puddles after a heavy shower. While the other passersby cursed the road-building authorities, the reflections these puddles provided fascinated me. The well-connected white areas formed a path on the drenched road, creating a visual flow. The other whites of buildings and umbrella tops tie in the top edge of the rectangle.

In *Night Lamp*, though, I layered the washes carefully to form the design shapes. Also in Pune, the single source of light caused diagonal shadows and a sense of mystery. (I am indebted to the "night mode" on my digital camera.) I didn't let any sharp edges form except in the shadows where I used a deliberate play of lost and found edges to build the design.

Cycle in the Puddle Milind Mulick
15" × 20" (38cm × 51cm) (TOP)

Night Lamp Milind Mulick
15" × 20" (38cm × 51cm) (BELOW)

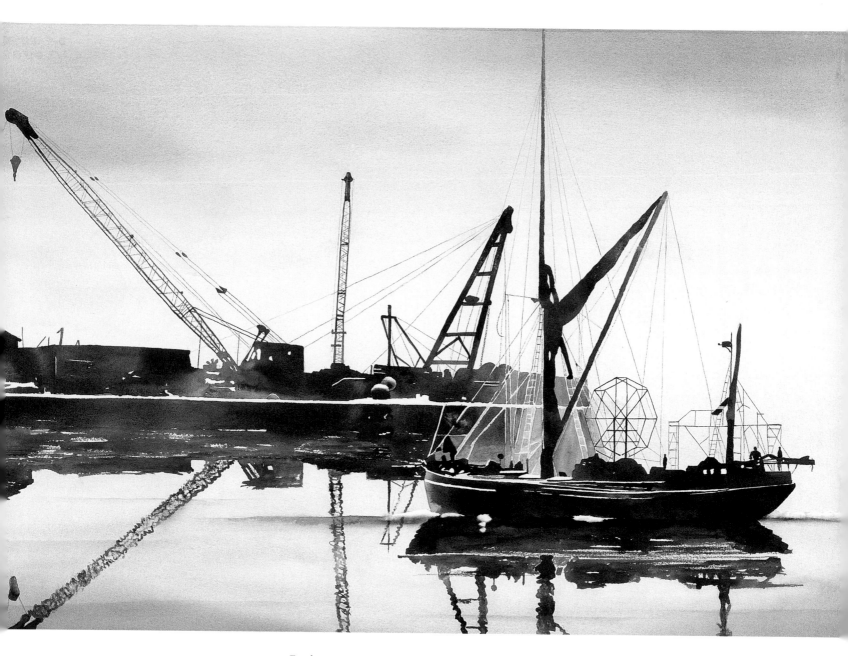

Evoke an Emotional Response

In this painting, I commented on man's intrusion on nature using linear and directional elements. Lines may be straight or curved and horizontal, diagonal or vertical. Though there is variation, I maintained unity by letting straight and diagonal elements dominate. Man's protrusions into the stillness of the water and sky convey a conflict with the horizontal tranquility of nature and the format of the painting itself. I abstractly reconstructed and rearranged the scene to leave an impression of realism. I sacrificed the background objects' identities for the design by backlighting them into one detail-free shape. All the lines lead toward the red circular shapes. Touches of red elsewhere in the design further relate the sections to one another.

Fairhaven Shipyard Mike Mazer
22″ × 30″ (56cm × 76cm)

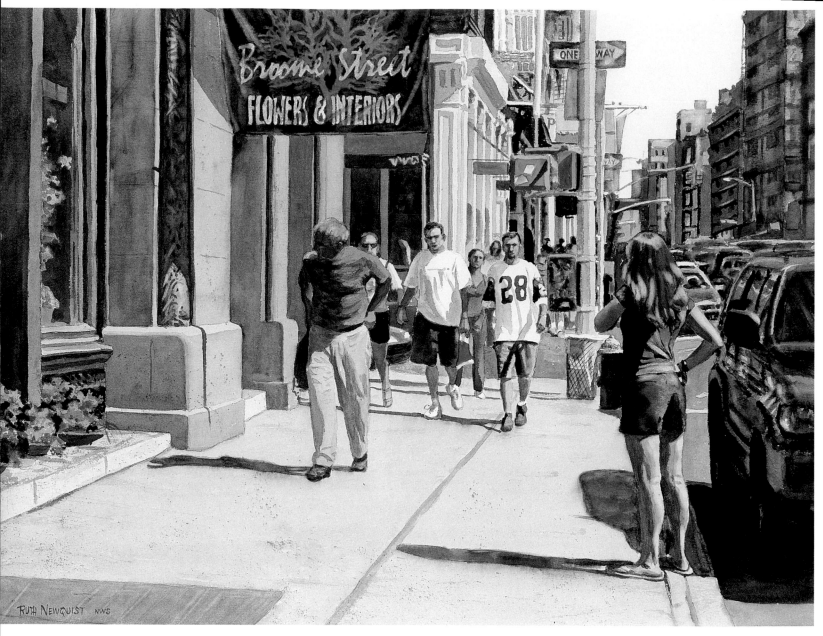

Communicate the Energy of the City

I love to paint the city. But it's very difficult to set up on a busy street, so I instead visit on sunny days and take lots of pictures. I usually have a clear idea of what I want to capture. I first look for buildings rich in character to set the stage—buildings with strong color, exciting imagery and dark, shadowy accents for punctuation. To communicate the energy of the city, I look for interesting people in colorful dress, in action, with an attitude. A storytelling quality in the scene is always a plus, but I am careful not to let the figures take over. By the time I am ready to paint in my studio, I've done my planning, often including a careful color study. I have created the entire picture clearly in my head. City scenes are so full of detail that it is easy to get confused working all over the painting, so I usually work one area at a time and finish it before I move on to the next. As the painting progresses, I look to capture on my canvas the energy I felt on the street.

Waiting Ruth Newquist
21" × 29" (53cm × 74cm)

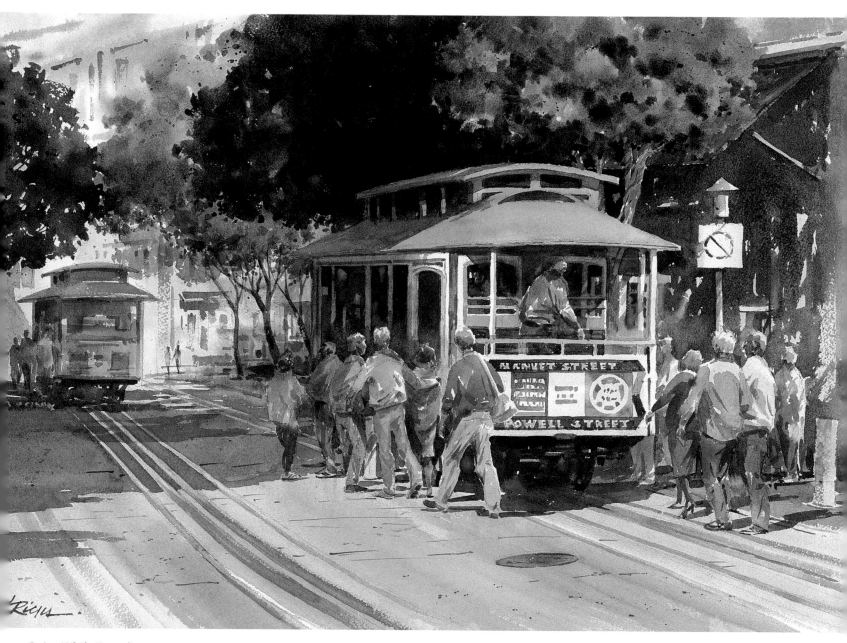

Paint While Traveling

I look for appealing subjects with exciting local color and good value patterns. This gives a scene the potential to attract viewers from a distance and invite further interest. When I happened on this scene in San Francisco, the possibilities presented by the colors in the trolley and the movement of the people intrigued me. The strong patterns of light and shadow appeared to be nearly a ready-made composition. I returned to the spot several times until the light was just right. Working from digital photos back in the studio, I drew a well-defined value sketch in pencil and enhanced it with light, medium and dark felt-tip markers. On cold-pressed paper, I started wet-into-wet and then brought out more detail as it dried. I lifted the tracks with masking tape and a small, stiff brush. The interplay of warm golds and mauve-y blues make the painting sing. I added some of the figures were taken from other photos of the same area to capture the hustle and bustle.

San Francisco Shadows Lee Ricks
14" × 20" (36cm × 51cm)
Collection of Helen Casterline

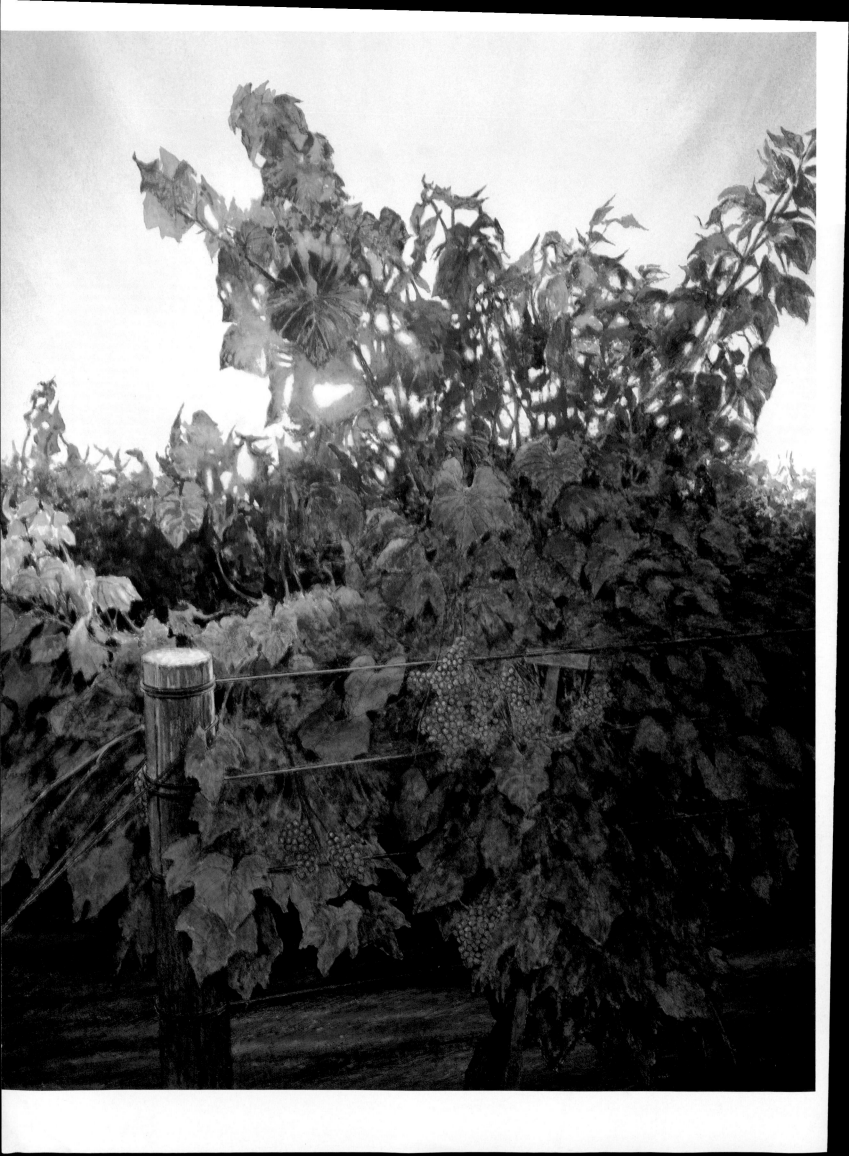

I don't think watercolor painters will ever tire of portraying light and color. At least I hope not!

When I review the slides for *Splash*, I am always struck by the number of paintings that communicate the

breathtaking beauty of natural light and the sumptuous radiance of delicious watercolor color. I simply

asked these artists, "How do you do it?"

Rachel

Paint the Light Source

"Harnessing the light" creates the drama in this painting. In order to create the atmospheric effect of the sun's glow, backlighting the foliage, the colors and values of the grape leaves, and the quality of their edges are extremely important. Some artists would be tempted to paint leaves in front of a glowing light source as nearly black to show strong contrast. But it works best to do just the opposite. Glow will produce more glow. The leaves nearest to the source of light need to reflect three light qualities: warm color, softness and diffusion. As the leaves move away from the light they will get cooler and darker, like the leaves in the lower part of the composition. To achieve this diffusion, softness and glow near the light source, I select lighter warmer colors and use a number of techniques for lifting and softening the shapes and edges, such as blotting and lifting with a dampened facial tissue or, for details, the cotton tips for eyes found in pharmacies.

Vineyard Radiance Robert Reynolds
27¼" × 21½" (69cm × 55cm)

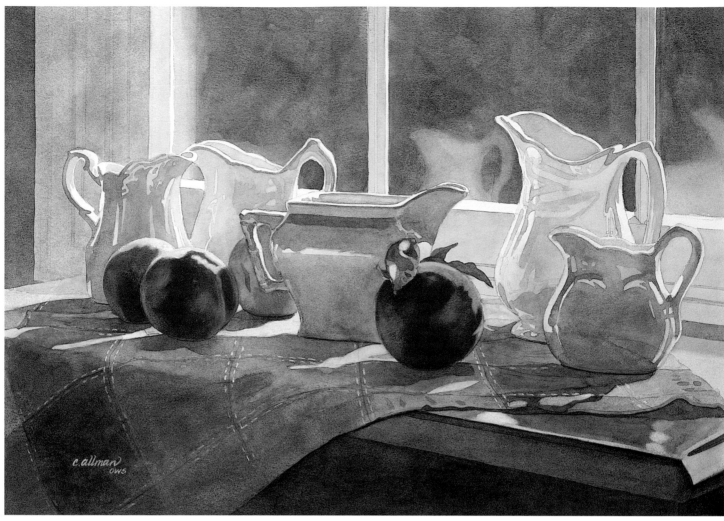

Add Glow to Still Lifes

For *Peaches With Creamers*, I wanted to see how much reflective color from nearby objects I could bounce into a group of solid white creamers. After projecting my finished drawing onto cold-pressed watercolor paper, I began the process of layering transparent washes to create the illusion of soft ambient light falling onto and around objects. Backlighting from the late afternoon sun created dramatic shadow shapes and an overall warm, glowing light. I enhanced the colors bouncing into the shadows from surrounding objects with additional thin layers of pure pigment. Careful to keep my values accurate, I exaggerated the color in the shadows and reflected light.

WHY DO YOU PAINT?

"It is instinctive. I have always drawn or painted, even as a child. It is as natural to me as breathing. And I don't know why I do that, either."

—Cindy Allman

WHY DO YOU PAINT?

"For the challenge! Capturing the sensation of a moment armed with only paper, brush and pigment is exciting every time I attempt it. When I succeed, I am rewarded with the joy of sharing that moment with the others. What fun!"

—Kris Parins

Create Bright Sun on Fresh Snow

Use cool, transparent colors, allowing the white of the paper to shine through, applying the colors wet-into-wet in one hit. Don't overwork it, or you will lose the glow. First, I worked wet-into-wet in the foreground using a large mop brush and cool primary colors: Manganese Blue, Aureolin Yellow and Rose Madder Genuine. When dry, I painted the cast shadows primarily in Cobalt Blue, taking care to vary the edges from hard to soft by stroking some with a clean, damp brush. I added the reflected rock color by charging Rose Madder Genuine into some of the blue shadows while they were still quite wet to create a soft blend to violet. Finally, I added the darkest snow shadows with French Ultramarine Blue. Whenever I look at this painting, I am transported to the scene of my regular hikes around the frozen lake and can feel the warmth and blinding brilliance of the winter sun.

Peaches With Creamers Cynthia Allman
15" × 21" (38cm × 53cm) (ABOVE)

Hard Rock Café Kris Parins
21" × 14½" (53cm × 37cm) (RIGHT)

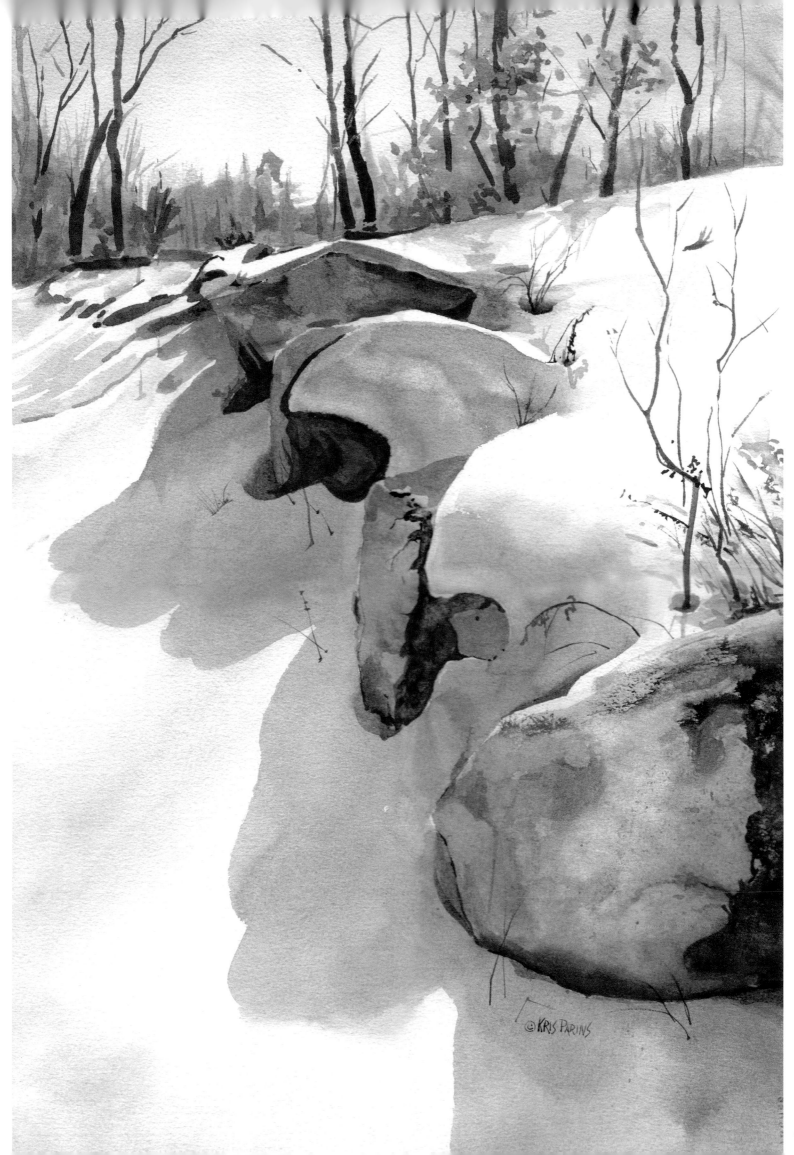

©KRIS PARINS

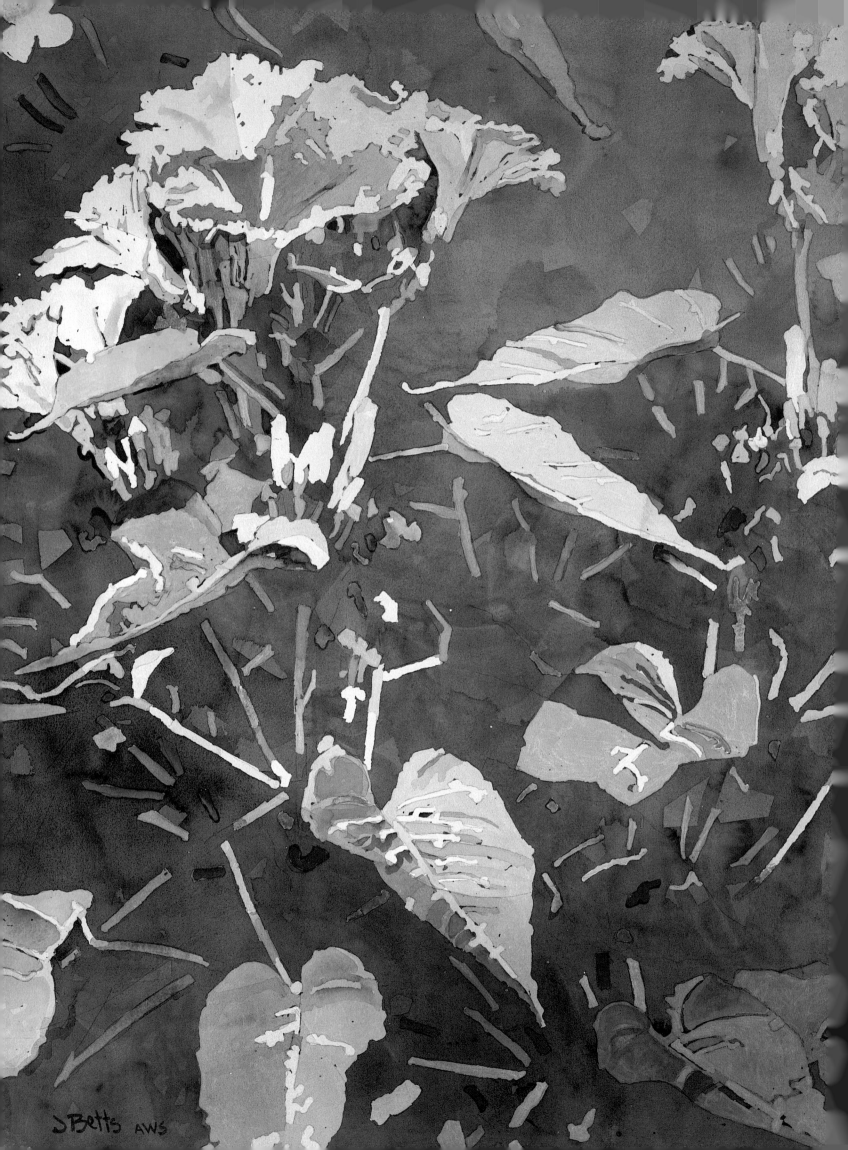

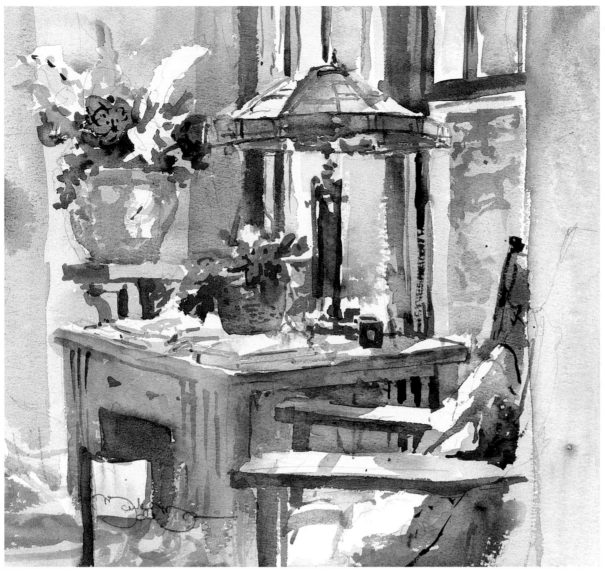

Catch Fleeting Light

I painted *Comfortable Elegance* on location at a bed and breakfast in bright, indirect light. To communicate the cheerful, relaxed mood of the bright, fresh day flooding inside, I had to capture the colors and values quickly, before the light shifted. Using bright clean colors—Gamboge, Rose, Cobalt Turquoise and Ultramarine—I first established the large areas of reflected light with a variegated, medium-value wash, leaving white highlights of direct sunlight. I then created form from secondary washes and calligraphic strokes.

Exaggerate and Stretch Reality

In the original scene, the plants in this painting were entwined in a fence. I eliminated the fence but exaggerated the vines and leaves to make them more angular. The focal point in the upper left gives a diagonal emphasis. I start with a value study to determine light areas. Then comes the underpainting: six rectangular shapes, each painted a different, exciting light-value color. I then use the complementary color of each rectangle to build up layers. I paint around areas I want to save as lights. I design additional light shape as I go scrubbing them out of the existing underpainting with a damp, natural sponge and a note card as a straightedge. You can add more color later to save light areas. Large gray areas, juxtaposed with bright colors, create visual vibration, as in the lower right, where an intense red sits in a pale green area.

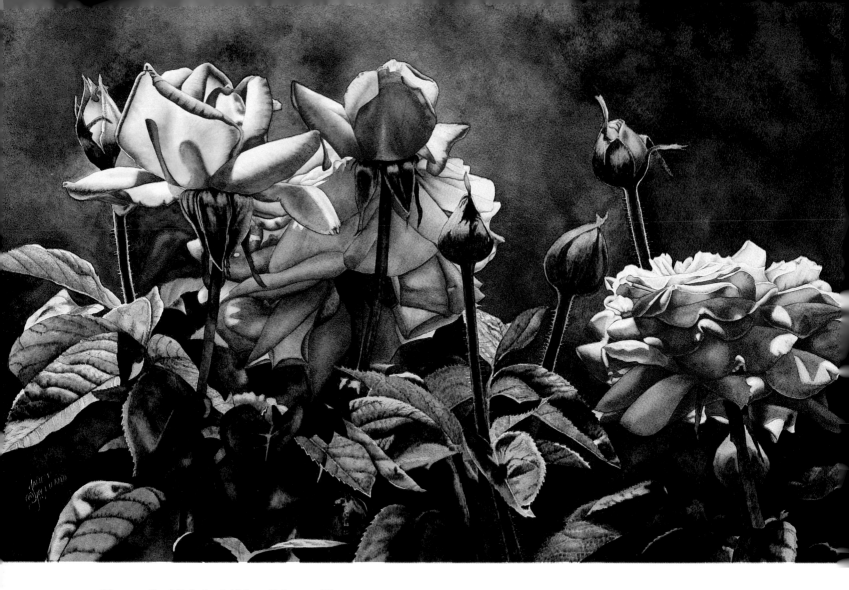

Observe Backlighting's Value, Color and Temperature

Backlighting on delicate petals is one of the most beautiful lighting situations to paint. The key is to make careful observations of the changes in value, color and temperature on the different areas of each petal. Also paint only one color at a time, using very light washes and letting dry between colors. To achieve the translucency of the petals, I kept the central areas of each backlit petal very light while indicating cast shadows and curving contours with darker colors. I highlighted areas where sun shines through with light washes of Indian Yellow and areas that the sun hits directly with very light washes of Cobalt Blue. I also illustrated backlighting by leaving warm light values of local color at the edges of opaque sunlit areas and by showing shadows from rear petals and leaves on the forward ones. A dark background makes the flowers "pop."

WHY DO YOU PAINT?

"I've always known I wanted to be an artist. I love trying to capture that fleeting moment that makes me stop and look again."

—Janet Gilliland

Afternoon Peace Janet Gilliland
18½" × 29" (47cm × 74cm)
Collection of the artist

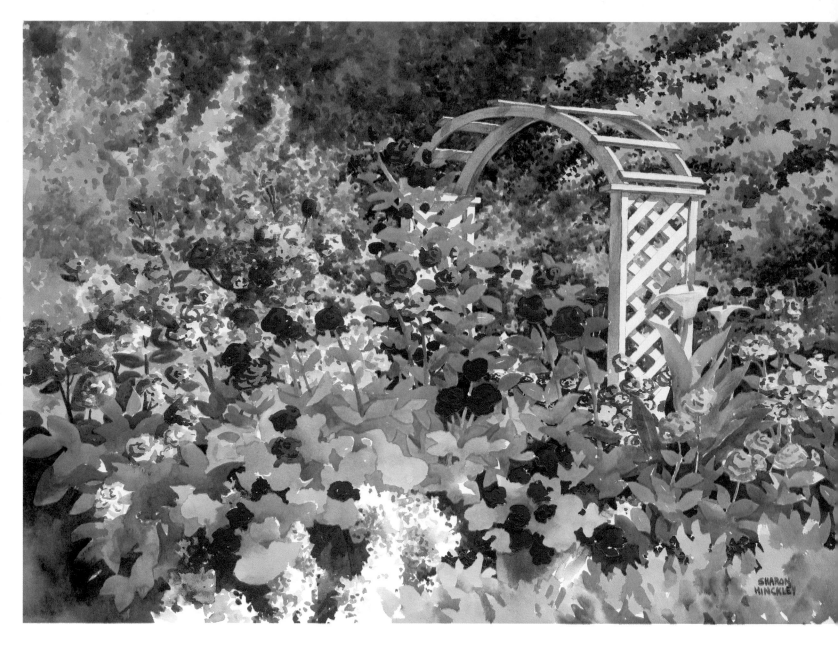

Paint Shades of Green

I have always enjoyed working in and from nature. I painted *Portal II* on location in a lovely private garden in La Jolla, Calif., during the annual Secret Garden Tour. To work successfully out of doors, consider setup, timing and persistence. Also take care to render the numerous shades of green that appear in nature. The secret is to not put any shades of green pigment on the palette. I mix all of my greens, primarily from combinations of New Gamboge Yellow, Winsor Lemon, Cobalt, Manganese and French Ultramarine Blue. I use Antwerp Blue and Cobalt Turquoise occasionally, as well as touches of Brown Madder, Alizarin Crimson or Opera to suggest nature in her infinite varieties. Now for a confession: Though, you seldom see pure emerald green in nature, I do break the "no green pigment" rule for this color because it's so much fun!

WHY DO YOU PAINT?

*"For me, painting really isn't so much a choice.
Rather it is an inner drive to appreciate and
explore the beauty in nature and the natural world.
It is a celebration of living."*

—Sharon Hinckley

Portal II Sharon Hinckley
21" × 29" (53cm × 74cm)

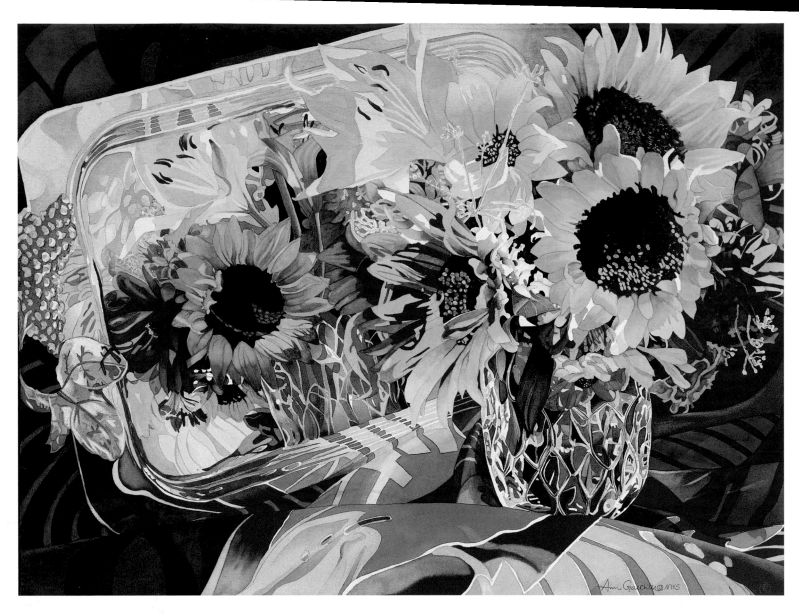

Paint Saturated Sun-Washed Light

Light subdues, enlivens, sparkles and dances. Light is magical and inspires us to paint. With a few simple techniques you can create radiant, sunlit paintings. It's all about the whites, the juxtaposition of warm and cool colors and value contrasts. In *Rampant Reflections*, I first reserved whites in strategic places to give the appearance of very brilliant sunlight. Notice the brightest whites in the primary bouquet and the cut crystal vase. Next, to produce the effect of light on each flower petal, I placed a warm yellow (Hansa) adjacent to a cool yellow (Winsor Lemon). Last, I used a play of light and dark values. Look at the value contrast between the brightly lit bouquet and the dimmer values of its reflection in the silver tray. To enhance the appearance of a sun-washed image, I used very dark values in the background to push the subject into the light. On paper, you are the creator of light!

Make Deep Shadows Breathe With Transparent Color

It's difficult to "make up" imaginative light sources. Seeing, in this case, is better than inventing. I hung the Oriental rug specifically for the portrait image in *Sun and Daughter*. The diagonal shapes come from the piercing sunlight as it passes through venetian blinds. When depicting shadows, I find it necessary to paint the object where the shadow falls. A wall that is in sunlight is the same wall that lies in shadow. I painted the entire wall, then the shadow on top. Although contrasting intense darks creates the illusion of intense light, these dark shadows need to "breathe," not become black holes in the painting. Often watercolorists attempt to create darker values by building up thicker paint. But creating darker value in watercolor, requires mixing darker and cooler paint. Mixing paint in lower color keys allows the artist to create deep shadows that breathe with transparent light.

Rampant Reflections Ann Gaechter
22" × 30" (56cm × 76cm)
Collection of Jean Beloso

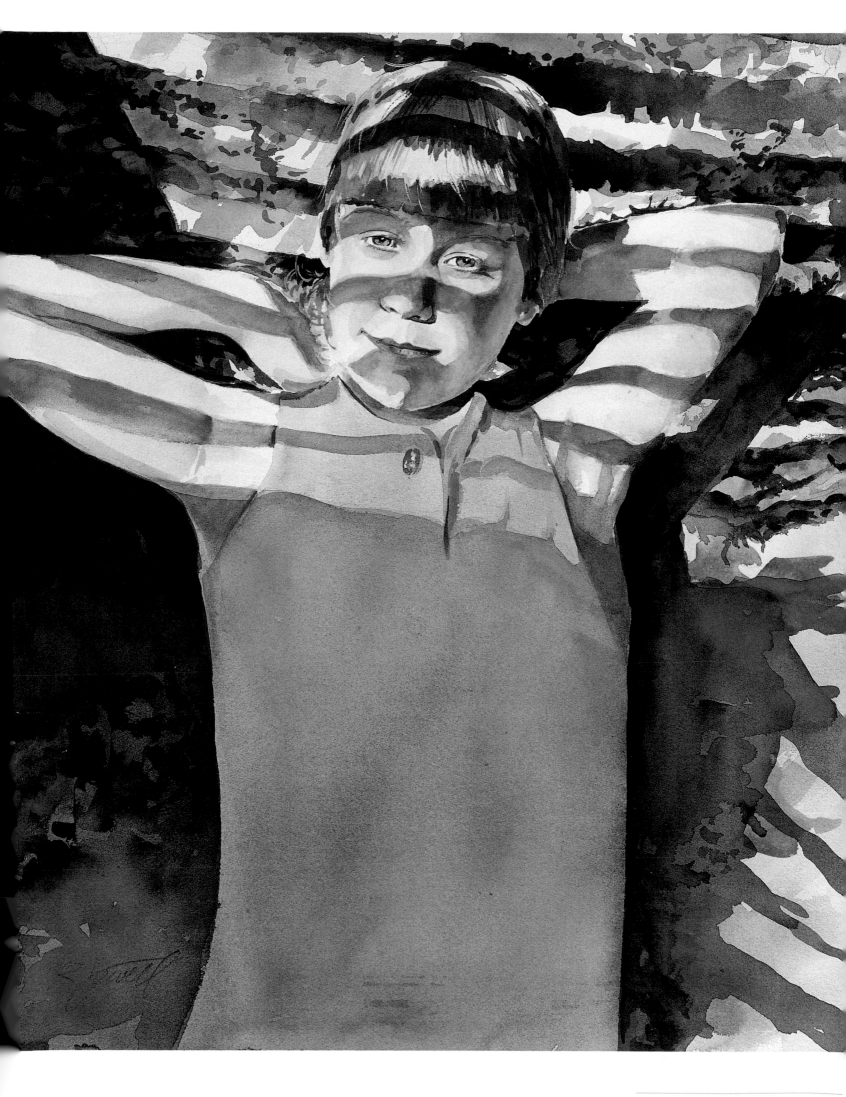

Sun and Daughter Russell Jewell
28" × 18" (71cm × 46cm)

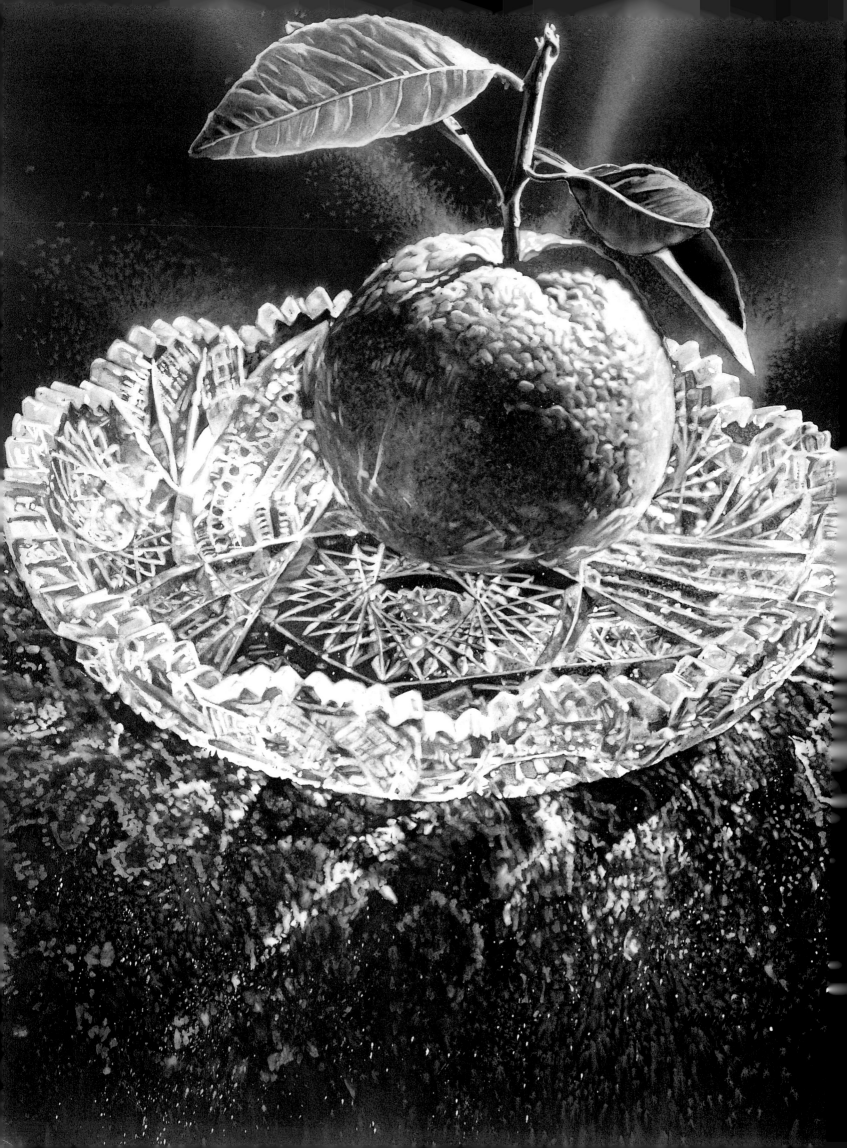

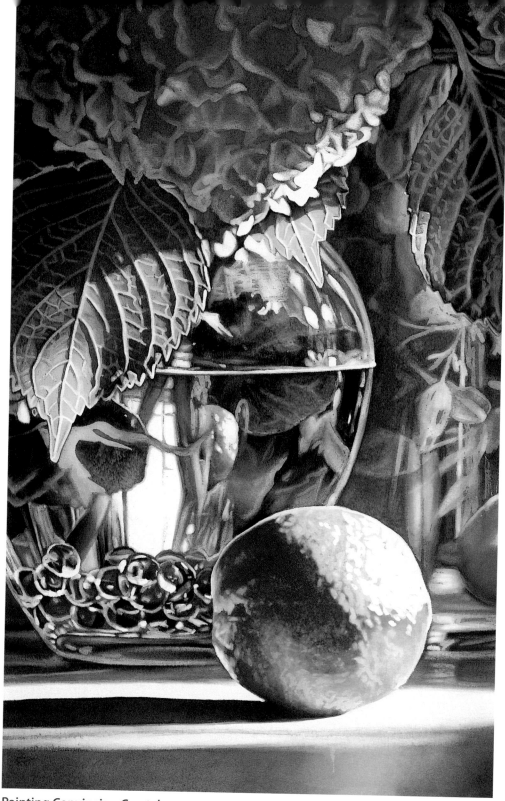

Painting Convincing Crystal

Use maximum value contrast of value with numerous hue and temperature variations. Painting a clear object, as a matter of fact, is actually portraying everything around it, including wonderful refractions and reflections of light and color. I layer the important darks and colors with many thin washes of transparent watercolor. To define the actual shape of the dish in *Sallie's Satsuma* and to push the feeling of sunlight on the orange and hydrangea in *Seeing Through*, I left the lightest areas completely unpainted.

Because of the complex layering process, I save the essential white of the paper with yellow masking fluid applying it with a good no. 2 round brush that I dampen, dip in Dawn liquid soap and wipe off before using it to apply the masking fluid. Masking fluid usually leaves rough edges, so after removing the masking fluid, I use assorted sizes of Fritch Soft Scrubber brushes to soften and clean up the edges. These special brushes also help lift unwanted paint and create highlights.

Sallie's Satsuma Gwen Talbot Hodges
30" × 22¼" (76cm × 57cm) (LEFT)
Collection of the artist

Seeing Through Gwen Talbot Hodges
30" × 19" (76cm × 48cm) (RIGHT)
Collection of the artist

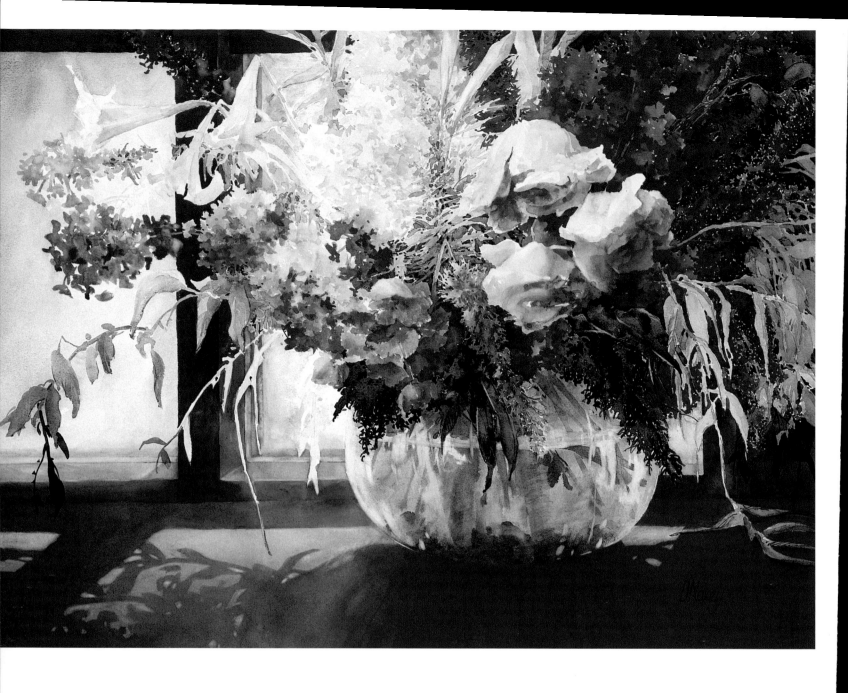

Establish Mood With a Dominant Color

I chose red as the dominant color in each of these paintings to create a strong and immediate unity and to establish the heat and intensity of a sizzling summer day. I arrange my pigments on my palette in color families from warm to cool. I first establish a light source and start painting with a deliberate selection of the warm colors and light values, progressing into cooler pigments and darker values. This enhances the sunlight to shade effect. The color and temperature arrangement becomes a major factor in creating the focal areas in each of the paintings. In *Poppy Parade*, I planned the position and direction of each bloom to create a pleasing rhythm through varied spacing between the stems. The interior textures of the petals direct the viewer to the focal bloom. In *Summer Bouquet*, I designed the surrounding structure of the window frame and the shadow shapes to direct the viewer's eye to the bowl and flower arrangement. I placed blooms in the negative area of the window to create interest in these secondary design areas and to establish movement toward the focal area.

Summer Bouquet Diane Maxey
22" × 30" (56cm × 76cm)

WHY DO YOU PAINT?

*"Unquestionably, painting is the best means that I possess to express what is
special and important to me. I employ the world of nature as a visual metaphor,
channeling my love and passion for the abundance of its gifts."*

—Robert Reynolds

Poppy Parade Diane Maxey
22" × 30" (56cm × 76cm)

41

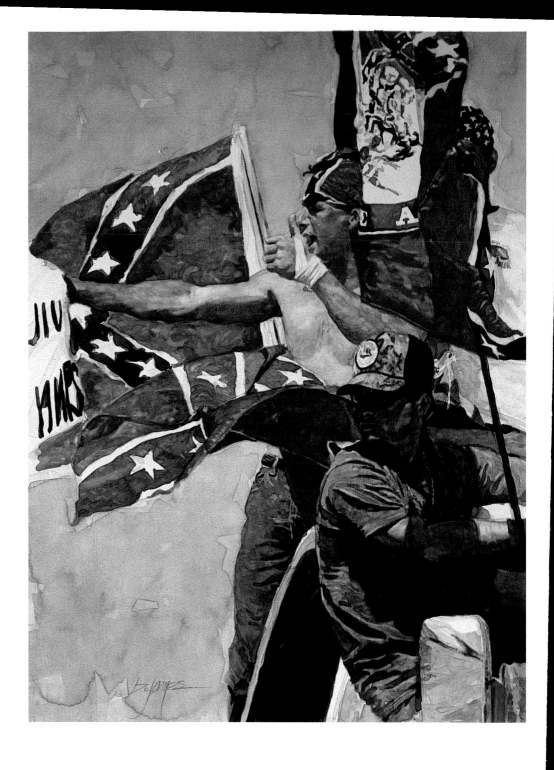

Tell a Story

I like to tell some kind of story with most of my paintings and at the same time spark some kind of emotion from the viewer. I can do this several ways with figurative work. In *The Red Quilt*, the woman was wearing period clothing, so I used her costume along with the color of the quilt to tell the story. With *The Rally*, I used expressions (gestures) and color to convey what was going on. When painting with watercolors, my technique is Impressionistic. I apply washes of transparent gouache layer over layer. I always paint on cold-pressed illustration board or a sheet of watercolor paper, both coated with gesso, so I can rub out particular sections to indicate the lighter areas. As I paint, I always keep the correct drawing of each element in the scene in mind. I also glaze and scumble. Glazing is the application of a darker wash of color over a translucent or opaque lighter color. Scumbling is the application of a light wash of color over a translucent or opaque darker color. I continue with this painting process until the desired effect is achieved.

The Rally Bill James
26" × 16" (66cm × 41cm)

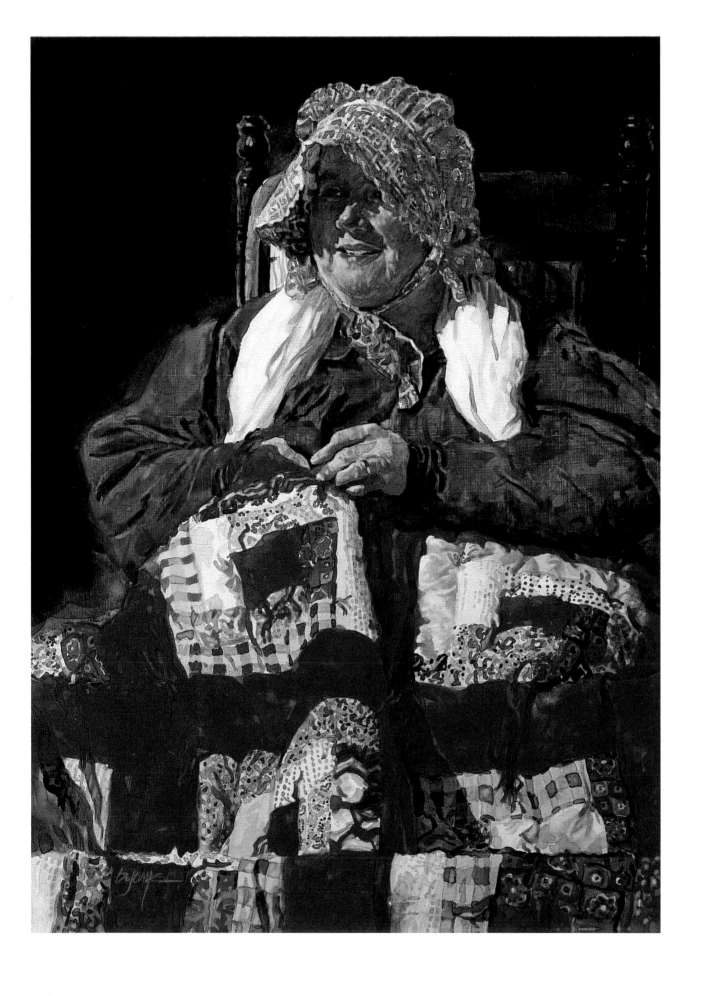

The Red Quilt Bill James
19" × 14" (48cm × 36cm)

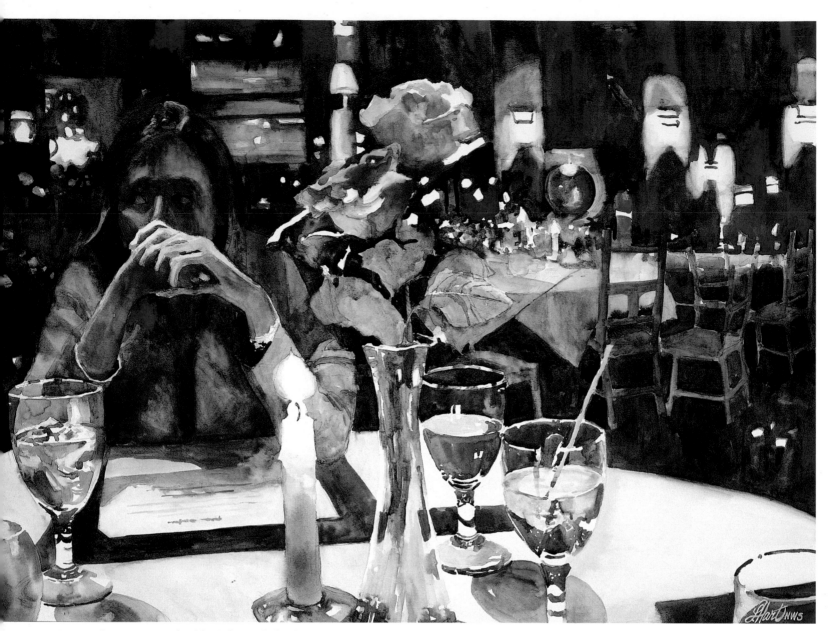

Create a Mood With Light and Shadow

I created the mysterious mood in this painting by placing the figure in shadow and directing her worried gaze out of the scene. The bright lights of the table and background grab your attention, so the figure almost catches the eye by surprise. Interestingly, the more abstract an object in a painting is or the less detail I use to paint it, the more realistic it will appear at a short distance. I painted the foreground glassware and vase merely as a collection of abstract shapes of reflected light and shadow, fit together like pieces of a puzzle. Our eyes record this abstract information, and the brain processes it into something recognizable—"Oh, those are goblets." If you can train yourself to paint what the eye really sees, the "realistic" quality your work will take on will surprise you.

Paint Clear

I am often asked: "Niki, how do you paint clear?" My response is usually the same, "I just paint exactly what I see." The only way to paint complex subjects, such as clear or colored glassware, is to examine the details closely. I carefully map out in pencil not only the outlines of the subject, but also the tiniest highlights and reflections. Without accurate drawings, my paintings would not be successful. When it gets down to the nitty-gritty aspects of a painting, I do a lot of drybrushing with a very small brush. As I paint, I look for those fascinating little gems of color usually found on or near the brightest highlights. I usually push those colors even further than they actually appear in real life. I guess you could say then that I don't just paint what I see; I paint a little more than I see.

Maybe He's Just Late Laurel J. Hart
21" × 29" (53cm × 74cm) (ABOVE)

The Red Apple Niki Lawrence
18" × 13" (46cm × 33cm) (RIGHT)

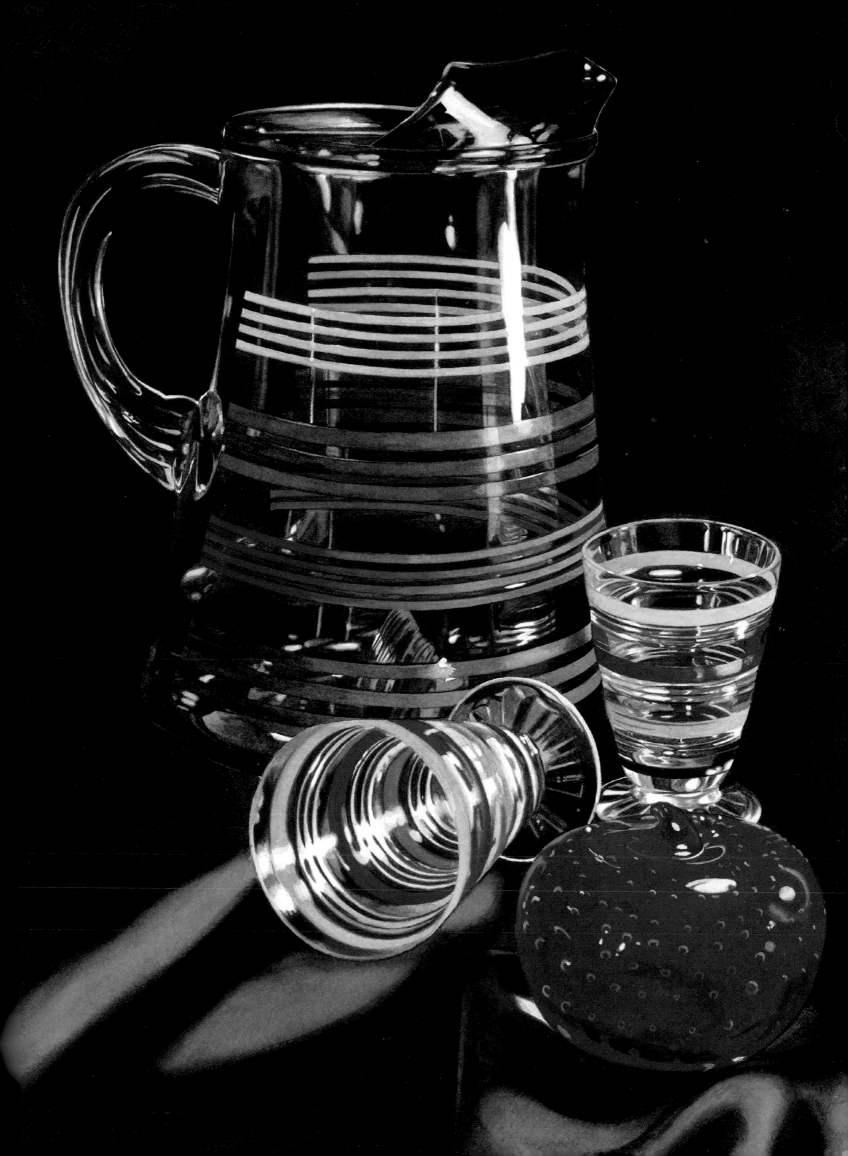

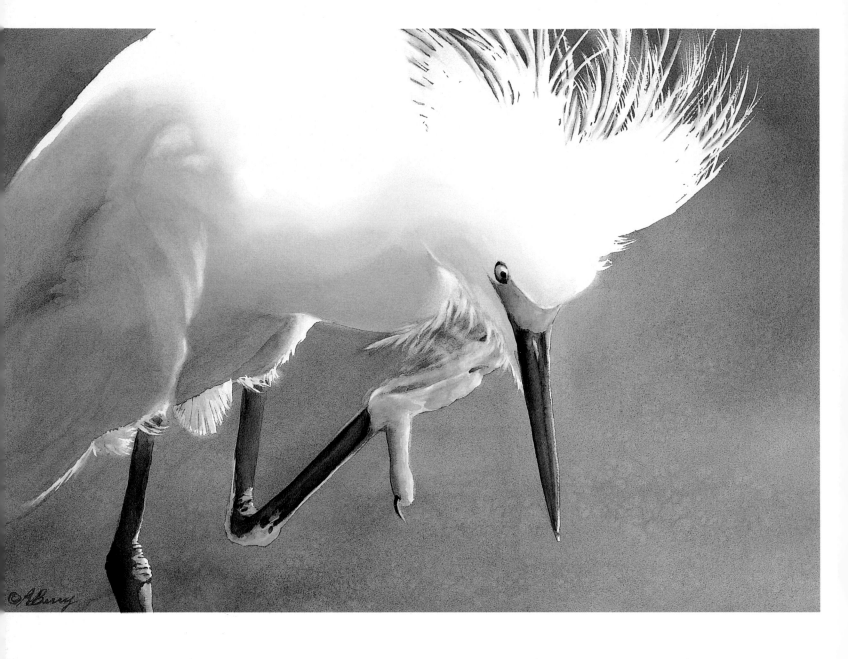

"Spotlight" Paint

I want my subject to be anatomically accurate and placed on the page so the design mirrors the grace and beauty of the bird, as if you have just come upon the scene and the bird is not yet aware of you. To achieve the spotlight effect, I use the white of the paper as light. I start with stretched 140-lb. (300 gsm) Arches cold-pressed watercolor paper and mask the light while I paint the other values. After I remove the masking, I gently scrub out most hard lines, feathering them back into the color so they won't stop the eye. When dry, I burnish the area to restore the surface of the paper and then carefully glaze the glowing edge of the shadow. I paint the bird's eye last because I want it to sum up the mood of the painting and serve as the focal point. While painting on a Captiva Island beach, this particular snowy egret sat on the back of the chair that held my paints every day for a week, an arm's reach away. The tropical light spotlighting her pristine white feathers thrilled me. My view of her was very personal and privileged.

Grooming Snowy Robin Berry
18½" × 27" (47cm × 69cm)

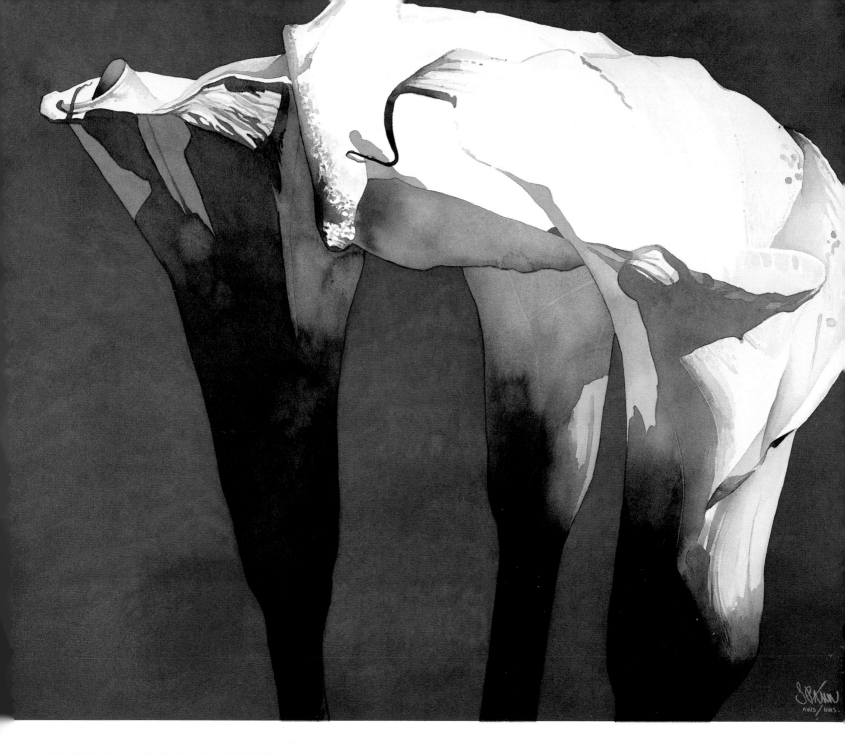

Paint in a Realistic Style

I shoot references and the photos become my maps. A small black-and-white value sketch allows me to understand the light patterns before I begin painting. I glaze, letting each layer dry completely before painting the next value layer. On occasion I paint wet-into-wet, but, generally, I prefer wet-onto-dry.

Scarlet Ladies Susanna Spann
50" × 57" (127cm × 145cm)
Collection of Ragan Alice Brown

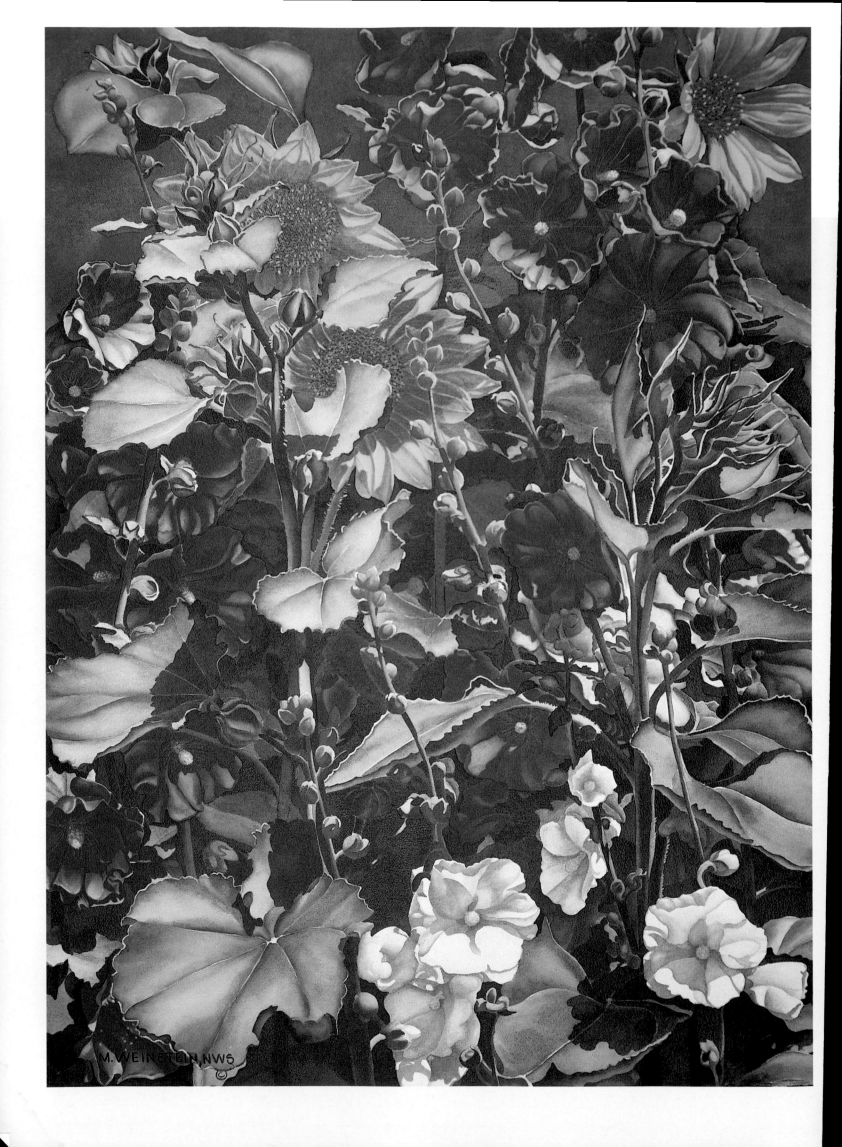

M.WEINSTEIN.NWS

Being more of a "first impression," "one-wash" painter myself, I am always fascinated by the delicate intricacy brought to watercolor paper by some artists. Whether painting woven fabrics, glass, crystal, silver, lace, even the complex patterns of leafy foliage, these artists manage to capture it all while also maintaining artistic unity and overall beauty in their works. I asked them how they do it (and how they have so much patience!).

Rachel

Intensify Patterns of Color

Kaleidoscope is an arrangement of patterns of color. My paintings appear complex, but I compose them of simple shapes arranged on the paper to form a whole. I want to absorb the viewer in the beauty of the color, form and variety. I start with an underpainting of light tints of local color to establish the underlying tone of each plant. My goal is to cover the entire sheet with a tint of color, leaving only white paper where the object is to remain white. Continuing to work in watercolor, I add layers of color to the flowers and leaves, modeling the form and deepening the color. When I am satisfied with the underpainting, I spray a coat or two of acrylic matte medium over the painting to seal the watercolor. I finish the painting with a matching palette of acrylics, varying the thickness or thinness of the pigment. Then I apply glazes over the colors to increase the intensity. I spray three to five coats of matte medium over the surface to blend in the watercolor and acrylic. In all appearances, it is a watercolor painting. Working in layers, stacking one pure pigment over the other, gives me the brilliance and intensity that I strive for in my florals.

Kaleidoscope Mary Weinstein-Backer
41" × 30" (104cm × 76cm)
Collection of the artist

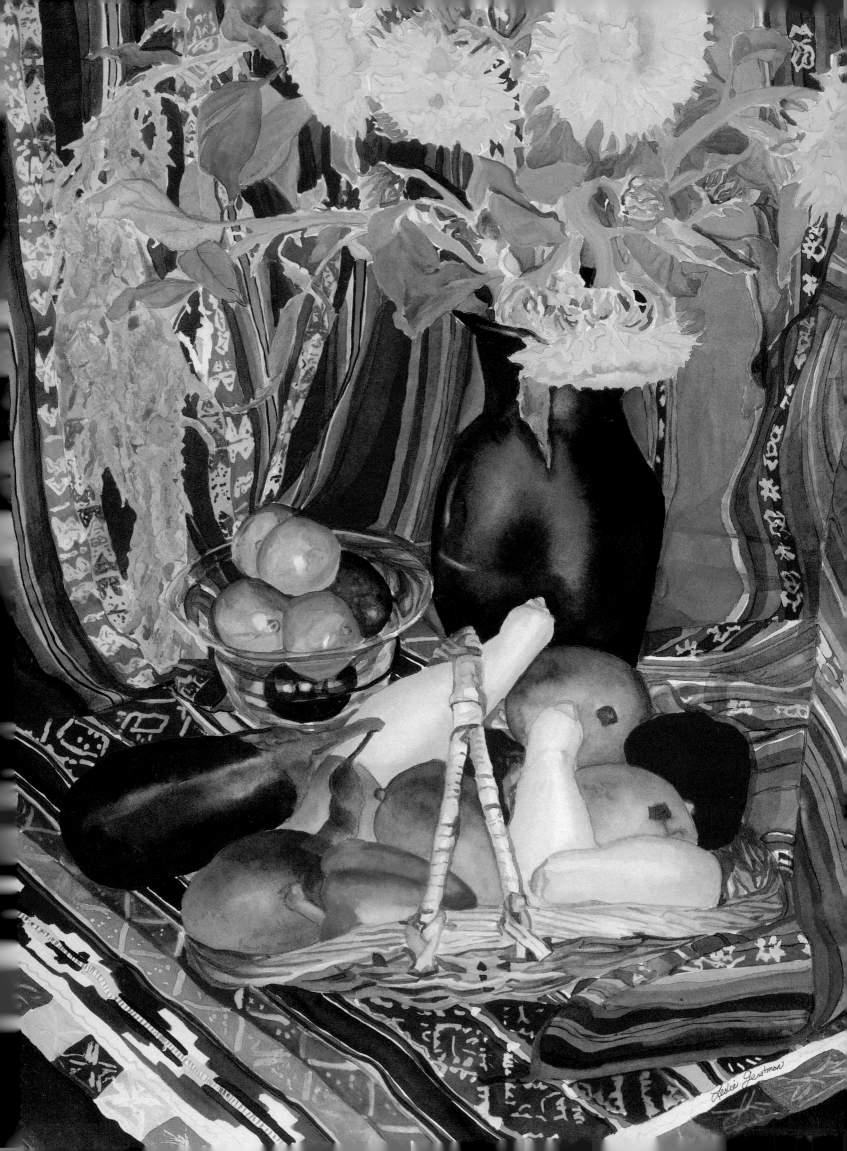

Leslie Gerstman

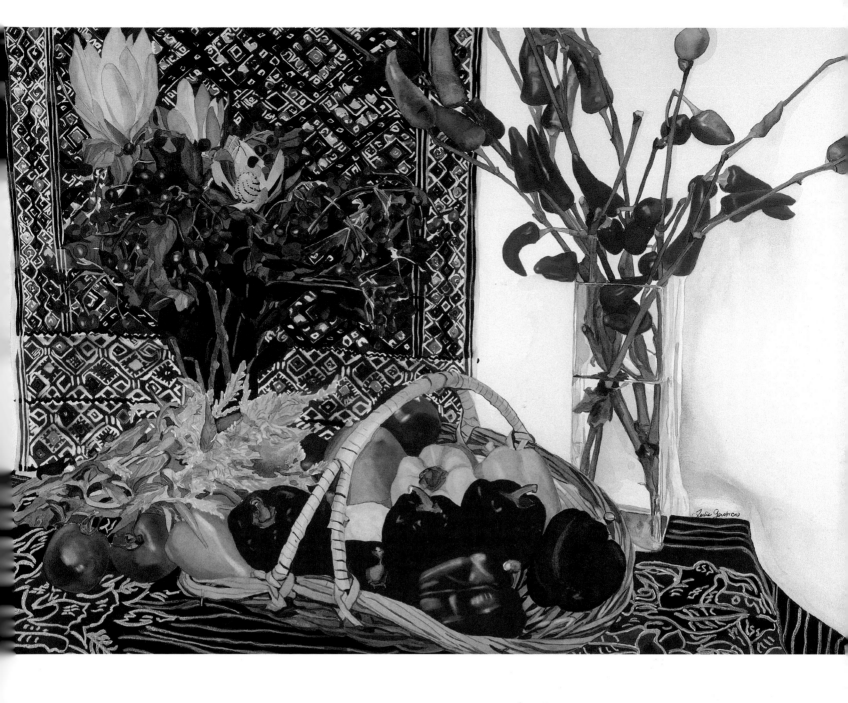

Tone Down Whites When Using Intense Color

My goal is to achieve intense color, complex patterns and dynamic movement. It all starts with a good composition. I photograph various arrangements of my still life objects and then I work with a viewfinder to determine the best dimensions and crop of the selected composition. Mounting the photo negative in a glass slide mount, I project that portion of the image onto watercolor paper. I undercoated most of the fabrics that have white patterns in a light value to eliminate any harsh whites, which stand out inappropriately when intense color is the goal. Though a white tablecloth hangs behind the textile in the background of *Chiapan Weavings*, none of the white of the paper remains. I usually mix very little water with my pigments. I try to layer as little as possible, aiming to hit the values correctly by controlling the amount of pigment on my brush. I find it easier to lift pigment when I have applied it heavily than to slowly build up layers of transparent washes. I paint from background to foreground so the objects in the foreground have the sharpest edges.

WHY DO YOU PAINT?

"My coffee mug displays the quotation, 'Life isn't about finding oneself. Life is about creating oneself.' I paint as a means to become the person I want to be."

—Leslie Gerstman

Peruvian Passion Leslie Gerstman
30" × 22" (76cm × 56cm) (LEFT)

Chiapan Weavings Leslie Gerstman
29¼" × 40¾" (74cm × 104cm) (ABOVE)

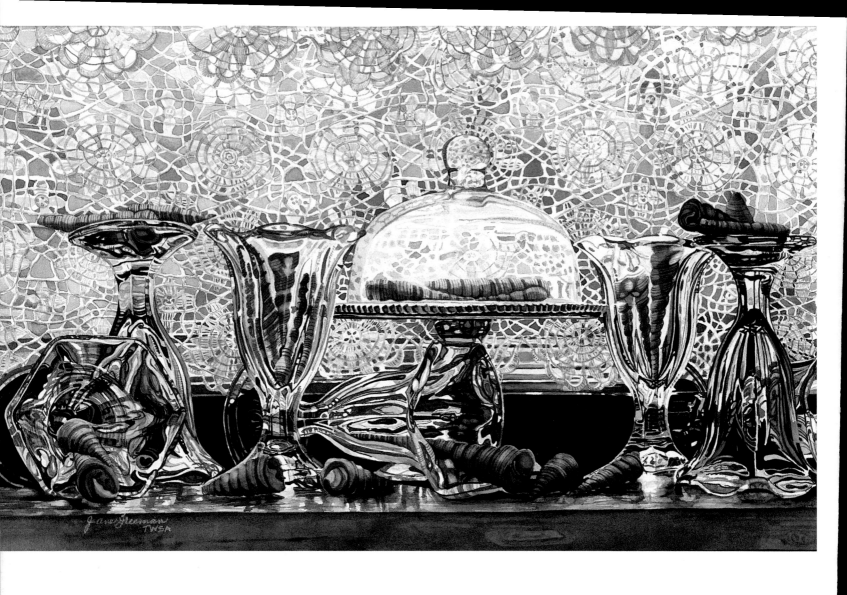

Draw Crystal and Lace From a Map

Painting lace can be as simple as painting the holes. If you draw the pattern fairly accurately, these holes will be enough to describe lace. I know how to crochet, so I often show details that I do not actually see but know are there. I use enlarged photos that have been lightened so I can see details in the shadows under the lace, as this always adds more interest to the painting. The enlarged photo also helps me see the abstract forms created in crystal. Having a good drawing helps me isolate these forms so they are much easier to paint. Be observant with crystal, as it reflects all the surrounding colors and will hold some of your whitest whites and darkest darks. That contrast helps to make the glass sparkle. In these paintings I used only four or five colors. Though they are very detailed, this limited palette helps unify the painting and keep things cohesive so the lace and glass read as solid, not disjointed, objects.

Sundaes On Padre Jane Freeman
13½" × 20" (34cm × 51cm) (ABOVE)

Bananas Fostoria Jane Freeman
18½" × 14½" (47cm × 37cm) (RIGHT)

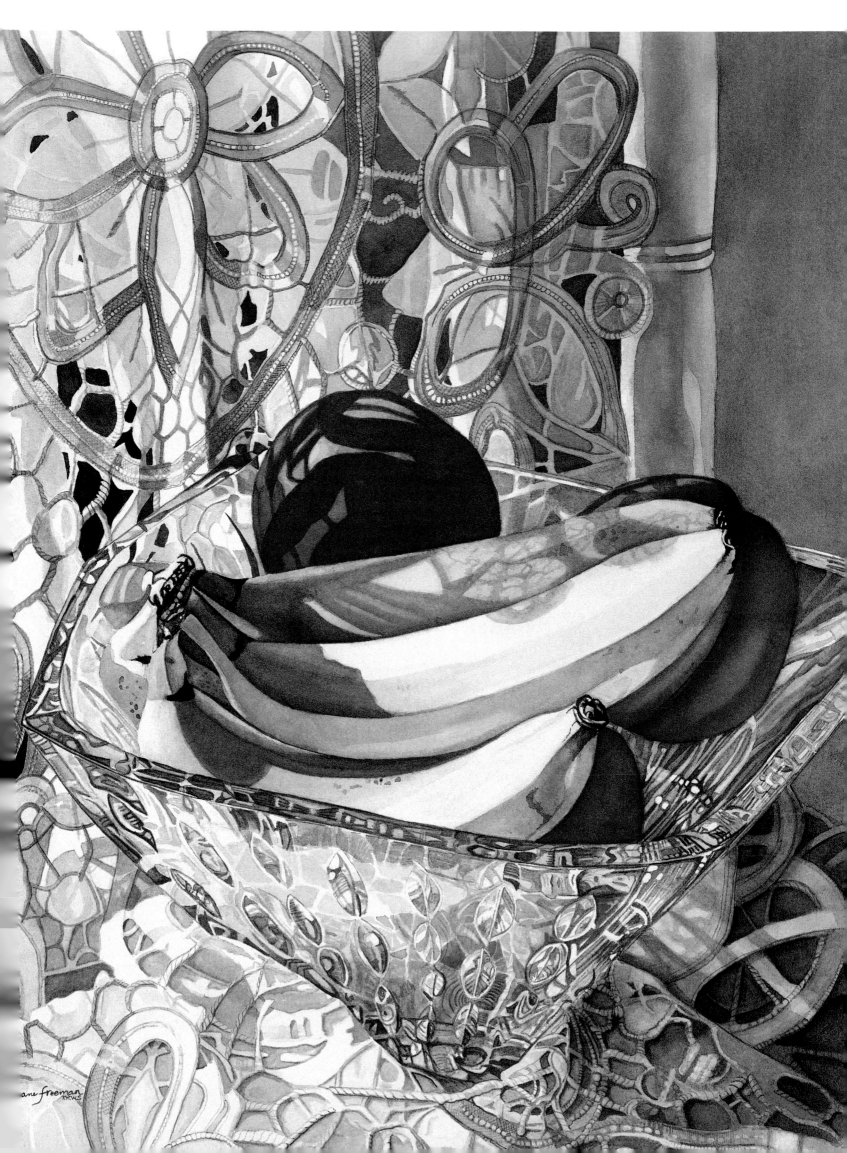

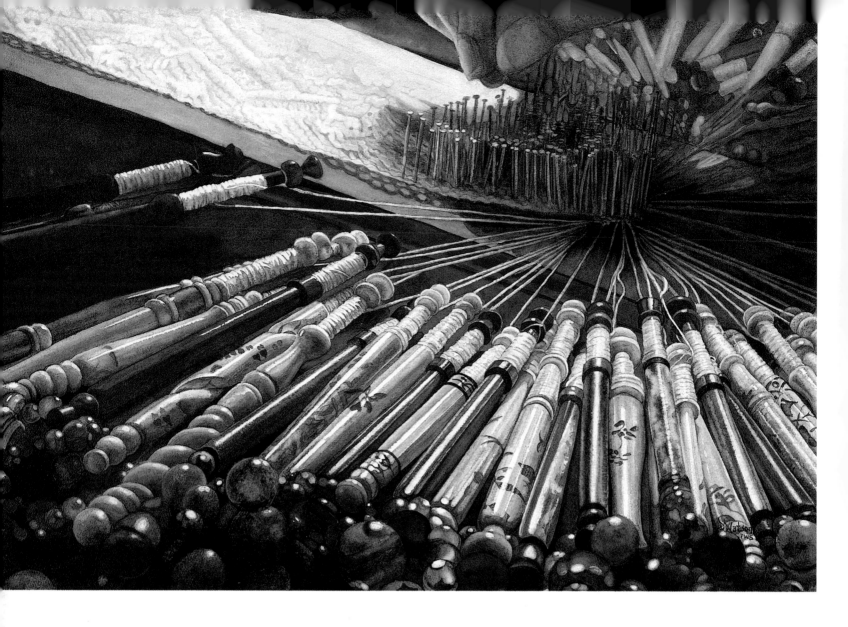

Focus in on the Details

At our local farm museum, I observed a woman making bobbin lace. The tiny jumble of antique bobbins pulled me in for a closeup. I always hunt for a unique subject or viewpoint, eliminating the everyday clutter to focus in on compositions I find fascinating. Those deft fingers manipulating a tiny forest of pins seemed to be the unifying force creating order out of chaos. To unify my composition, I used a limited palette of five colors, including the complements Phthalo Green and Quinacridone Red. I only masked the threads and the highlights on the bobbins, carefully painting around the remaining shapes. Even with the precise detail, I used large brushes with a sharp point instead of small brushes to keep my colors flowing smoothly and evenly. I achieved color intensity by building up soft layers of professional-grade paints that were fresh out of the tube and that I never allowed to dry out on my palette.

WHY DO YOU PAINT?

"Painting is my most successful and satisfying means
of communication with other human beings."

—Debi Watson

The Human Touch Debi Watson
20" × 28" (51cm × 71cm)

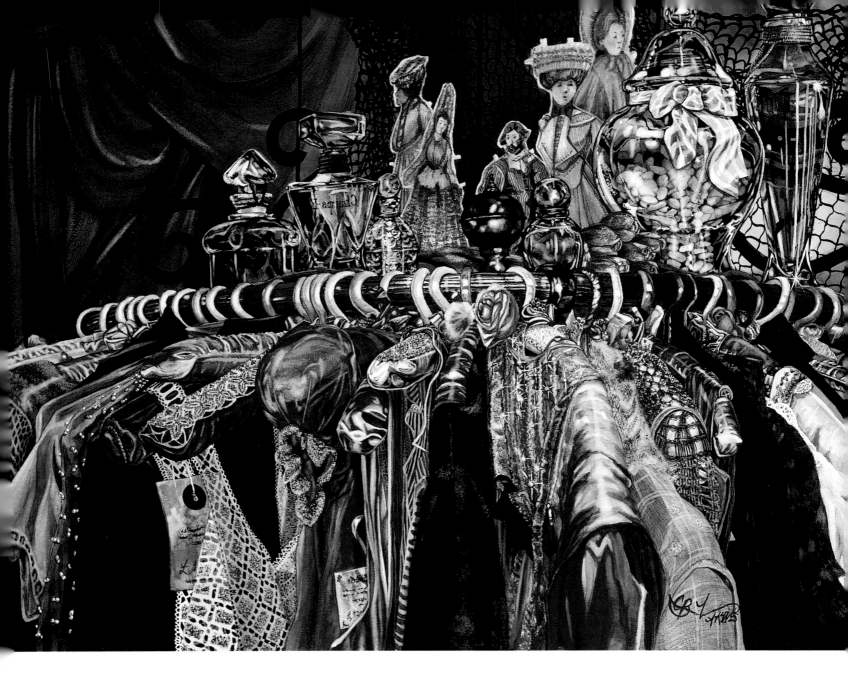

Use Complexity

To create "touchable texture and a nostalgic mood," invite the viewer to get involved in the details, such as paper dolls, fabric and glass. Restful, soft edges contrast with the sharp, hard edges to bring balance. The low light source gives a soft ambience that sets an "antique" mood. I use thick mixtures and color exaggeration to create a rich base color. Arches 300-lb. (640gsm) rough watercolor paper makes texturing a breeze. Dry-brush techniques, such as patting, dotting and splattering, work for velvet, lace and stripes. Cerulean Blue and violet, glazed over folds, create layers and depth. In some places, the pure basecoat shows through, popping these areas forward. I lift sparkles and glass highlights using flat, wet brushes. Then I pick the extra glimmer in the centers of the sequins with a razor blade.

French Paper Dolls and Perfume
Cindy Brabec-King
22"× 30" (56cm × 76cm)

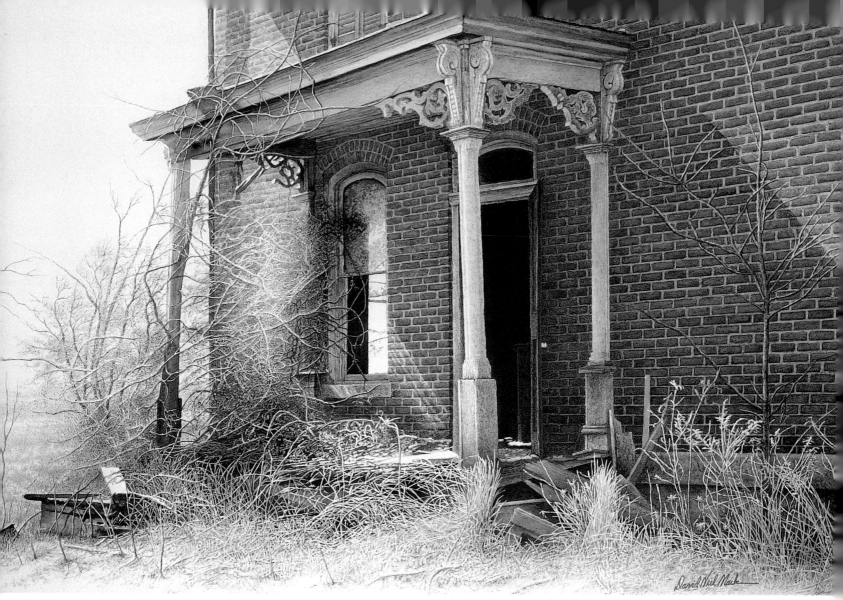

Use Simplicity to Paint Complexity

My key to painting complexity, such as the intricately tangled branches of trees and shrubs, is to paint wet-into-wet as long as possible, developing each area to about 80 percent completion. I then decide which areas to bring into extra focus, and I fine-tune them by drybrushing and glazing. Equally important is an atmosphere devoid of texture, which intensifies the textured objects. I use wet-into-wet glazes of Rose Madder Genuine and Transparent Yellow, followed by glazes and gradations of a variety of transparent blues. Judicious masking is another crucial aspect of my technique. I make sure to have a brush with a point for masking small details and running uniform widths of liquid mask along edges of larger shapes. To maintain a tapered brush point, I shake it in rubber cement thinner. You don't have to nor should you mask each little area. For instance, I didn't mask the mortar on the farmhouse. I floated warm and cool glazes in clear water to soften and the edges of the brick and suggest reflected light.

WHY DO YOU PAINT?

"When they passed out the boxes of letters and num-
bers in the first grade, my eyes glazed over and didn't
clear until the crayons came out later in the day.
Nothing has changed all that much."

—David Neil Mack

The Fabled Farewell David Neil Mack
18" × 26" (46cm × 66cm)

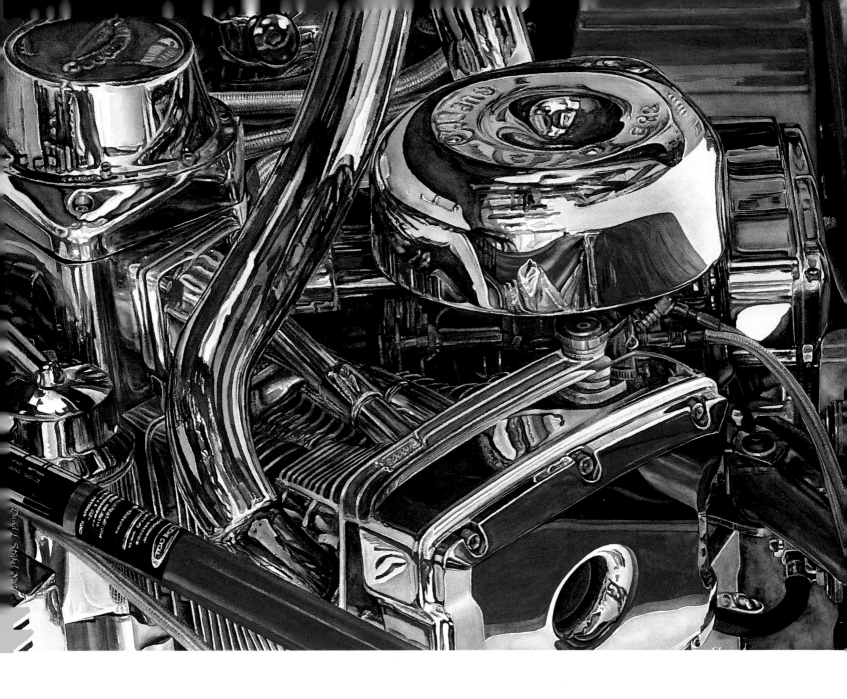

Paint Beautiful Reflections

I edited a digital image on my computer, including some details and eliminating others. To avoid the complex detail compromising the painting's overall integrity, I used the highly reflective chrome as a unifying context. I work in sections, usually bringing one area to 90 percent completion before starting another. I go back and refresh areas until I am satisfied and push the color and value to their richest potential for contrast and depth. After an initial underlay of color, I use a drybrush technique with the side of my brush and just the right amount of paint to add texture and value. Every line has a value and often will be darker on one side. I continually ask myself: "What exactly do you see? What colors bring about this effect?" Then I begin with the lightest color of any area and patiently work to the darkest.

Cycle of Color David L. Stickel
30" × 22" (76cm × 56cm)

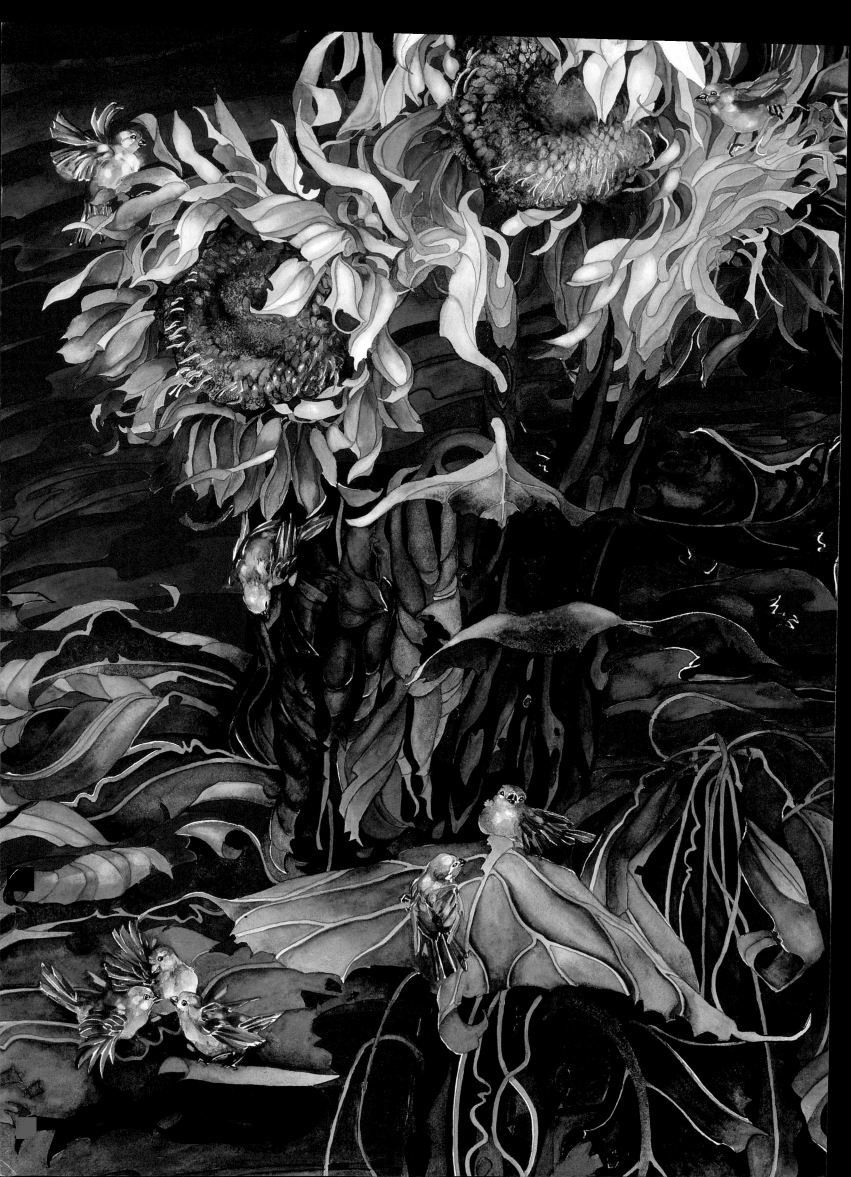

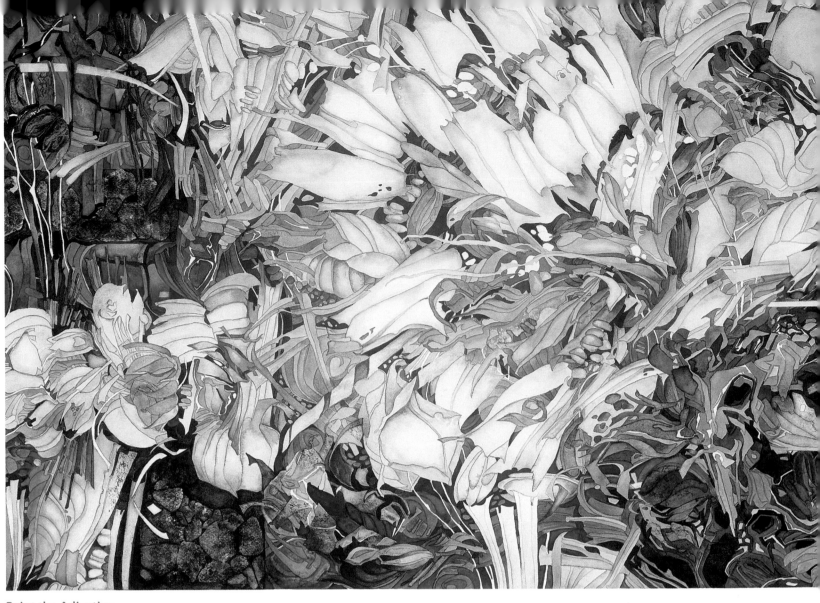

Paint the Adjective

When I have a quiet moment, I often walk in my garden and take extra time to notice the small details that would not usually catch my eye: the pattern of fallen rose petals, the curl of a dried leaf, or the design made by leaves and twigs gathered in the corner of the pool. I internalize and personalize these shapes rather than representing them in a realistic or literal way. I attempt to paint the "adjective" that describes the leaves and then exaggerate it. How does the curl of a leaf translate into a general flow of a curvilinear pattern? How do the layers of leaves create new positive and negative shapes? How do the intricacies of the many shapes relate to each other harmoniously as a composition? *Entropy* and *Windrush Blue* are similar in content, but different in interpretation. In *Entropy*, I painted layer upon layer of interwoven, intricate, small shapes that suggest natural material, such as leaves, petals and twigs. The confusion of detail made creating some kind of order out of chaos necessary. I used a palette of pale colors to maintain a calm and controlled mood with an emphasis on understatement. I set the tone in *Windrush Blue* with the strong, vertical thrust of the scaffolding. I enhanced this powerful mood with the grid-like pattern of stems and leaves that divide the format and the vibrant, contrasting hues of reds and blues pushed to their fullest color saturation.

WHY DO YOU PAINT?

"I enjoy the process of painting, which I find a challenge as well as meditation, alternately requiring both concentration and reflection."

—Daryl Bryant

Windrush Blue Elizabeth S. Groves
30" × 22" (76cm × 56cm) (LEFT)

Entropy Elizabeth S. Groves
22" × 30" (56cm × 76cm) (ABOVE)

59

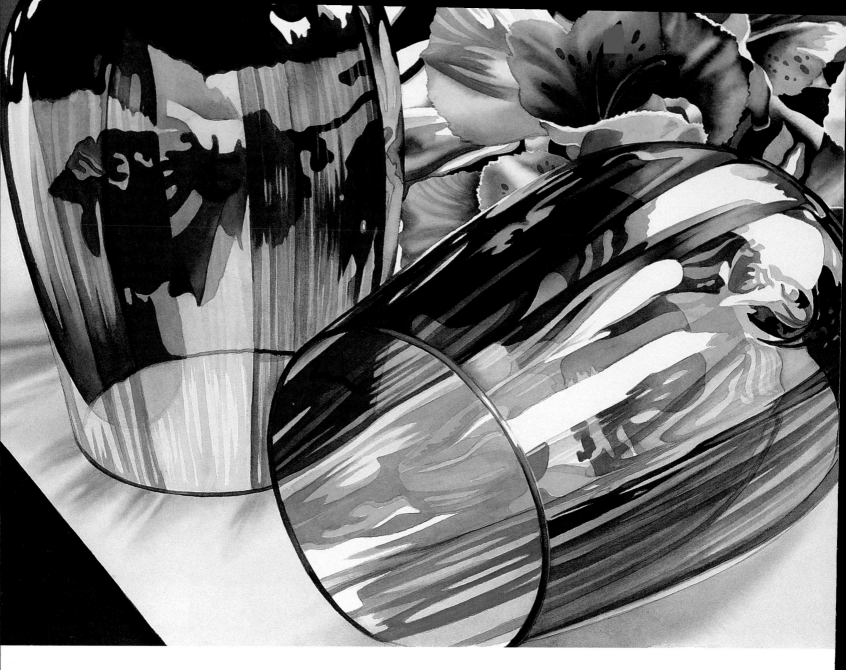

Begin With a Detailed Line Drawing

Pay close attention to where you'll place the reflective highlights. After doing this, I establish some of the darker values with an underpainting by painting wet-into-wet and mixing colors on the paper. When dry, I neutralize the underpainting by glazing with pure, clean color. The glaze also sings with brilliance where it hits the white of the paper. Bright colors appear even more intense when neutrals offset by neutrals. For the texture of the glass, I used mostly flat washes. Simplify the process of painting multicolored glass by painting all of one color at a time—all of the blues, then all of the greens, etc. Capturing the many subtleties within the reflective surface of glass requires a sensitive eye.

WHY DO YOU PAINT?
"I paint to set my ideas my free."

—*Margaret Dwyer*

Glass Symphony Margaret Dwyer
21½" × 28½" (55cm × 72cm)

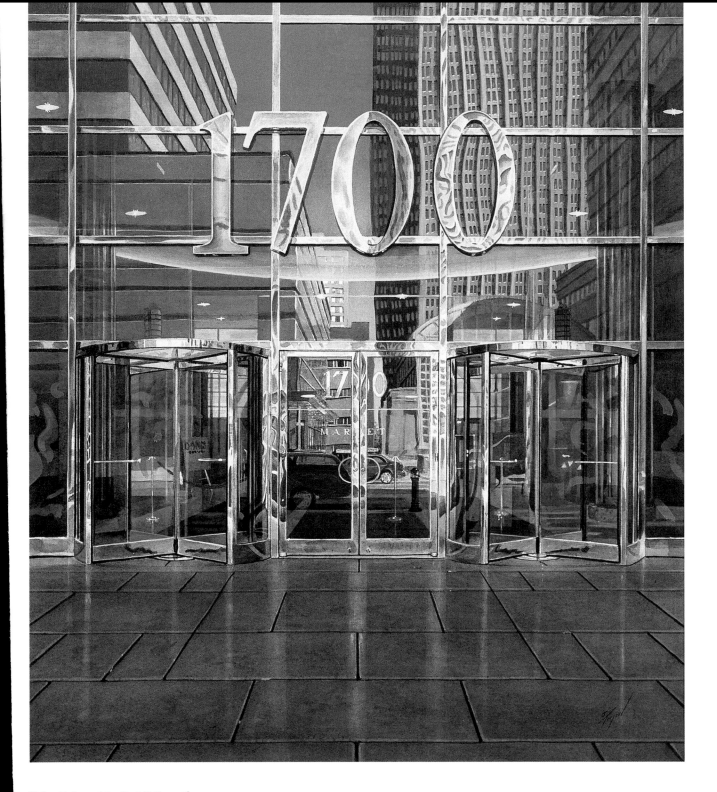

Take It Apart to Put It Together

Many people find the visually complex patterns on reflective surfaces intriguing. Though they are fascinating to look at, some artists might feel overwhelmed at the prospect of actually trying to paint these inscrutable patterns. But you can take them apart and put them back together in a clear and understandable way. Begin with the easiest things first. I started by drawing the doors, the windows and the "1700". I then drew the sidewalk and several elements inside the building. Next, I put a light wash of Ultramarine Blue inside the windows and doors, followed by Ultramarine and Dioxazine Violet on the sidewalk. Then I started on the reflections. No matter how distorted, these surfaces basically act like mirrors. After careful observation, I accurately drew and started to paint the reflected buildings across the street. With that done, I focused my attention on the most complex part, the interruptions of the reflection by elements visible inside the building. I glazed Phthalocyanine Green and Lemon Yellow to represent the lights inside the building. Those areas received less color as I completed the reflections and finished the painting.

1700 James Toogood
22" × 18½" (56cm × 47cm)

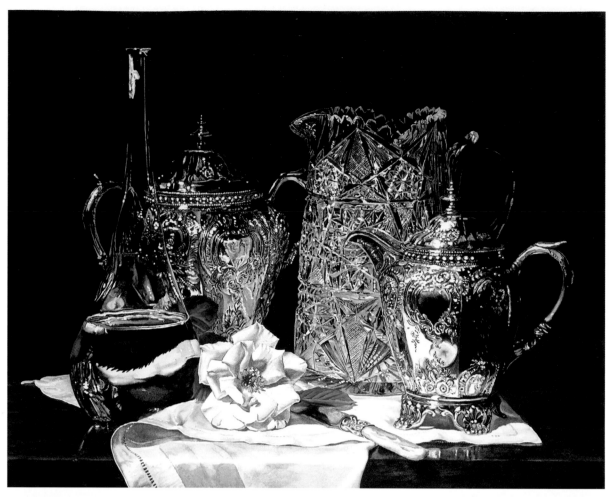

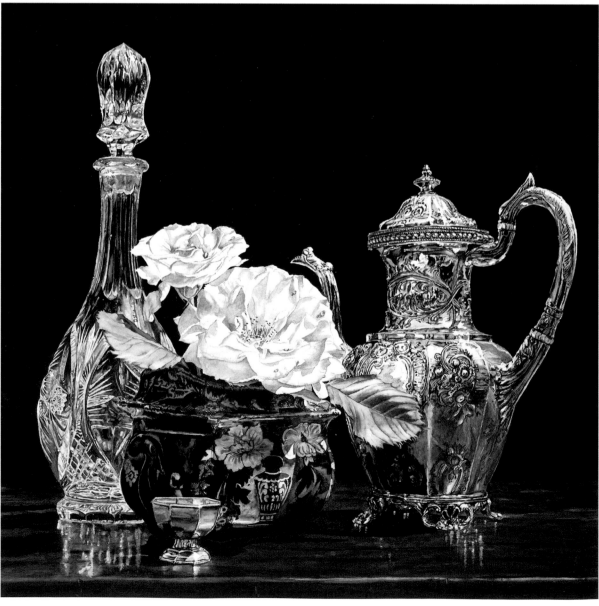

White Lightnin' Laurin McCracken
20" × 28" (51cm × 71cm) (TOP)

White Roses Laurin McCracken
20" × 20" (51cm × 51cm) (BOTTOM)

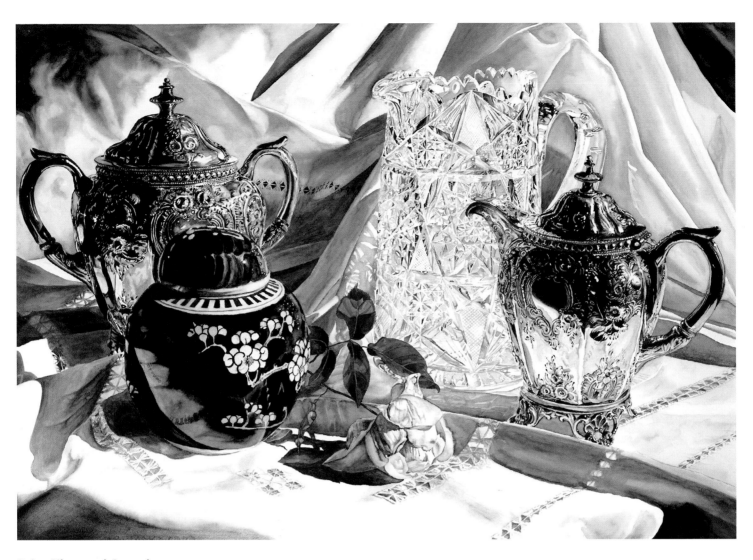

Paint Silver and Crystal

My paintings are heavily influenced by 16th- and 17th-century Dutch and Flemish artists, such as Williem Kalf and Davidz DeHeem. They painted mostly objects on a table with strong, single light sources, usually from the viewer's left. I take a lot of photographs of my still-life setups using a digital camera, sometimes as many as 100. I select a few and work with them in the computer to crop them and get the right contrast. I spend a lot of time drawing not only the shapes, but also the details of the highlights and the reflections. I use a mechanical pencil with 2H lead. I make a slide from my final digital photograph, project it and trace it to get the shapes of the objects and a first pass at the details. I often move things around and shift objects at this stage. This usually takes a couple of hours. Then I spend another few hours adding the details such as the curves of the chasing in the silver objects and the details and texture of the petals of the flowers. When painting silver and crystal, I start with a basic gray mixed from Cerulean Blue and light red. This gray has a temperature range from very warm to very cool. I darken it using Prussian Blue and Quinacridone Gold to warm it up. I paint with a basic two-brush technique. I use small brushes, No. 1 to No. 4 Kolinsky Sable rounds and always have a wet brush in my other hand that is one size larger than the brush I am painting with to soften the edges and create the curves of the silver or the curl of a petal.

I look carefully for the colors that the silver and crystal reflect and refract. The way the color bounces around these objects always amazes me. To add warmth and color to the painting, I often use the colors of the fruit and flowers as underpaintings for the grays of the silver. First, I usually give the backgrounds an overall wash. To achieve the rich dark backgrounds, I paint over the base wash with a "soup" made of Prussian Blue, Alizarin Crimson, Permanent Magenta and Mineral Violet. If I want the paint to be more opaque, I add light Red or Cadmium Yellow. I do this in one pass to prevent the development of a sheen from the gum arabic leeching up through the paint.

Winter Rose Laurin McCracken
20″ × 28″ (51cm × 71cm)

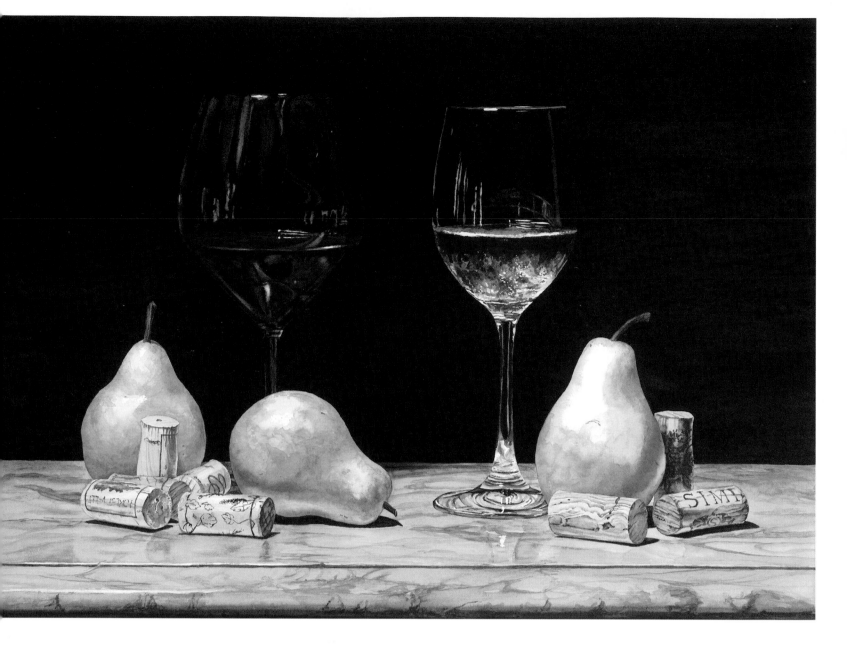

Paint Pears

Pears are very sensuous fruit, full of curves and color. After masking the highlights, I usually apply a mixture of Winsor Yellow and Cadmium Yellow wet-into-wet. For the greens, I add a range of blues, still working wet-into-wet, starting with Cerulean, then Winsor Blue, then Prussian Blue. I also might add some Permanent Magenta or Mineral Violet in the dark areas for richness. For the varieties that are warmer, I add Quinacridone Gold to warm up the lighter blues and then hit them with splashes of Cadmium Red and/or Alizarin Crimson. Here I might also add Mineral Violet for richness in the shadows. I usually mask the stem and paint it last, using layers of Quinacridone Gold and Burnt Sienna with a touch of Alizarin Crimson. After removing the masking fluid, I soften the edges. Then I look closer to see if the pear has green dots, brown dots, yellow dots or imperfections that will help make it more real. I pay close attention to the reflections from the surface under the pear, especially if it is sitting on or near a piece of silver. The interplay between the silver and the color of the pear can be intriguing. I use the texture of cold-pressed watercolor papers to enhance the texture of certain types of pears and the lemons in my paintings. Sometimes I use a soft-finish paper, such as Fabriano or TwinRocker, for pears that have smoother finishes.

Fermentations Laurin McCracken
18" × 25" (46cm × 64cm)

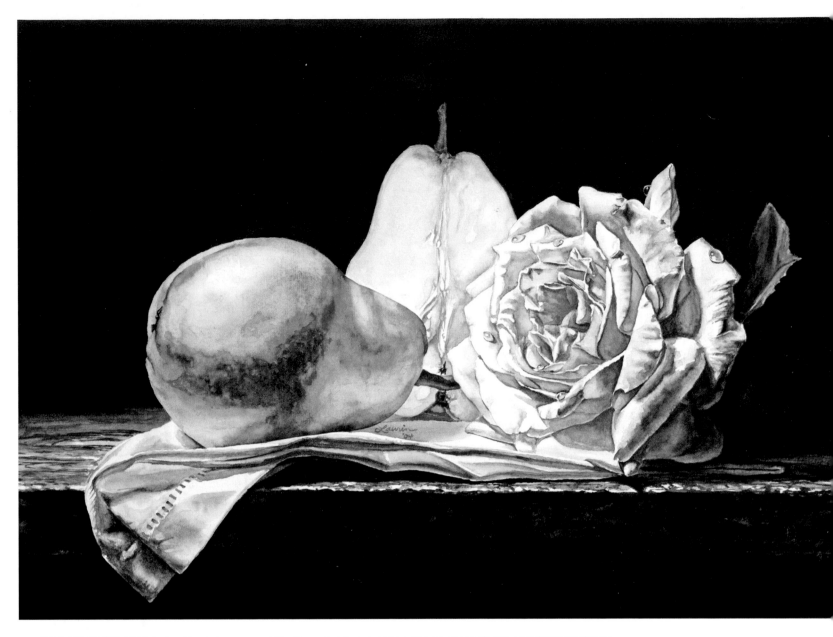

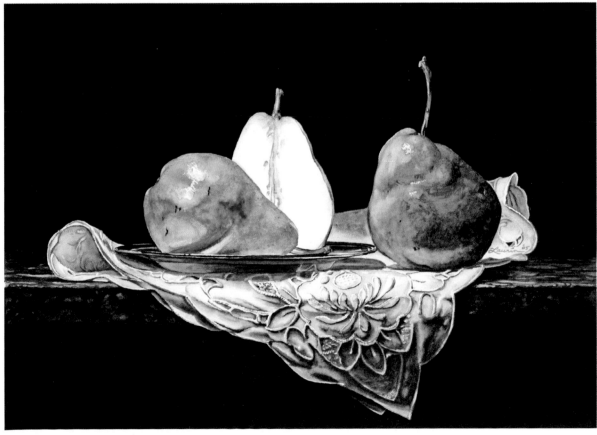

Pears and Rose Laurin McCracken
11" × 15" (28cm × 38cm) (TOP)

Pears With Silver Plate Laurin McCracken
11" × 15" (28cm × 38cm) (BOTTOM)

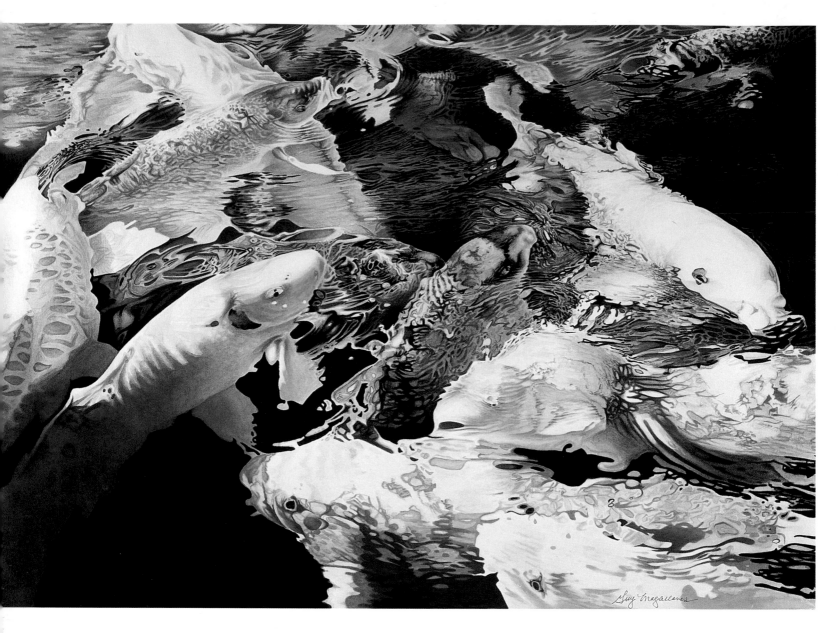

Paint What You See, Not What You Know

This image is from a hot sunny day in the Japanese Garden of Kelley Park in San Jose, Calif. I used a quick shutter speed on my camera to capture the energy I felt when in the scene. Fish moving in to feed caused ripples, which created distortion and abstraction. To make the distortion look like what I see, not what I know, I painted shapes from my reference photo, which turn into eyes, mouths and fins. I know eyes, mouths and fins are symmetrical, but there is nothing symmetrical about this painting. After sketching the detail, I applied many washes of color until shapes emerged. I added stronger color to define them. I continually step back and use a mirror to see my paintings from a different view. I find other shapes and rhythms I might not have noticed and areas to enhance or remove.

WHY DO YOU PAINT

"Painting allows me to get my ideas out of my head and onto paper. Once the ideas are out there, then there is room for more. Life is too short not to paint."

—*Gail Delger*

Exaggerate Value Changes

I took photos for this painting when snow covered the ground, providing the strong light that comes through the window and the stained glass. Placing the water goblets in front of the stained glass roundel resulted in an image of colored light fractured by the pressed glass patterns. I work from both photographs and the actual objects in a still life, but I usually change values and colors as I develop my composition. Emphasizing and exaggerating the slight value changes and shifts in positions of colors helps create the illusion of seeing the different layers of transparent and colored glass. I intensified the lighter values and colors to achieve my goal of emphasizing the quality of light coming through the glass.

Fiesta Guy Magallanes
27" × 38½" (69cm × 98cm) (ABOVE)
Collection of the artist

Betty's Glass, Wally's Goblets
Laurel Covington-Vogl
28" × 21" (71cm × 53cm) (RIGHT)

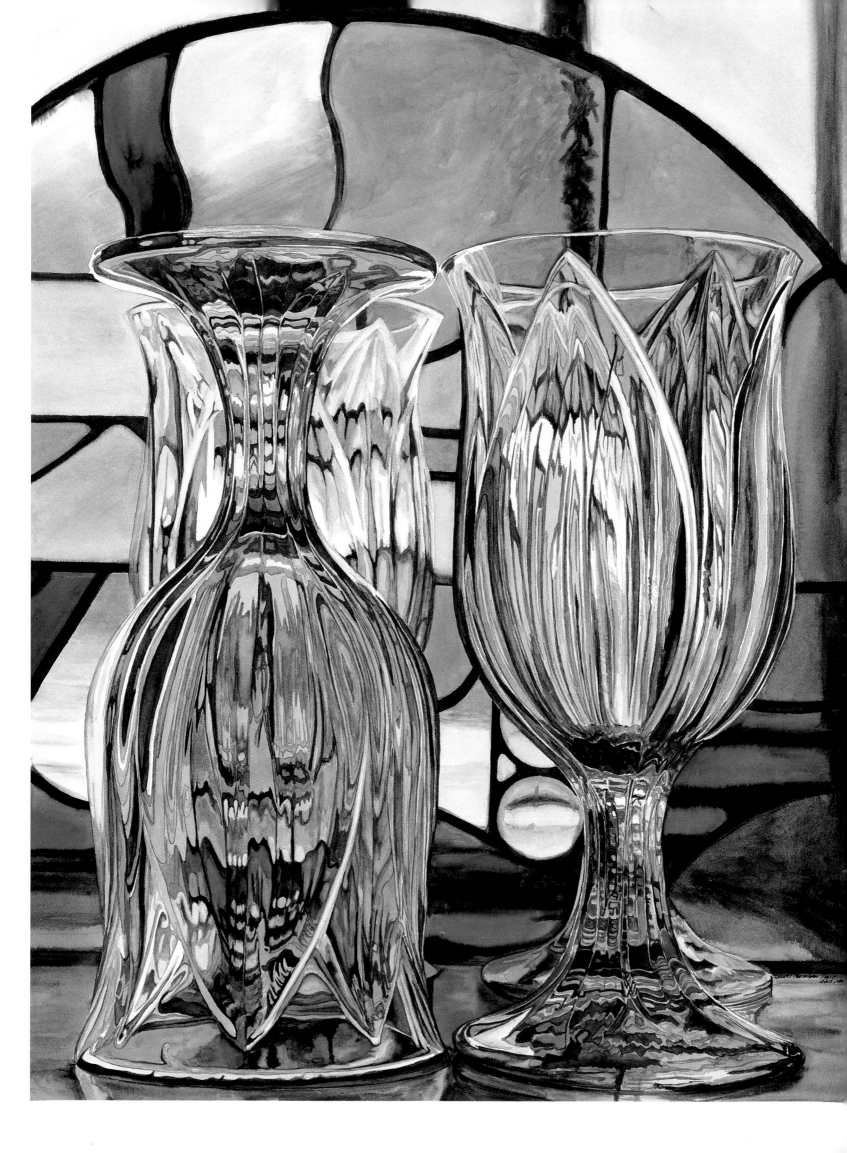

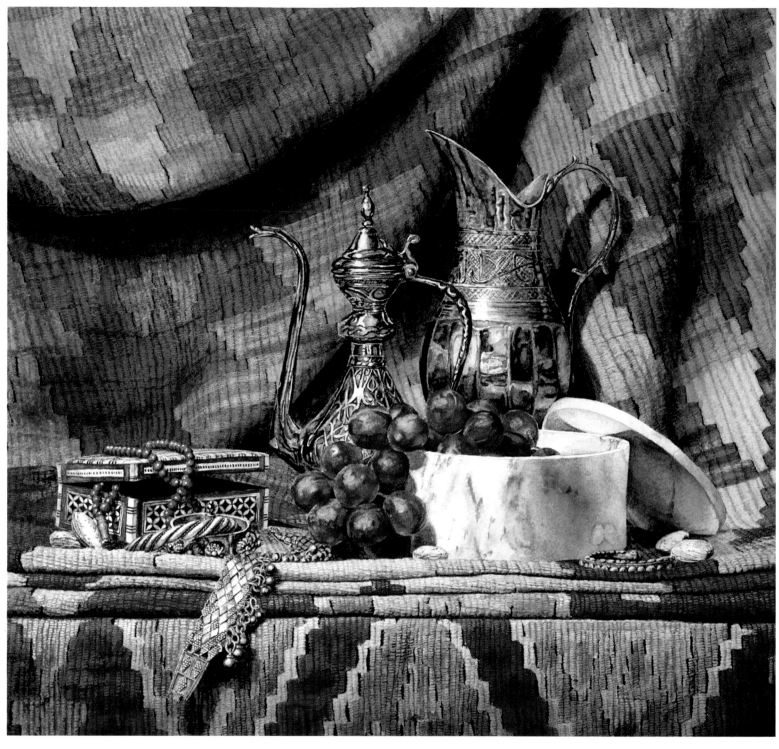

Paint Lush Fabrics With Contrasting Textures

I created this still life by combining two kilims purchased in Istanbul with objects collected from past trips to Saudi Arabia, Egypt and Abu Dhabi. The contrast between the textures of the rugs, the smooth marble bowl and lid, the fruit, and the Bedouin jewelry interested me. Strong lighting helped define and differentiate the textures. I used liquid masking fluid with a very fine nib to cover the highlights in the details of the jewelry and the water ewers. Then, I covered the main elements of the painting with tracing paper and masking tape. I painted the rugs first, knowing that if I did not get the texture right there, the whole painting would not work. I laid down broad washes for the different colors of the woven shapes in the rugs and then used a no. 1 brush to add texture over the base color with a combination of brushstrokes that imitated the knots in the rugs. I used darker colors in the shadowed areas to deepen the colors there. Like in any detailed painting, you have to work inch-by-inch, especially when creating a fine repetitive pattern like the texture of the rug, so you can slide easily into an Alpha state and let it be a Zen experience. Good music playing in the background helps, as does a smile on your face.

Ottoman Still Life Laurin McCracken
18" × 20" (46cm × 51cm)

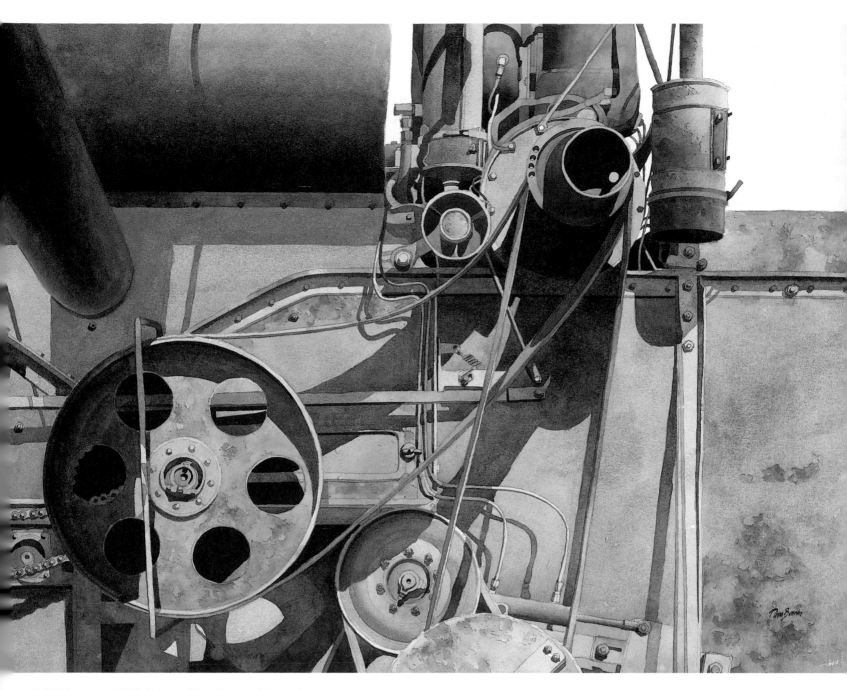

Add Character With Dents, Dimples and Scratches

They are proof of long, hard days and honest work. I paint in three basic stages. I begin with a strong foundation of color, often dabbing with a tissue so one color can peek from behind to create depth. These layered washes set the stage for textural effects later. Next, I drybrush around imaginary dents and dings, leaving some hard edges, which give the illusion of a disruption on the surface of the subject. Be cautious about overdoing it: Too much texture can be tedious. In the final stage, I use a tiny brush to paint shadows under my dry-brushed edges carefully. Remembering to keep your light source in mind, vary the thickness of these edges depending of the heaviness of the texture casting the shadow. Maintain the appearance of random texture, but place detail to enhance your center of interest. When necessary, throw a broad wash over areas that you want to de-emphasize.

WHY DO YOU PAINT?

"Life becomes richer and fuller as we grow and take on additional roles, but it also gets complicated and, well, crowded. I find it vital to my daily happiness to stay in touch with the girl I've always been—before any of the should-haves, could-haves, or might-have-beens. When I'm drawing and painting I'm just quietly me and I cherish that time."

—Dana Brown

One Thing Leads To Another
Dana Brown
21½" × 29" (55cm × 74cm)

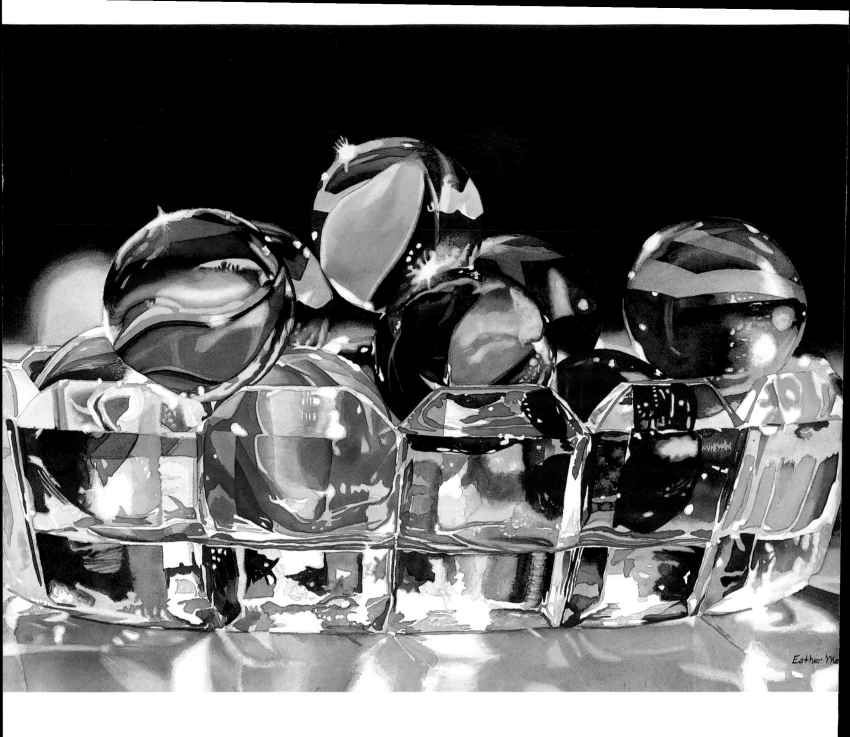

Don't Lose Your Marbles Painting Complex Color Patterns

Start with a composition in which the shapes and values move the eye throughout the painting and have strong, exciting contrasts. Combining shapes of similar values as you draw the design on your paper helps simplify and strengthen the overall design. When painting, try seeing the objects as groups of shapes in order to understand the abstract components of the shapes, colors and patterns that the sunlight creates as it reflects and bounces off the objects. Viewing a complex composition this way will make it easier to create the illusion of correctly-colored shiny objects.

Marbles I Esther Melton
22" × 28" (56cm × 71cm)

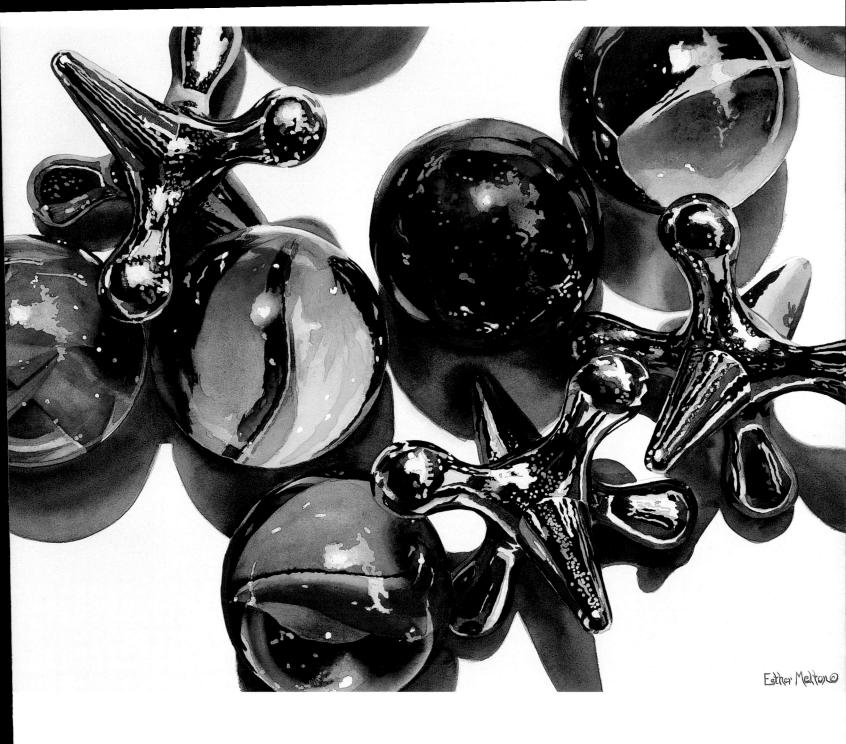

WHY DO YOU PAINT?

"In the past few years, I have had the good fortune to paint quite frequently and find it very rewarding. My motivation is due to the fact that I have found what I truly love to do in life. But motivation was not always present. It grew gradually as I put more time and energy into studying and practicing watercolor. Do not despair if you have a difficult time motivating yourself to paint in the beginning. Setting a specific goal, such as entering a local art show, can some-times get you going."

—Esther Melton

Shadow Play Esther Melton
21" × 28" (53cm × 71cm)

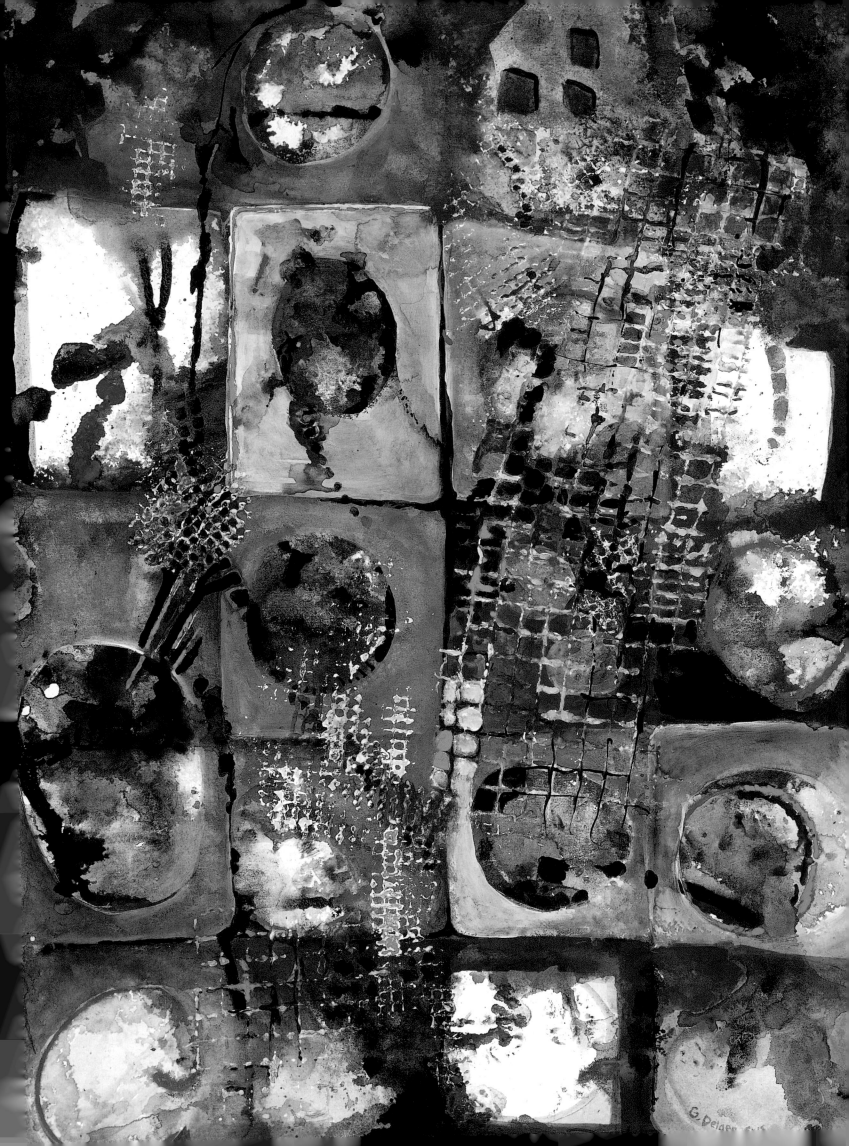

DARE TO BE DARING

In every edition of Splash,

I like to include at least one painting that is just plain fun! It is easy to

forget that painting started out as pure play. In this chapter, I included paintings that, maybe, took a little

risk on the part of the artist, whether in subject matter, style or both. Some paintings are merely very wet

and loose, others employ a variety of materials, just for the fun of experimenting. (Note: "Experiment" is the

grown-up word for "play.")

Rachel

Add White Gesso to Your Supplies
In this painting, I use Robert Doak & Associates liquid watercolors, mainly Gamboge and Quinacri-
done Red Gold. I squirt them directly from the bottle, forming circles and lines, like a tick-tack-toe
game, on dry watercolor paper. Then I spray water over those lines so they spread. Before it dries, I
paint white gesso shapes around the circles. Then I paint around and through the design with sepia
and other colors. When I'm satisfied and it is dry, I stamp gesso in the areas that need more texture.
I tint some of the gesso shapes. At the very end, I add turquoise acrylic for accents.

Full of Holes Gail Delger
20" × 14" (51cm × 36cm)

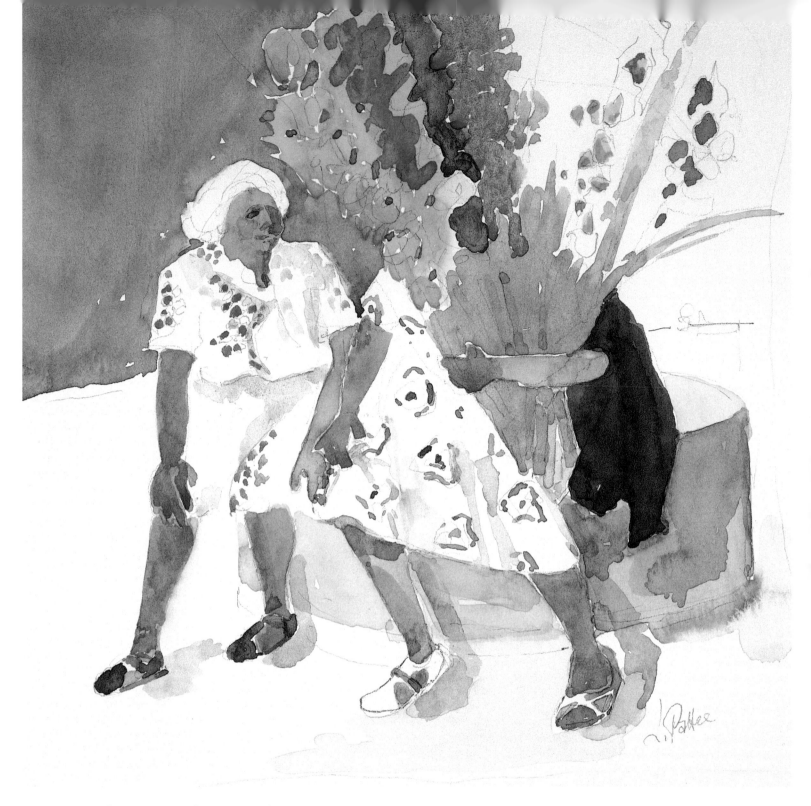

Seize the Moment and Paint Directly

The Flower Sellers sat to chat together near my easel as I painted in the plaza in Ajijic, Mexico, and I became more interested in their charming "pose" than in my landscape. Not wanting to draw their attentions, I worked in a small pad in my lap, using a contour drawing technique for the way its quick, fun and natural distortions capture gesture and immediacy. Normally, I prefer to glaze, but I assumed the opportunity would be fleeting, so I used a direct application of bold, bright colors in both negative and positive shapes to create a strong composition in the shortest amount of time. I never saw the face of the seller carrying the flowers, even though they sat there for well over an hour!

WHY DO YOU PAINT?

"I paint mainly to record what I see, as in a journal, but in the process arrange or rearrange shapes and values to make a design that really works. It can be an addictive cerebral puzzle."

—Lynda Pattee

The Flower Sellers Lynda Pattee
7¼" × 7" (18cm × 18cm)

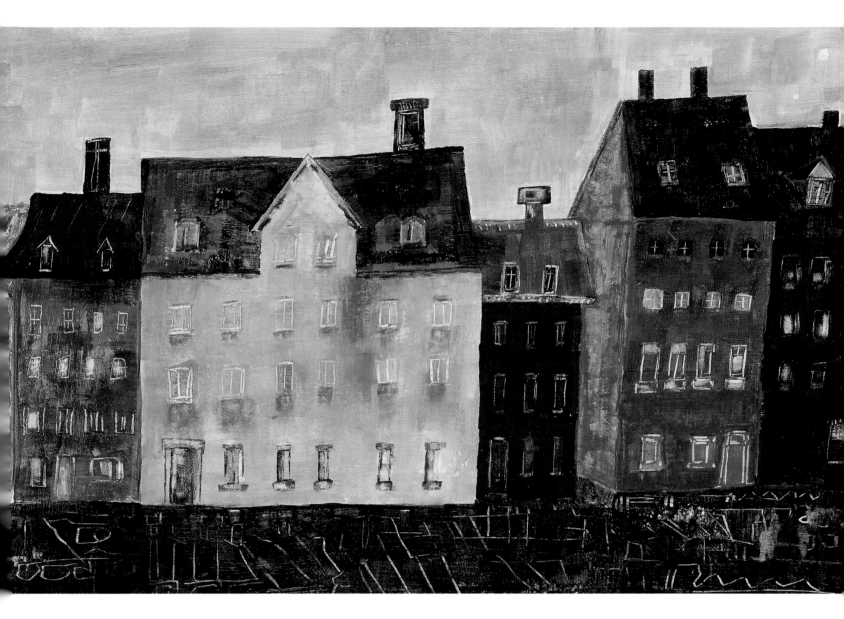

Paint Your Emotional Response

This painting is one of a series, based on sketches I made in Copenhagen. Painting from a sketch frees me from a literal interpretation of the scene. Working in a series allows me to experiment and gives me time to develop an emotional response to a scene, resulting in a very personal style. I worked on illustration board that had been coated with matte medium, and I used only fresh paint. The intensity of the primary colors comes from using many variations of a primary color. For example, I painted the yellow building with Aureolin, Quinacridone Gold, Indian Yellow and Yellow Ochre. These colors blend softly and create a yellow that has depth and movement. I also used Stabilo crayons because they work so beautifully on a wet surface. I made the random marks in the gouache at the bottom of the painting with the pointed end of a brush.

Copenhagen No. 3 Patricia W. Rapoport
14" × 22" (36cm × 56cm)

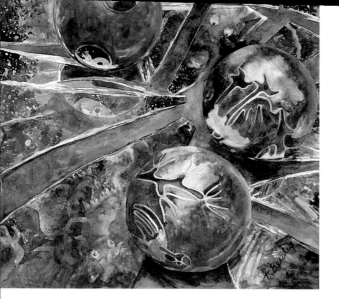

Find Good Luck

This series of paintings began when I found a broken mirror. My son and I set up several arrangements and spent the day photographing them from various angles. I then made detailed drawings from the photographs. The resulting paintings are metaphors about the broken things in our lives and what we create from the pieces. The mirror fragments served two additional purposes: reflective surfaces for elements that are not actually in the picture frame, and directional lines to lead the viewer's eye around the painting. Instead of using flat washes, I prefer to mix colors on the paper and use brushstrokes to give my work rhythm and energy. I focus on cutting out shapes using the tip of my brush. I also make spontaneous strokes by using the entire side of my brush to "push" color across the paper. These brushstrokes have become my personal language.

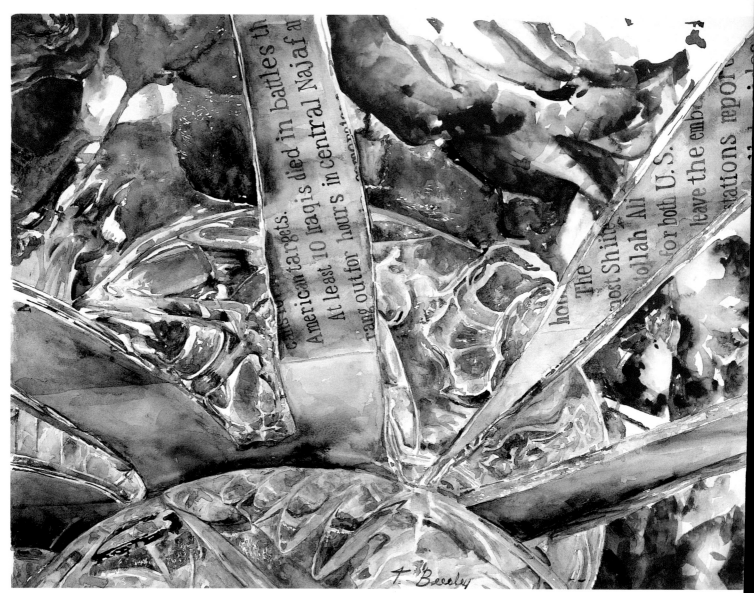

WHY DO YOU PAINT?

"My brother says I paint because I throw like a girl and there was no hope of becoming a professional baseball player. But I think I paint because there is still a child inside me yelling, 'Hey, look what I can do!'"

—Terrece Beesley

Bad Year for the Dragon Terrece Beesley
20" × 22" (51cm × 56cm) (TOP)

War-Torn Reflections Terrece Beesley
20" × 28" (51cm × 71cm) (BELOW)

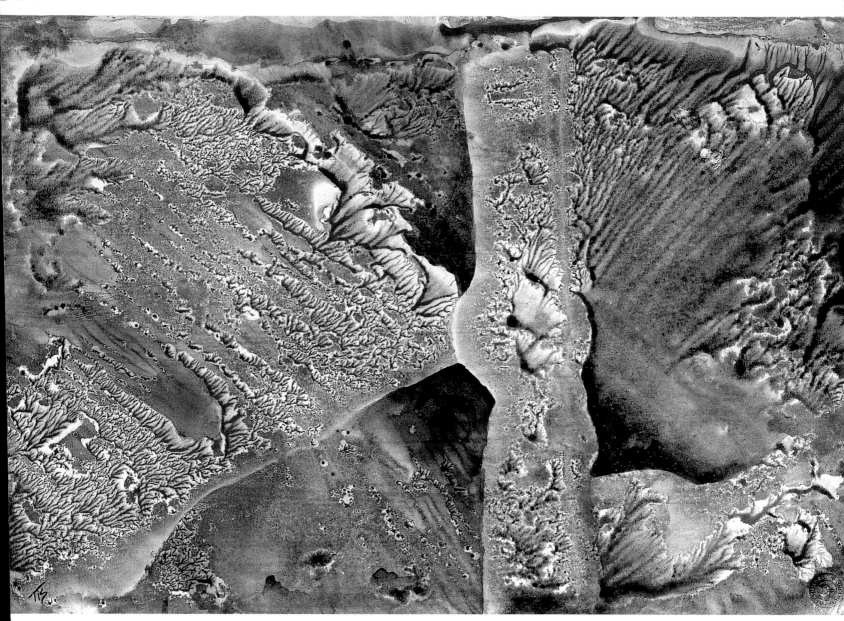

Paint With an Attitude Rather Than With a Plan

Allow the surface to develop as you proceed. I painted *Primordial Patterns* with Golden Airbrush Phthalo Blue, Burnt Sienna and Yellow Oxide on Aquarius II paper primed with acrylic matte medium. I dropped the colors at random on the wet surface, then loosely brushed them with a wide flat brush without mixing. After the shine left the surface, I folded over edges of the paper, pressed them with my hand, being careful not to crease the paper, and lifted to create the texture shown, like a self monoprinting technique. Once the surface had dried, I created the illusion of depth with gradated glazed in negative areas.

WHY DO YOU PAINT?

"I paint because it energizes me, awakens my creativity and makes my everyday self disappear."

—Tis Huberth

Primordial Patterns Tis Huberth
13½" × 20" (34cm × 51cm)

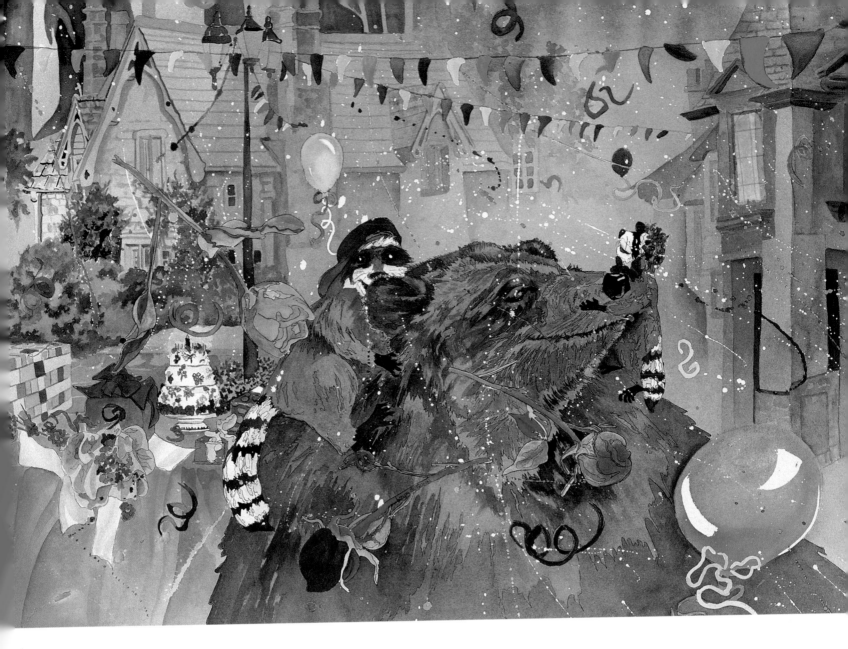

Plan Like a Painter, Play Like a Child

This children's book illustration is a compilation of personal references from my journals, sketchbooks and photographs. Much more than mere child's play, this painting was completely planned using a four-step process that I learned 20 years ago from artist Nita Engle. I drew the scene on 300-lb. (640gsm) cold-pressed watercolor paper. To save the white of the paper, I carefully painted or splattered masking fluid onto selected areas. After the masking was dry, I thoroughly wetted the paper and applied paint with a large brush. Working quickly with a spray bottle to help move and blend the paint, I turned the paper vertically numerous times until I achieved the desired blended effect. Then, I removed the masking fluid from the dry paper, added bright color to the selected white areas of the paper and applied the darkest values. I brought out the details with black ink outlines.

Mr. Bear's Birthday Party Linda S. Gunn
22" × 30" (56cm × 76cm)

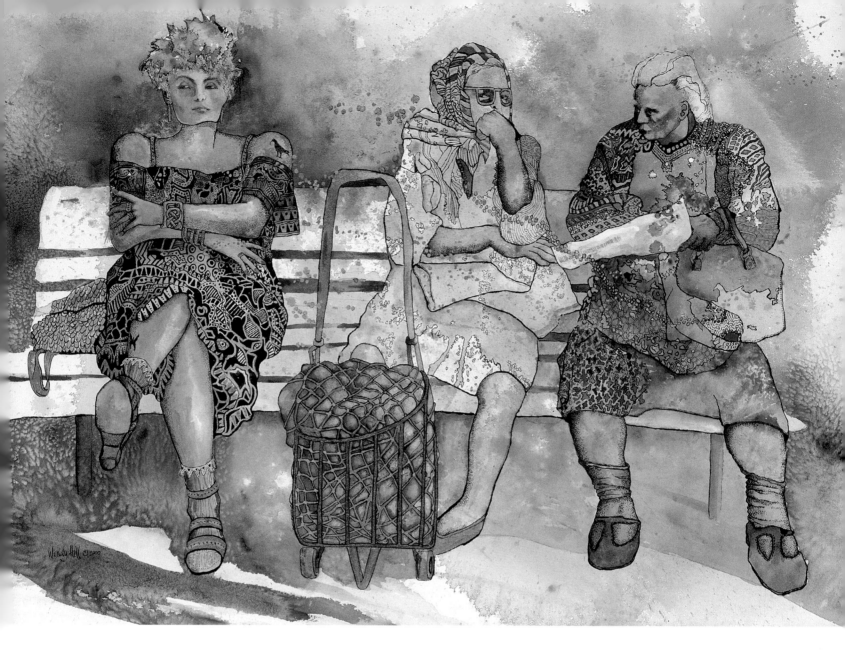

Match Medium to Mood

Adding gum arabic to my water, I splash it onto the surface of the paper randomly. I drip, spatter, pour and drop colors into the wet areas, lifting and tilting the paper to allow the colors to mingle and mix. By chipping and scraping at the watercolor crayons and allowing these tiny shards of waxy color to melt into the wet surface, I achieve a lovely confetti effect. The paint application creates the picture mood. I may re-wet the surface several more times until there is a balance of color and saved white. At this time I apply some used tea bags randomly. The paper tea bags will trap color as well as allow air pockets to form, staining the surface with concentrations of color and tea. I may throw some salt onto the surface at this time.

With an active underpainting completed, I draw the subject onto the surface using a watercolor pencil or Berol Prismacolor pencil depending on whether I want the line to dissolve. I built the figures up with many glazes of thinly applied crayon. I draw, stipple and crosshatch with a pen to add dimension and texture. I apply metallic watercolors and acrylics to create tension and interest. Dipping into the black ink, I trace around the odd shapes, creating the design. I use a long list of techniques with these materials. I paint the figures by applying watercolor crayons with a brush using gum arabic as a medium, diluted 10 parts gum arabic to 1 part water. It's a great way to apply glazes and not worry about mixing neutrals into an unwanted color. I finished by inking around the figures to re-inforce them and again spattering several different colors of acrylic metallic inks.

Is the NASDAQ Up Today?
Wendy Dawn Barnhill-Hill
22" × 30" (56cm × 76cm)
Collection of Charles and Carol Knappow

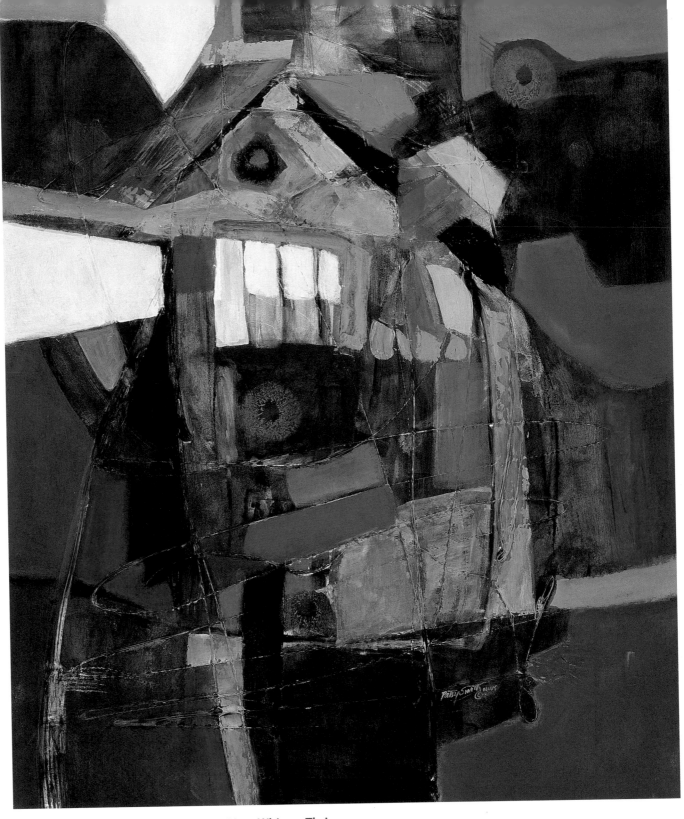

Let Your Whimsy Thrive

I began by pouring thick clear acrylic medium on the surface, moving it around with a palette knife to create levels of texture. Once the surface was bone-dry, I brushed on strips of color, striving to produce shapes that would lay a strong groundwork for the overall composition. Filling in with rich paint, I suggested walls and a roof. Layering complementary colors creates exciting nuances in the textured area that I created with the original pour. It is so much fun to watch the magic that happens here. Decorating the area of interest is always a delight. I paint imaginary tiles, doorknobs and lamp shapes. These whimsical accents enliven the focal area. I try to bring the painting into a unified whole with rhythm, color and repeating patterns. As artists, we are influenced by what is going on in our lives. Building my new studio likely influenced the theme of construction on which I based this painting.

Construction Patsy Smith
40" × 30" (102cm × 76cm)

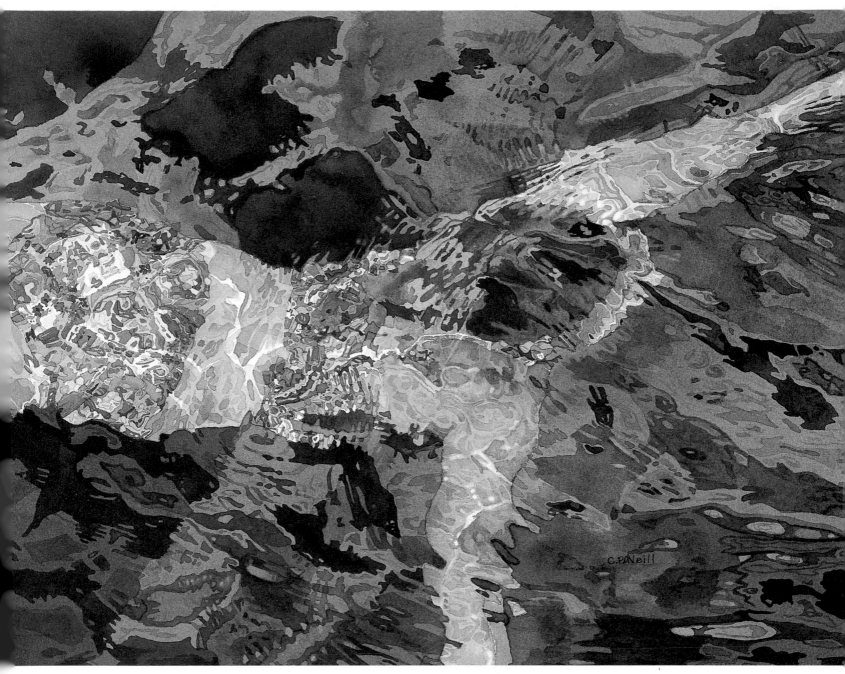

Catch Fleeting Moments

Watercolor painting has changed the way I see. I find myself noticing the sunlight touching the tip of my daughter's nose or the distorted reflections of an underwater swimmer. In order to catch these often fleeting details, I rely on my camera. Photographs can capture the busy activities of children, one of my favorite subjects. I generally take multiple candid shots from various viewpoints. Once developed, I place the photos in a small album and look them over whenever I have a few moments. The ones I keep going back to are the ones I ultimately select to paint. Often, I use several reference photos to design a final composition. Black-and-white copies can help define values, and I frequently refer to these during the actual painting process. Once I render a detailed drawing, I paint fairly traditionally, working from light to dark, sometimes completing a section at a time. I spend much more time planning how and what to paint than actually putting brush to paper, but for me this is the most exciting part!

WHY DO YOU PAINT?

"Joseph Campbell once asked, 'Who would want to eat Cezanne's apples?' I think that's the ultimate challenge as a painter: to create images that transcend the object. This moving target is a lifelong quest."

—*Irena Roman*

Meg Underwater Catherine P. O'Neill
15" × 19½" (38cm × 50cm)

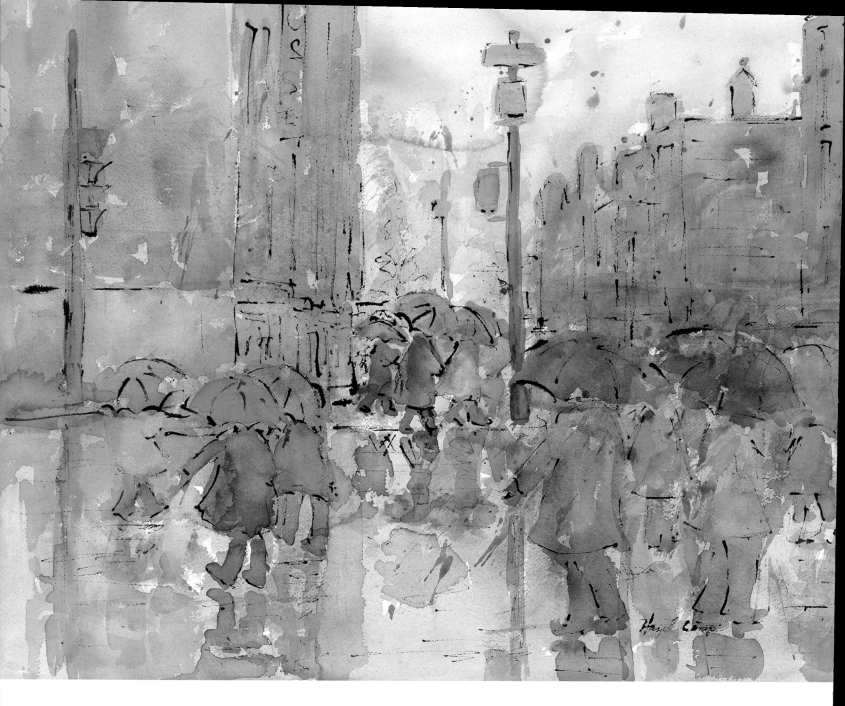

Add Definition to a Loose Painting Style

Reflections of people with colorful umbrellas in wet city streets long has been a favorite subject of mine. Some years ago, while on a trip to Washington, D.C. , I took wonderful photographs of street scenes that I use often for reference and inspiration. To begin a painting, I look at a projected image of the photo and make a light pencil drawing on dry Bockingford 140-lb. (300gsm) paper. I usually try to complete a painting in one sitting, so I paint rapidly, spreading my paints on the dry paper using my favorite 1-inch (25mm) ox hair brush. When spatters and drips happen in my excitement, I leave them. When thoroughly dry, I study the painting to decide where I should add ink lines. Then, using a nib and black India ink, I quickly draw lines and dashes where I think I need them. This gives the look of glistening rain and defined certain areas.

Washington Rain Hazel Camp
18½" × 23½" (47cm × 60cm)

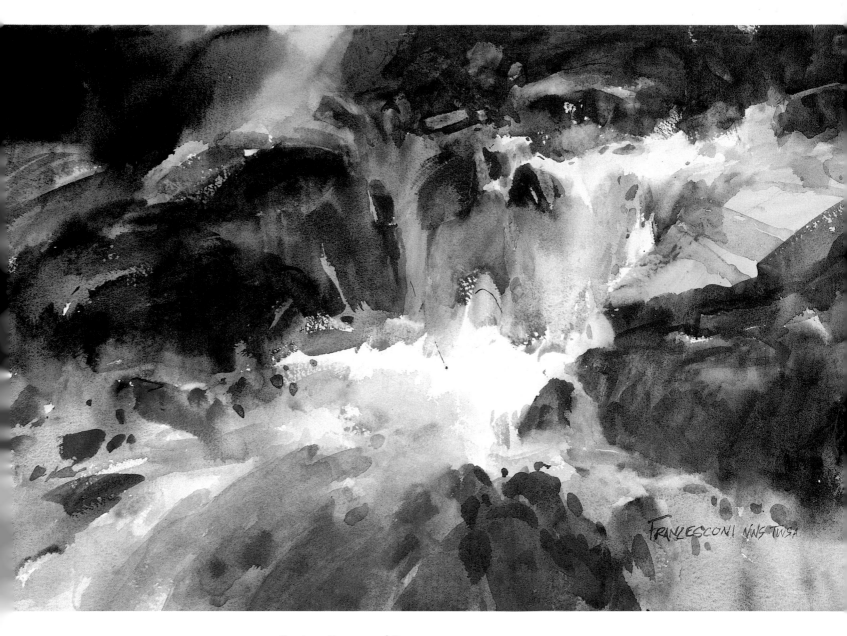

Capture Power and Energy

I wanted to capture the fury of rushing water against solid rock forms. Beginning with a loaded brush, I applied paint in a bold and decisive manner on dry paper, encouraging the pigment to flow and mingle. I painted most of the darks into washes that were still wet. I infused a sense of movement and strong directional forces into the work as the brush curved around rock forms and dashed into the water. Where the central waterfall plunges downward, I used vertical brushstrokes, allowing the paint to run. Color is richest in this area because of its special interest. Into this wet paint, I stated rocks directly. As the water emerges from the foam, I abandon the strong vertical presentation in favor of brushwork that arches toward the viewer, helping to bring the water forward and over the edge. To further emphasize this onward rush and its inherent splashes, I added some dark, bold strokes of paint in the foreground. Some of these marks, being crisp and identifiable, provide a note of contrast to the overall soft presentation of the water.

WHY DO YOU PAINT?

"Communication is an enjoyable and essential part of life. I express myself through the language of paint because it provides a sense of fulfillment, both in the challenge of the creative process, and in the culmination of my visual statement."

—Tom Francesconi

Timeless Tom Francesconi
13½" × 20½" (34cm × 52cm)

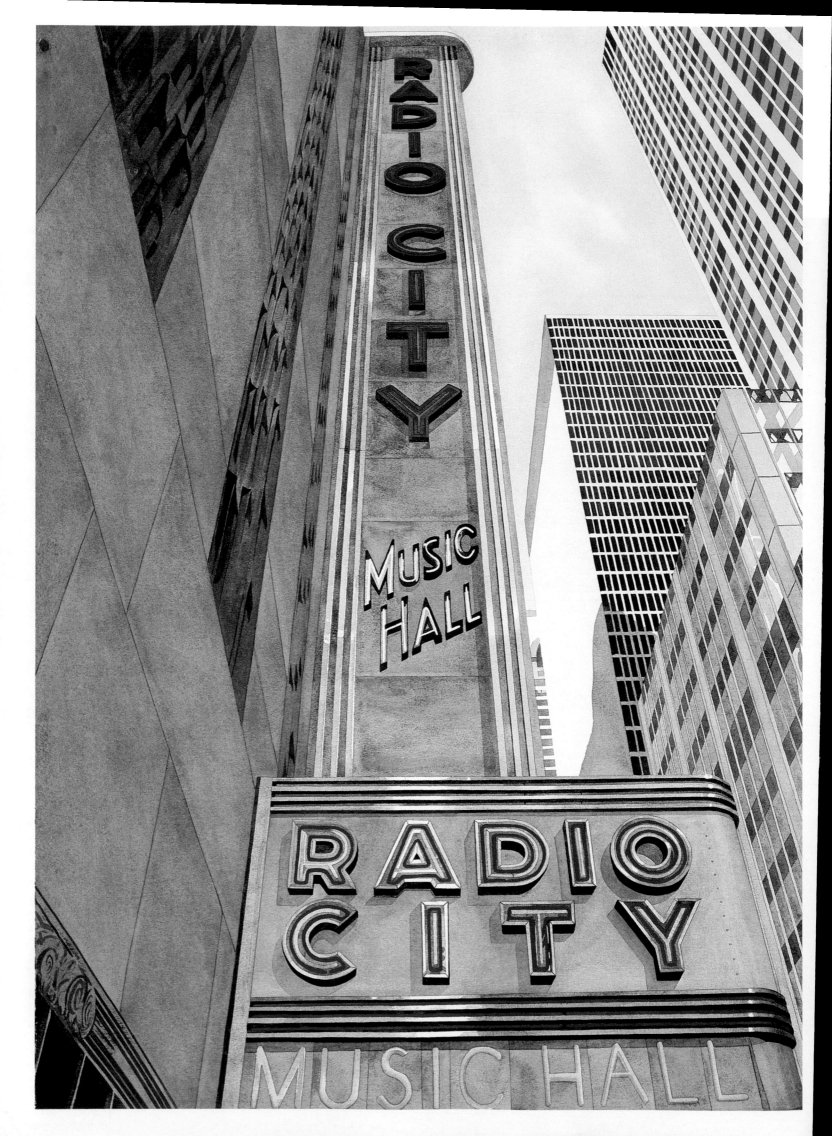

The paintings in this chapter

struck me as having an unusual viewpoint or I felt that the artist

was able to portray an "overpainted" or cliché subject in a fresh new way. I am always amazed at the

bottomless pool of creativity available to us mere humans when we dive in. I wanted to know some of

the creative processes that led to these fresh views of common subjects.

Rachel

Use a Childhood Point of View

As a child, looking up at skyscrapers created an almost breathless sense of excitement that I recall with pleasure to this day. I remember a sense of wonder and wished to capture it. To depict Radio City Music Hall, I chose a full sheet of Arches 550-lb. (1170gsm) paper, the large format allowing me to include as much detail as necessary. Working from my photographs, I carefully created the drawing, down to the finest detail. I used a combination of artist's quality tape and masking fluid to save white as I spread fluid washes of color. I enjoy the contrast between tight and loose areas. Although I use only transparent watercolor, I apply the paint quite heavily in areas to achieve a depth of color not usually associated with watercolor. I build up multiple washes of the same color to achieve this depth, a technique that requires a great deal of of patience and time. It took three months to complete this piece.

In the Big Apple David Milton
40" × 30" (102cm × 76cm)

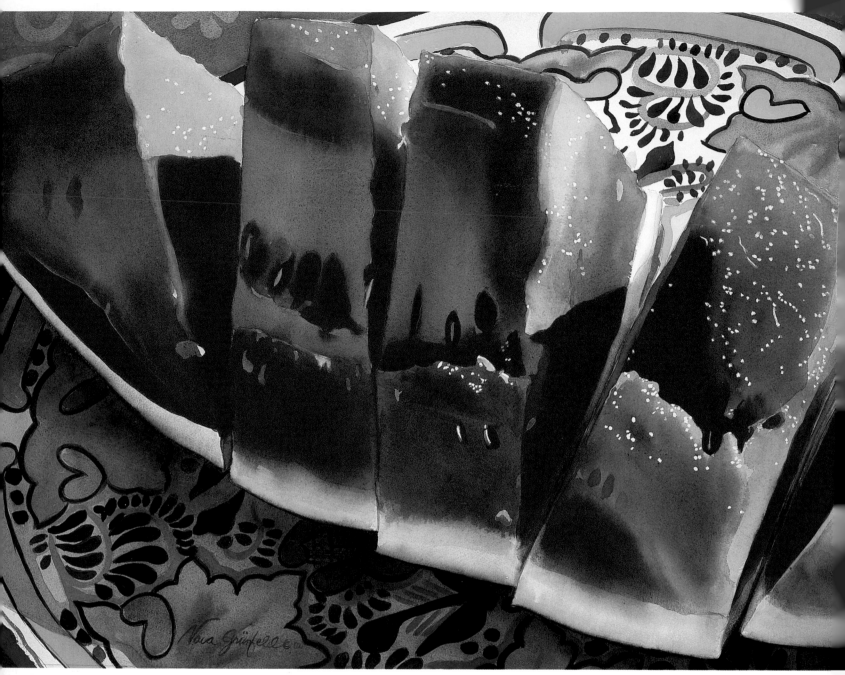

Photo by Stephen Petegorsky, 413-586-3257

Avoid Playing It Safe

Take a leap with color, pattern and composition. Luminous saturated, color is my goal. It's a time-consuming process. Layering transparent veils of color is the only way I have found that works for me. My travels inspire the images I paint and the way I see color. I find inspiration all around me. I paint still-life objects because I like getting close and observing closely, but I do not get bogged down by detail. Using a wet-into-wet technique and large round brushes, even when painting complex patterns, will keep the composition bold.

Watermelon Nava Grünfeld
24" × 40" (61cm × 102cm)
Collection of the artist

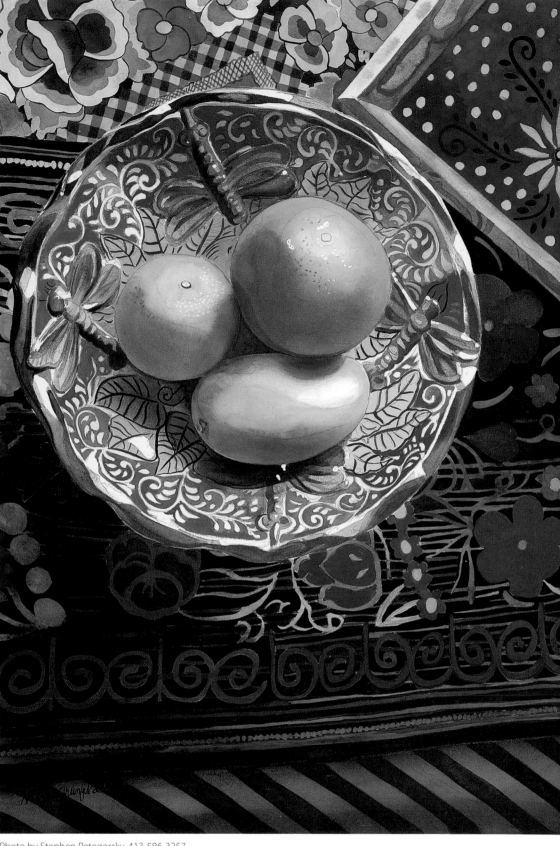

Photo by Stephen Petegorsky, 413-586-3257

WHY DO YOU PAINT?

"I never felt I had a choice. It was clear very early on that I was an artist. From an early age, I had a keen eye, a facility for drawing and a good sense of color and style. It wasn't until I met my father at age 23 and learned that he, too, was an artist, that I realized making art was my destiny. I feel very lucky."

—*Nava Grünfeld*

Dragonfly Bowl Nava Grünfeld
41" × 29" (104cm × 74cm)
Collection of the artist

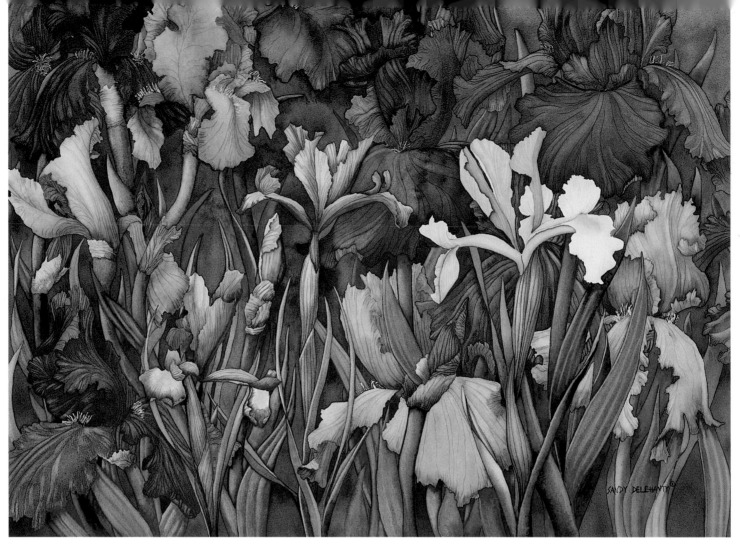

Paint an Over-Painted Subject Uniquely

My goal is to create paintings of exuberant color, and flowers offer me that opportunity. Rather than paint a formal arrangement of iris in a vase, though, I painted them here as a riot of color in a fantasy garden. I worked backward from dark to light values using transparent pigments. To imitate the velvet look of iris petals, I use a granulation technique on Arches 140-lb (300gsm) rough watercolor paper. To paint each iris petal, I created a puddle of clear water in the shape of the petal and dropped pure, intense pigment into the water to create the darkest values. Working quickly, I dropped in my second, third and even fourth color into the puddle and "tickled" the colors together with the tip of my brush. Granulation occurs as the sediment in the pigment settles into the valleys in the rough paper. When the paint is almost dry, I lift color using a dampened, stiff, acrylic brush to reach my middle to light values. Finally I add the fine lines of the iris veins with a liner brush.

Glaze With Patience

In my floral portrait paintings, I try to capture each flower's characteristics and mood to record a moment of grace and beauty. Iris has a strong vertical form with very delicate and fragile petals, conveying a sense of dignity and pride. These observations and impressions arise from studying them in my own garden. I made several thumbnail sketches and pick out the most pleasing one. For the translucent petals, I used a glazing technique to paint 10 percent of the value of a color at a time. This technique requires patience, but Nevada's dry climate cooperates well. For glazing, I use good, round sable brushes and Japanese bamboo brushes. These are much more flexible than flat brushes and can change form from round to flat instantly. The dark, rich background not only supports the main subjects, but also gives the viewer's eyes a place to rest and stay in the mood.

An Evening in May Sandy Delehanty
22" × 28" (56cm × 71cm) (ABOVE)

When Time Stands Still—Iris Reiko Hervin
30" × 22" (76cm × 56cm) (RIGHT)
Collection of Ms. Ann Campbell

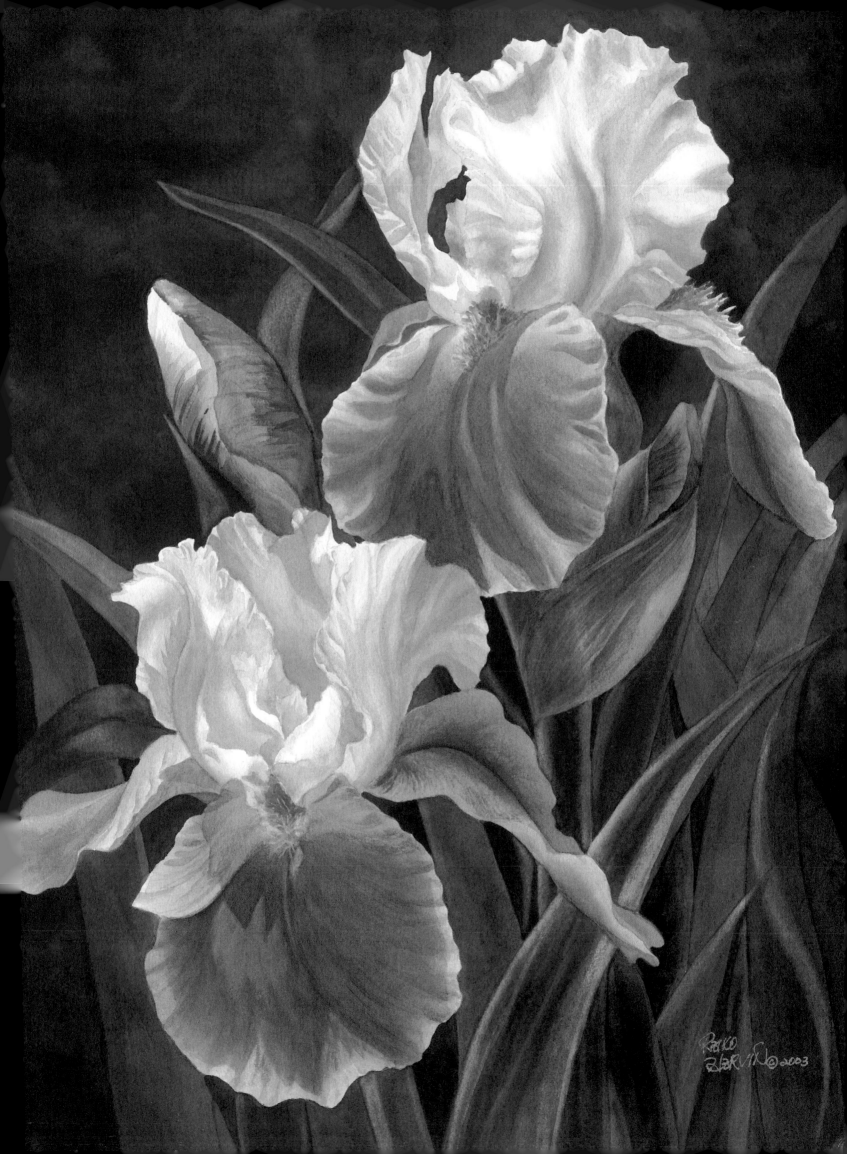

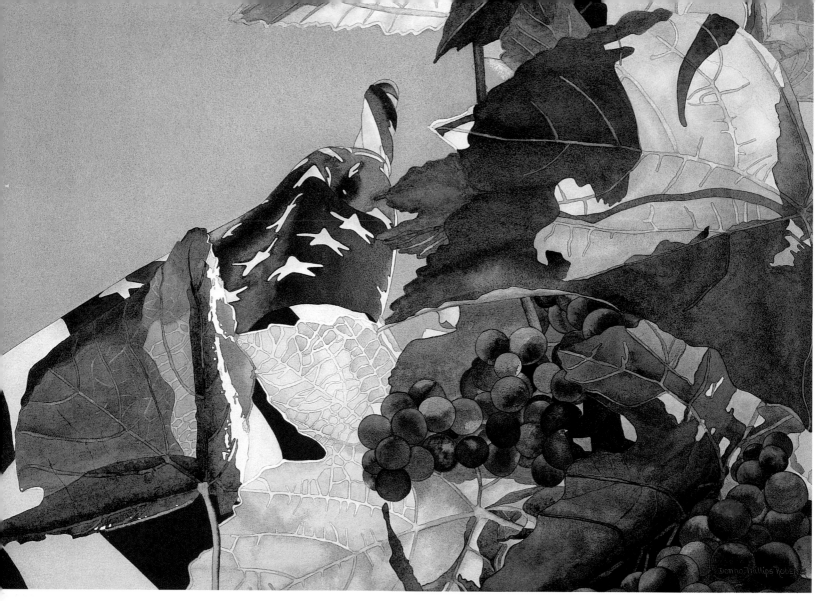

Paint a Unique Memorial

Events surrounding the 9/11 tragedy created dark days for most of us. My own personal process of recovery was simple yet effective: a self-assigned creative challenge to use everyday subject matter, bordering on the cliché, in an uncommon and unique way. I chose the American flag as my motif. And though the process of depicting the flag in unique way took many weeks, from the start, feelings of peace and compassion began to replace the darkness of anger and fear. I composed *Home Sweet Home* by laying on the ground and looking up at the flag waving through the grapevines in the deep blue sky above. Keep a tarp and an oversized towel in the trunk of your car for wet grasses, driveways and dirt. Don't be timid about getting down on the ground; you'll be surprised and inspired by the new world you will see. For *The Big Apple...We Will Never Forget*, my challenge was reflecting images that tell a story. I composed it by placing a large cardboard box with two sides removed on a picnic table outside in the sun. I gathered specific material to depict my vision of the story I wanted to convey, that 9/11 is something that we truly will never forget. First, I draped the red stripes of the American flag over the sides of the box, and I placed the blue flat on the picnic table. Next, I added a big bouquet, similar to the one presented to the First Lady when she arrived in New York City soon after 9/11. Then I added the most important element, a silver apple symbolizing New York City, to reflect my vision of the story as a whole.

I had to find a key element and reflect it into the silver apple to create a powerful image that could depict the wide range of associated emotions and experiences. I chose an image of the beloved New York Fire Department fire chief's funeral procession in the streets of New York City. Like so many, he gave his life for others and died a hero, and a fire truck carries the body draped in the flag, with two uniformed firemen standing proud on either side of the casket. A sign on the back of the truck reads "We Will Never Forget." Reflecting a specific image is a challenge, but lots of fun. Cut out the image you wish to reflect and glue it to a piece of mat board cut to the same shape, leaving three inches at the bottom to fold under as a stand. Move the image around to see what works. Getting just the right reflection is tricky, so take lots of photographs from various points of view. Usually, by combining two to three of these photographs, you will create a pleasing composition.

Home, Sweet Home Donna Phillips Roberts
21" × 28" (53cm × 71cm)
Collection of Greg and Susan Shinley

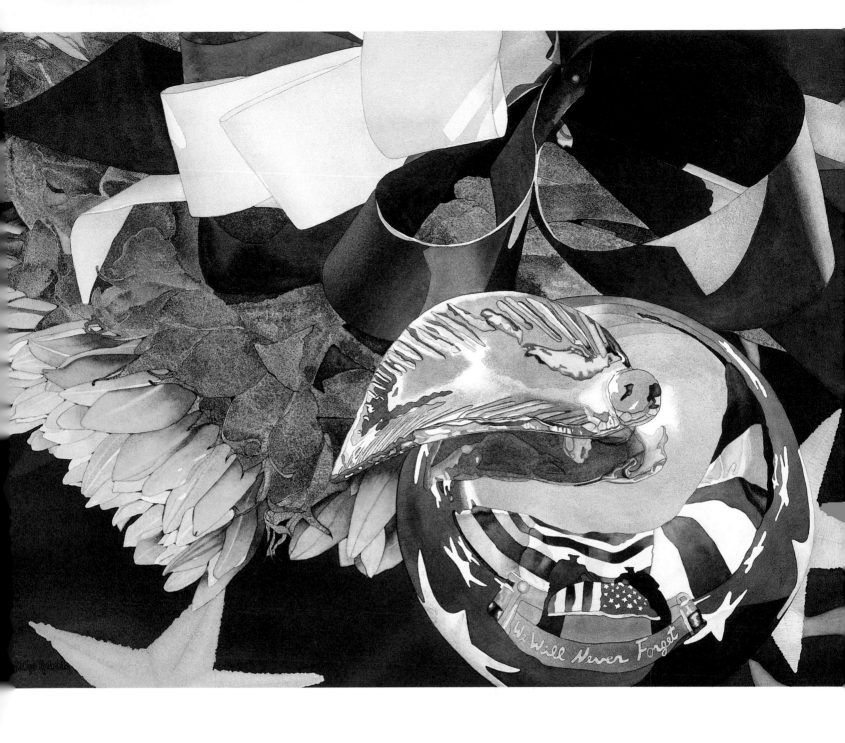

The Big Apple ... We Will Never Forget
Donna Phillips Roberts
22" × 30" (56cm × 76cm)

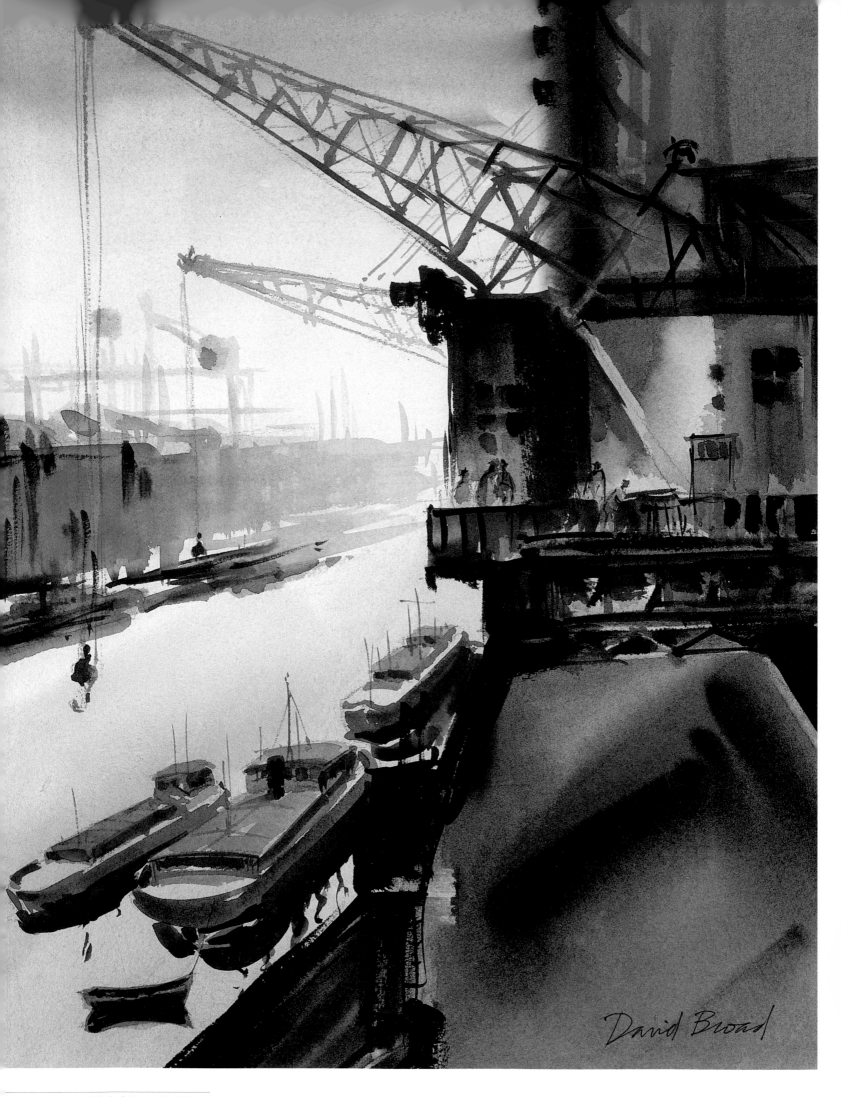

Ichabod Crane David Broad
16" × 13" (41cm × 33cm)

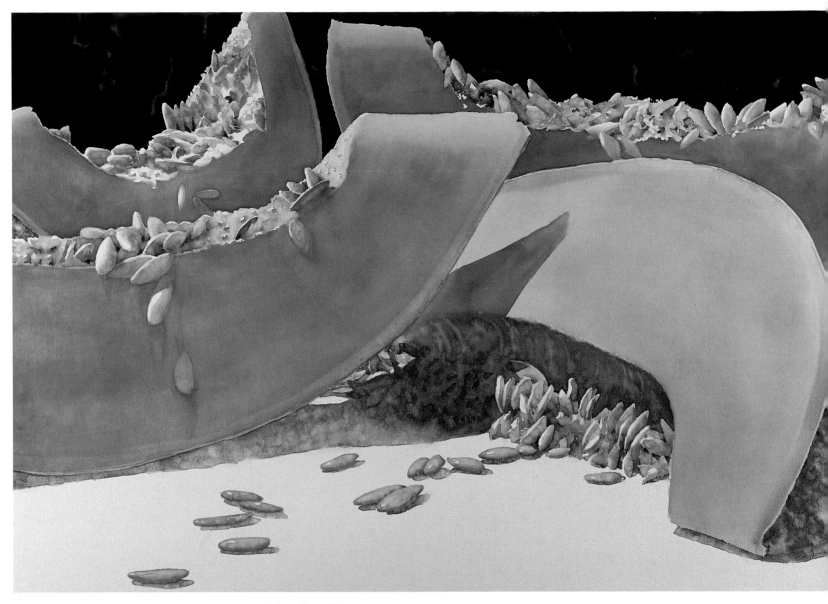

Paint Close Up

A close-up viewpoint provides the large shapes and interesting negative spaces I look for. Rarely using a single center of interest, I prefer a design structure that moves the eye through the composition. My intent is to achieve clean color in all my values. I do this by using a pure pigment palette (no tube pigment that is opaque or grayed down). I am a layerist, using a full range of values. I pre-wet the area where I will apply the wash no matter what size the area. There is no orange in my palette. I achieved the color of the melons optically by alternating layers of New Gamboge and Permanent Rose until I achieved the correct hue and value. I applied the dark-value section on pre-wet paper in just one application. I pre-mixed three colors using staining pigments: dark blue, dark blue green and dark purple. Any texture you see is a result of using water to cause intentional backruns as the wash is drying.

Add Drama With an Aerial Perspective

My process begins with an idea for a subject. I start with small sketches to determine composition and values and to provide a guide for the painting. In this case, I tried to imply a mystic scene of a fantasy industrial world. A sense of depth and drama comes from the aerial perspective. My tools consist of a large, soft, filament brush, a large round blended brush and a rigger brush for final details. I cover the paper wet-into-wet with an overall wash of diluted colors, considering warm and cool relationships. When the paper is dry, I define the architectural areas with broad wet-into-dry strokes of middle and dark values, giving the piece an abstract quality. Finally, I render details to give a feeling of realism.

Cantalope-x-ing #3 Sue Archer
29" × 41" (74cm × 104cm)

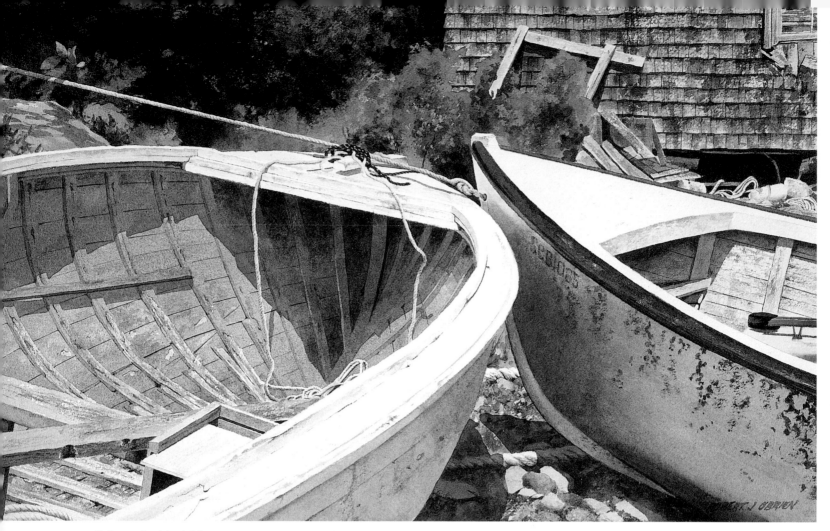

Take an Insider's View

I painted this boatyard in New Brunswick on Arches 300-lb. (640gsm) cold-pressed watercolor paper. I started this painting, like most of my others, with a very light wash of Winsor Newton Lemon Yellow Hue, giving the piece a sunlit appearance. I mixed Viridian and a small amount of Winsor Newton Cobalt Blue for the hull of the boat on the left. I applied the paint to dry paper throughout the entire painting. I painted the sides and interiors of both boats and to the boathouse in the background using a dry-brush technique to give them a weathered appearance. I created a focal point with the merging of the bows of both boats, the edge of the boathouse and the rope in the upper lefthand section. I darkened the background trees to help bring the viewer's focus into the painting. The foreshortened position of the boats is the key to an interesting composition.

WHY DO YOU PAINT?

"I paint to share the beauty and diversity I see while scuba diving and snorkeling. Through my paintings, I strive to encourage awareness, conservation and the protection of the fragile ecosystems within our ocean environments."

—Tanya L. Haynes

Create Dramatic Impact

I wanted to create the illusion of a four-dimensional perspective. The challenge was to bring the spinnaker's sail above the waves that are breaking on the water and surround that image with a dimensional view of the reef system below the surface. I painted the scene on Lanaquarelle 300-lb. (640gsm) paper with a rough surface. Where the waves crash into the hull, I first sprayed the image area and then charged light colors into it. I used clean, pure colors and allowed them to mix and flow on the paper. I then sprayed the edges of the image to create the darker layers of color, and mixed three shades of blue to create the final layer. To create the illusion of varied depths of the reef structures below the surface of the water, I allowed the painting to dry and then used a large, high-volume spray bottle to spray sections of the background. To remove color in varying degrees, I sprayed some areas more than once. The resulting variety of blue shades creates a fourth dimension below the water.

Low Tide Robert O'Brien
13" × 20" (33cm × 51cm) (ABOVE)

Spinnaker Flying Tanya L. Haynes
23½" × 14" (60cm × 36cm) (RIGHT)

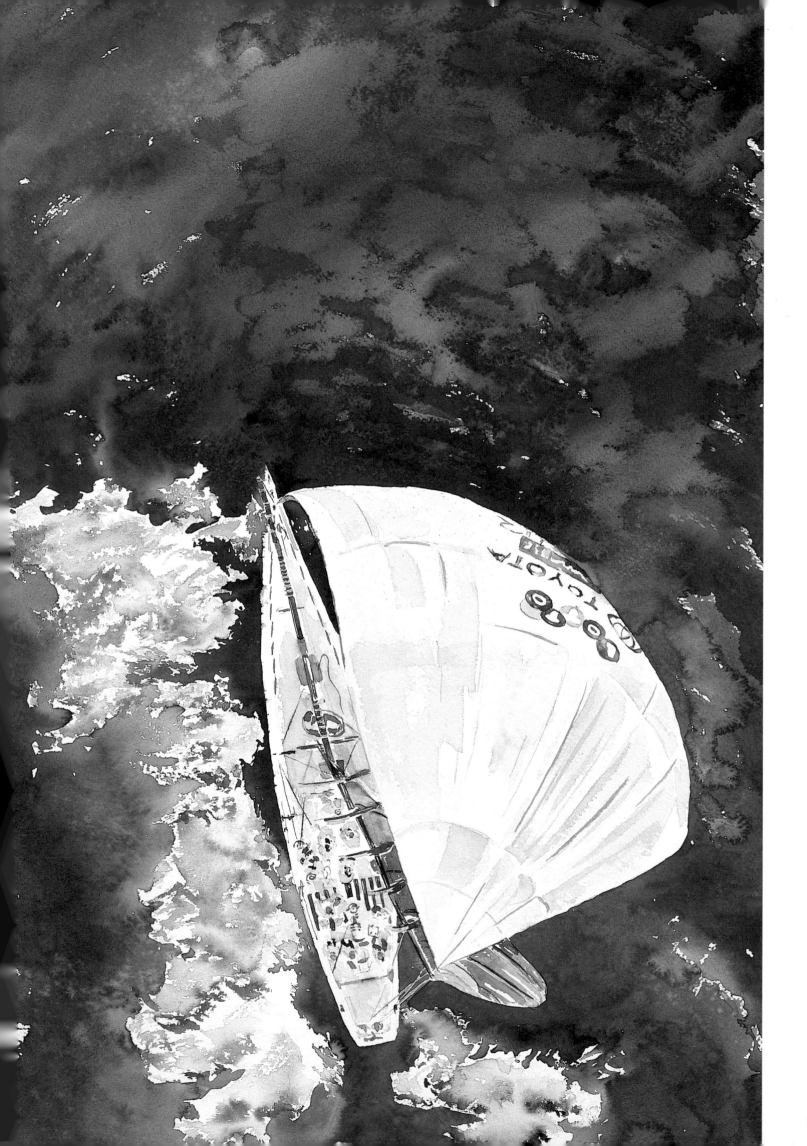

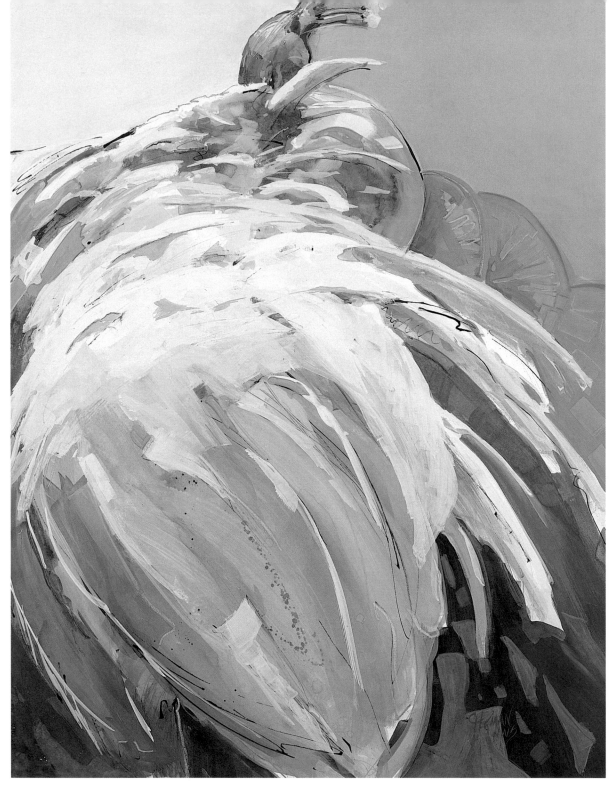

Exaggerate Your Subject.

Abstract or exaggerate your subject to create a sound composition. In *Preen*, I took the liberty of painting the peacock from below and behind, giving me a great design shape to use in the design of my painting. I chose to abstract and exaggerate the tail and the feathers to enhance the composition and make the painting more about shapes and color than about an actual bird. The better you know your subject and the deeper your connection to it, the more you can paint your feelings about it, rather than painting the actual object. I painted wet-into-wet using gouache over transparent watercolor. Gouache applied wet-into-wet gives dramatic textures, and when scumbled over the watercolor layer it gives even more texture. I later came back and added the sumi ink drawn with a stick to redefine my shapes. The stick gives an interesting line, while the ink blends and softens as I add more water or wet gouache to it. Great textural effects result while I leave edges defined but soft.

Preen Cathy Hegman
30" × 22" (76cm × 56cm)

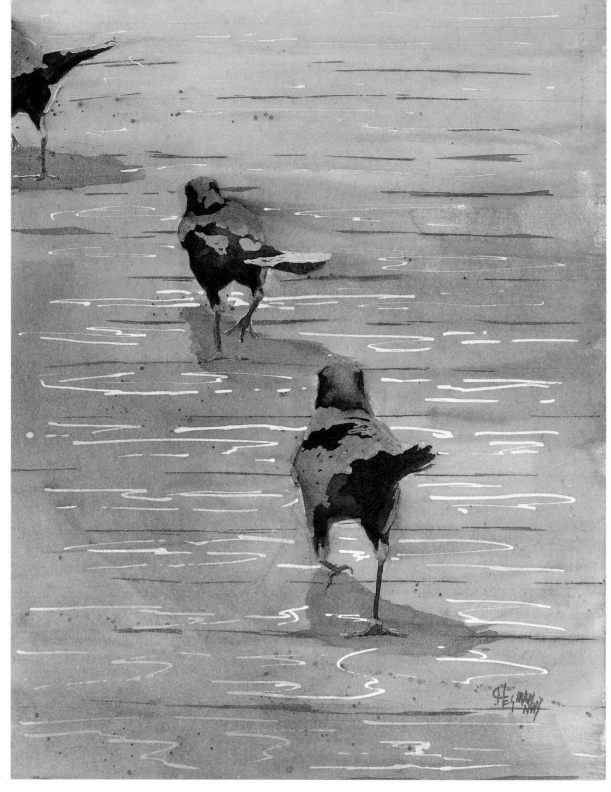

Renew a Common Subject

I am fascinated by the behavior of birds and, though this is a very common behavior for this kind of bird, I created interest in a new view. The fact that one bird is leaving the painting adds an air of mystery to their place of retreat. The painting has a simple complementary color scheme. The yellows and oranges keep the mood of the painting warm and upbeat, and even the complementary violets and blues on the birds remain warm in tone. I used this color scheme to allow the most contrast while still maintaining unity in the painting. Repetition of the birds and the wood grain also adds to the visual unity. I layered transparent watercolor on Arches 140-lb.(300gsm) paper. I used masking fluid after several layers to give the wood grain texture on the boardwalk, and then I added subsequent layers over the mask. The result is a warm and humorous painting.

Retreat Cathy Hegman
22" × 15" (56cm × 38cm)

Find Beauty by Looking Within

This series of landscape/botanicals came about as a visual response after I moved from a lush, rural area to an urban environment where concrete and buildings dominate. They are psychological self-portraits, in a way, and speak of the need to look within to find beauty wherever you are. I began each painting, a combination of wet-into-wet and dry-brush techniques, by lightly penciling the outline of the flower and rectangle on Arches 140-lb. (300gsm) cold-pressed watercolor paper. I applied masking fluid to these areas while I painted the background to save the white of the paper. I diluted each background color to 85 percent water. I misted the paper with water and poured the pigment mixture on, allowing the colors to flow and mix together. I added more color where necessary, turning and tipping the paper. When the background was completely dry, I removed the masking fluid and penciled in the details of the flower and landscape. I used a more controlled technique for the rest of the painting washing and drybrushing color.

Sunflower Irena Roman
22" × 18" (56cm × 46cm) (TOP LEFT)

Dahlia Irena Roman
22" × 18" (56cm × 46cm) (TOP RIGHT)

Bearded Iris Irena Roman
22" × 18" (56cm × 46cm) (BOTTOM LEFT)

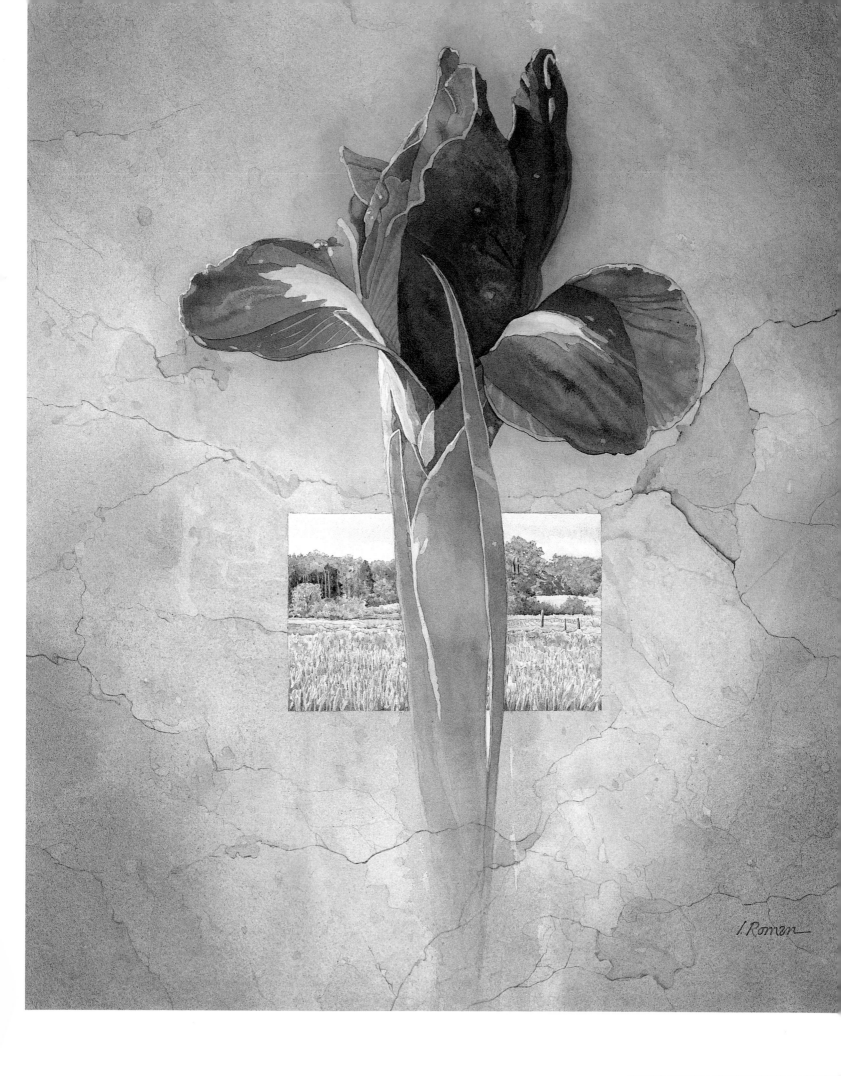

Iris Irena Roman
22" × 18" (56cm × 46cm)

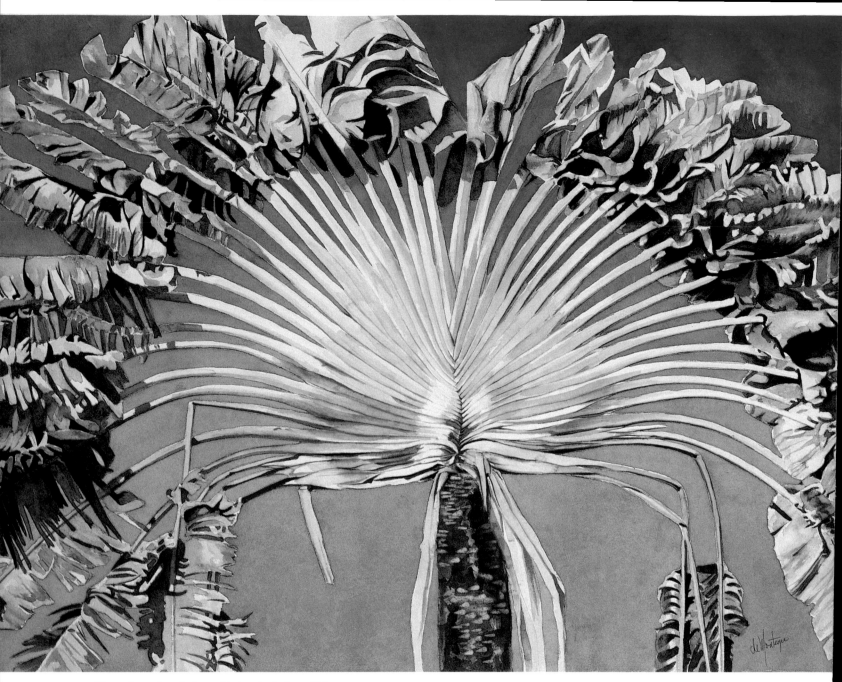

Use a Low Angle for a Majestic Point of View

While teaching art in Venezuela, I painted many of the tropical plants and trees. I selected the traveler's palm for one of my subjects because of its unique radial structure. To capture the majesty of the tree, I used several techniques. First, I placed emphasis on the tree—no other trees or clouds compete with the subject. Second, I carefully selected my point of view. The tree becomes monumental, as indeed it was, because the viewer is looking at it from a low angle. To draw the eye upward, I used a graded wash for the sky, with the most intense color at the top of the page. The spikes also lead the eye upward to the ruffled leaves against the vivid blue. To create the iridescent look in the leaves, I layered the colors from warm to cool, allowing previous layers to glimmer, as they would in the sun.

WHY DO YOU PAINT?

"Painting allows me to communicate with color. The complexity of watercolors provides infinite nuances of expression."

—Lois deMontegre

Fan Palm Lois deMontegre
22" × 30" (56cm × 76cm)

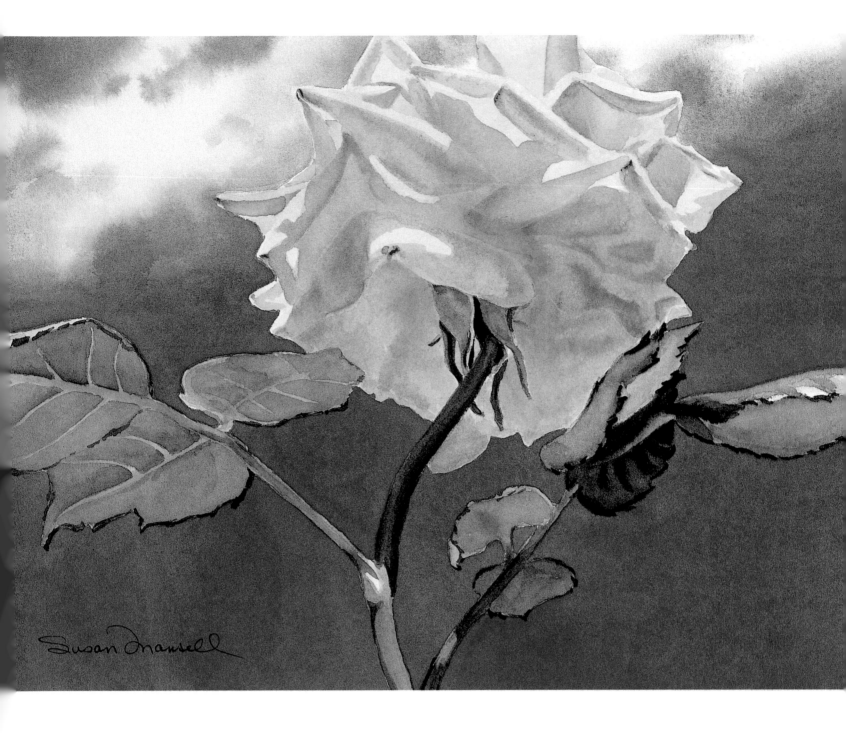

Make a Rose Unique

I could not go wrong with the brilliant yellow of this rose against the blue of a Texas sky. However, I faced the dilemma of trying to keep the yellows clear and bright and making a common subject look royal. By looking up through the leaves and petals, I captured the sunlight on the tips, thereby warming the green of the leaves and deepening the intensity of the yellow on the bottom of the rose. This view also made the rose seem strong and majestic, no an ordinary rose. After sketching the rose lightly on 140-lb. (300gsm) watercolor paper, I painted a light yellow wash over the rose, leaves and stem. I darkened the stems and the rose to medium values in greens and yellows before switching to the blue in the sky. After establishing the value of the sky, I adjusted the colors and intensity in the rest of the painting. The final step was to cool down the rose shadows without disturbing the clarity of the yellow. A light wash of purple in one continuous shape brought the whole painting together.

Yellow Rose Susan Mansell
7" × 9½" (18cm × 24cm)
Collection of Ralph and Judia Terry

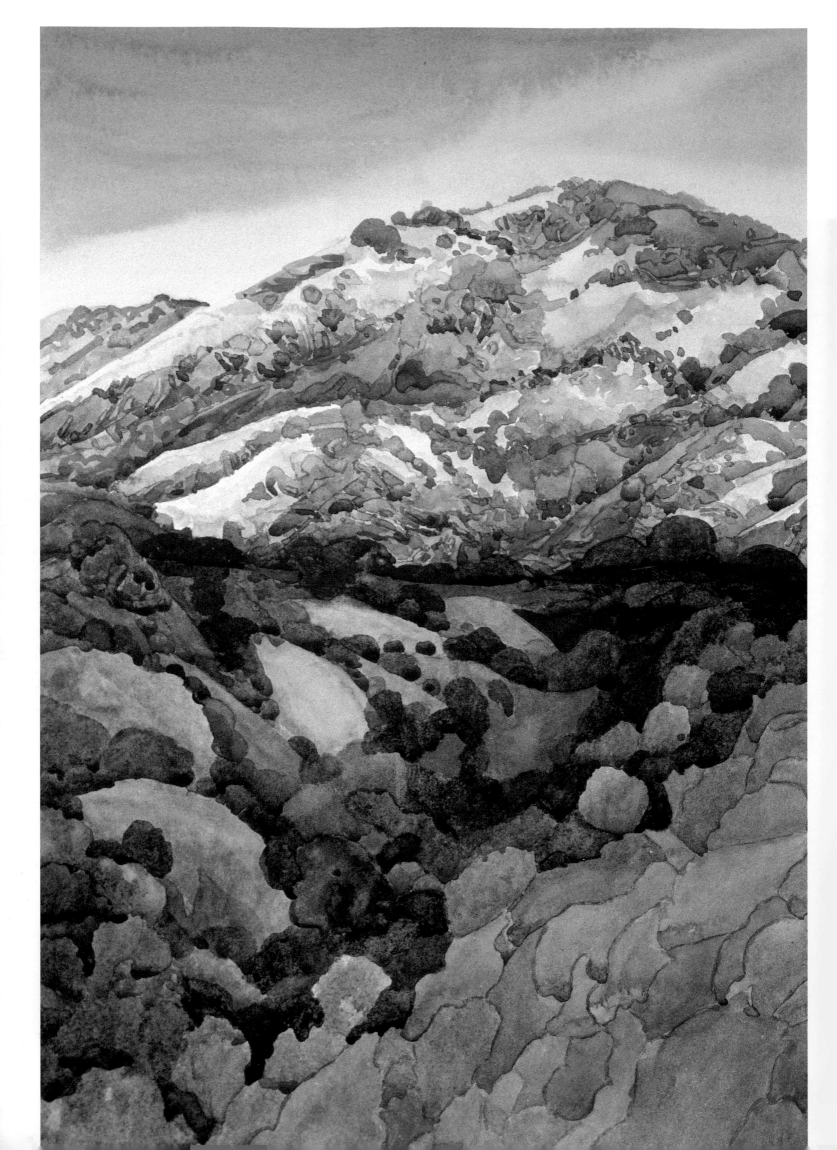

CREATING GLOWING MOOD AND ATMOSPHERE

Idyllic (Encarta World Dictionary): "Serenely beautiful and happy."

To me, landscape painting is the creature's loving attempt at capturing the beauty and power of creation. Contributing artist Mike Mazer says it well: "From its very first day, a newborn has an instinctive driven curiosity to see ever more. Such is the allure of nature that compels the eye of an artist. Over the impossibility of ever truly capturing nature's wonders, we find ourselves in a frustrating but delightful self-perpetuating cycle—needing always to try again tomorrow, never getting it quite as good as the 'original.' " But, I wanted to know, how do they get so close?

Rachel

Interpret Scenes on Location

I work on location. My process begins with a light pencil outline of the major shapes. This works as a guide, keeping me from getting lost as I begin painting dark, cool color patches down the paper. At this stage, when there is so much white, overcompensate: Use a value that appears to be a little too dark. I exaggerate colors and look for opportunities to contrast warm colors against cool, and large shapes against small. I also "charge" each shape by dropping in additional color or plain water. Charging gives the pigment life because the water flows down. Quinacridone Gold brings the nearest hills forward. I used the softer Yellow Ochre for the summit. A compact steel easel allows me to rotate my paintings easily, keeping them out of direct sunlight. Most of my paintings are on half-sheets on 300-lb. (640gsm) hot-pressed watercolor paper, painted over two or three days during short segments in morning light. A no. 10 or 12 round brush holds plenty of water and allows me to paint quickly. The vertical composition here accentuates the drama of the 3,800-foot (1,158- meter) Mount Diablo Summit.

Summit From Southgate Robin Purcell
22" x 15" (56cm x 38cm)

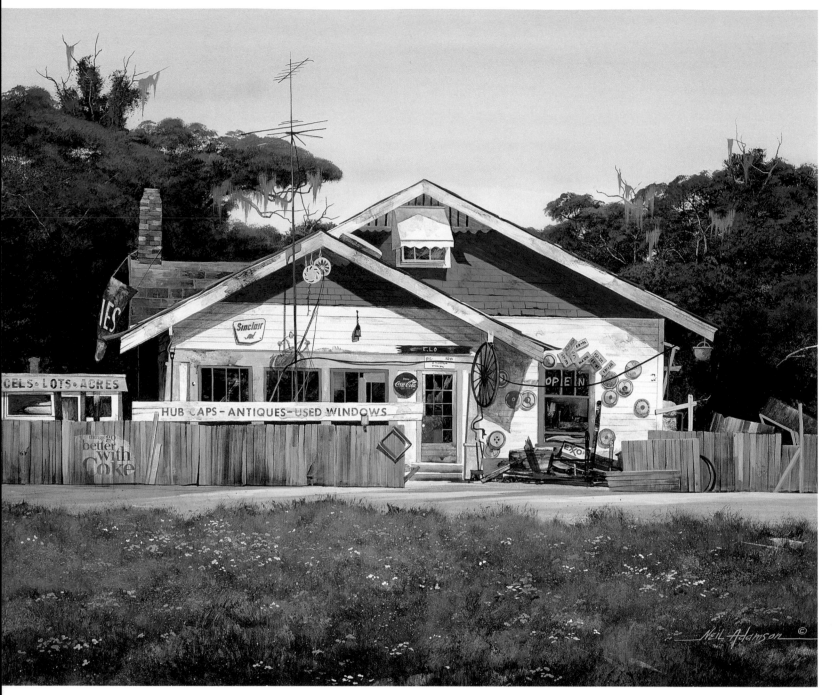

Look for Shapes in Realistic Subjects

To make realistic subjects matter in a painting, I look at the subject as a series of shapes that will translate into a good composition, a good dark and light value pattern, and a good drawing. These elements are of utmost importance. When these are satisfied, I concentrate on technique and detail.

Soaring the Canyon is a composite of many cliffs, rock walls and ledges—each made up of many colors, textures and interesting shapes and forms located on the canyon side of Yellowstone National Park. It's painted in [acrylic] with many transparent glazes of color using sponges, pieces of mat boards, razor blades for scraping, and spatter—all to achieve the look and the texture of the rocks. Colors and shapes were softened and muted in the distant cliffs. The eagle adds interest and movement.

Roadside Treasures is a local subject. This old store sold antiques, signs, hub caps, and many other eclectic items. I was attracted to the weathered building and the way it contrasted with the dark trees. The many colors and shapes of all the objects scattered about, along with the wild springtime phlox, added further interest. I toned the colors down and eliminated many objects as not to compete with the building. Both paintings were done in [acrylic] using both transparent and opaque techniques, painted on Strathmore plate surface illustration board

Roadside Treasures Neil H. Adamson
18" x 22" (46cm x 56cm)

Soaring The Canyon Neil H. Adamson
17" x 15" (43cm x 38cm)

Merge East and West

Growing up in the lush forest regions of southern Taiwan, I developed an early passion for nature. Waterfalls, streams, rivers and the ocean inspired me. I have been searching for a way to merge Eastern and Western painting. A few years ago I discovered the splash ink paintings of Chang Dai-Chien. His style fascinated me, and I decided to experiment with landscape painting that combines watercolor and Chinese ink techniques. I begin by splashing black ink and three primary watercolor pigments on three layers of rice paper. I spray with water to blend the colors, then let everything sun-dry before discarding the outer layers. I use the middle sheet for the actual painting. The shapes created by the ink and watercolors suggest foliage and rock images, which I refine by washing with watercolor, splattering and drawing with ink. I use opaque white to add waterfall details and birds and finish the clouds and mists with diluted acrylic gesso.

WHY DO YOU PAINT?

"When I am painting, I feel as if I am on a stage, performing and creating, attuned to every tree, flower and waterfall, being inspired by the many magnificent mountain trails I have hiked."

—Ming Shu Franz

Waterfall Ming Shu Franz
25" x 37" (64cm x 94cm)

Pouring Ink Technique

Kwei-lin is one of the most beautiful places in southern China. I wanted to bring out the spectacular and serene atmosphere. In experimented in this painting using a technique of pouring running ink on three layers of wet newsprint paper. First, I draw in the horizon line and wet the area where I will pour the ink. I pour black ink and tilt the paper back to form the rock shapes and then forward to form the reflection. I repeat this process with primary watercolors and then allow the painting to sun-dry, which generates a better watermark effect. I then peel away the outer sheets and finish the painting on the middle sheet. I outline the rocks and add moss, trees and background rocks.

Kwei - Lin, China Ming Shu Franz
18" x 24" (46cm x 61cm)

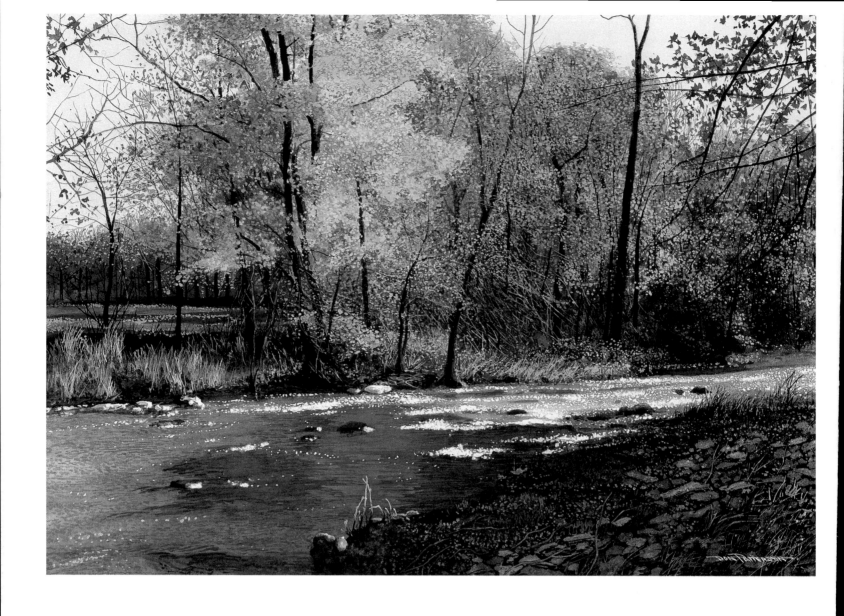

Portray Leafy Foliage

Using M. Graham & Co. watercolors, I always lay down several glazes of approximately 10 percent color over the entire surface. This establishes the "common light" in which my subject is bathed on this particular day. In this way, all of the transparent colors in my painting will be influenced by this common light. The textures created by the abundant tree leaves are of paramount importance to me. Over time, I have developed a method that uses an old style of drafting ruling pen filled with masking fluid. I begin by tapping dots and small shapes of the fluid on the lightest leaves. I then lay down a wash of the next darkest value. This procedure is repeated until the leaf areas are essentially covered with masking fluid and the last color I laid down represents the darkest value of the negative spaces. At this point, I remove all the masking fluid and brush the most intense colors over the lightest exposed areas. I then add gouache accents as needed. The masking fluid stage of my method is very tedious, but it all comes together easily and swiftly at the end.

Resplendent Autumn Donald Patterson
20" x 28" (51cm x 71cm)

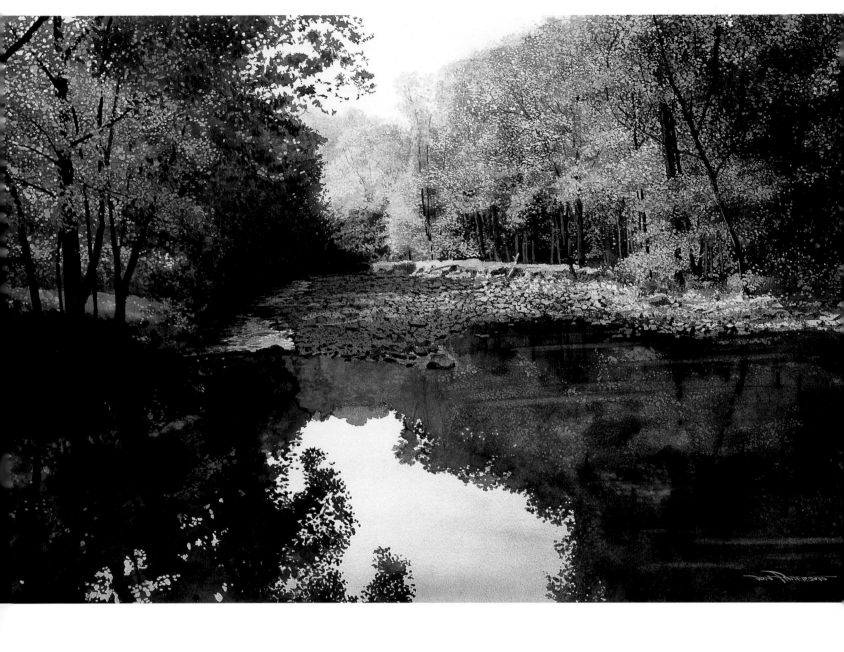

"I paint because it is what I do best and defines who I am."

—Donald Patterson

Still Water Donald Patterson
18½" x 28½" (47cm x 72cm)

Goyt Valley James Toogood
6¾" x 14" (17cm x 36cm) (TOP)

Meadows Near Buxton James Toogood
6¾" x 14" (17cm x 36cm) (BOTTOM)

Use Light Thoughtfully

Sensitive use of light can transform an ordinary scene into a beautiful watercolor. I bathed the Bermudian landscape, *High Point*, in the clearly attractive golden light of the setting sun. I depicted the light depicted in the other two paintings quite differently. Sadly many artists think the light on overcast days is dull, gray and uninteresting. Instead, think of this light as silver. It is typical to many landscapes of the United Kingdom: The moist air softens the light, and though not bright or golden, it is sufficient to see for miles. The delicate qualities of light on days like these are fascinating and exquisite. In spite of the dramatically different light in these paintings, I underpainted all of them with the same color, Quinacridone Gold. In *High Point*, I underpainted the entire painting to give it that warm glow. In the others, I underpainted the foreground with two light washes and the middle ground with one light wash. Because warm colors come forward, these initial washes warmed the subsequent colors and enabled me to clearly define the foreground, middle ground and background, giving the paintings their dramatic sense of depth.

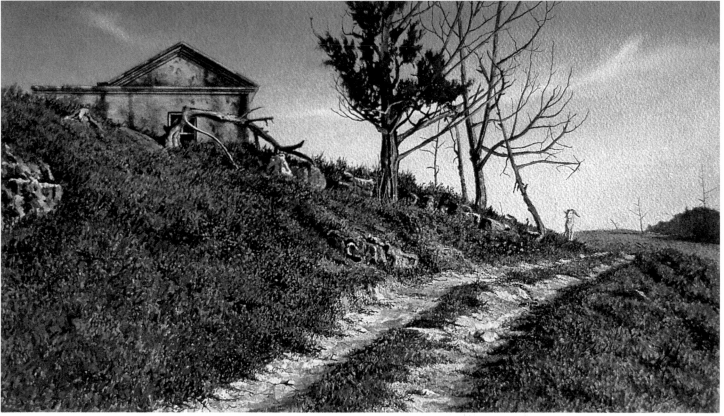

High Point James Toogood
10" x 14" (25cm x 36cm)

Drive-By Paint

I painted these landscapes from the car as we drove down the highway. I had to paint fast and very wet. Using a no. 12 Kolinsky brush on a Canson cold-pressed watercolor block, I tried to catch the shapes and colors of the unfolding scene. I tied the finished watercolor together with a pencil drawing, often dragging the pencil point through the wet paint, which resulted in an etched effect. Many of my drive-bys have served as work studies for a larger acrylic paintings on canvas.

Go West Ann Kromer
5" x 8" (13cm x 20cm) (TOP)

The Harvest Ann Kromer
5" x 8" (13cm x 20cm) (BOTTOM)

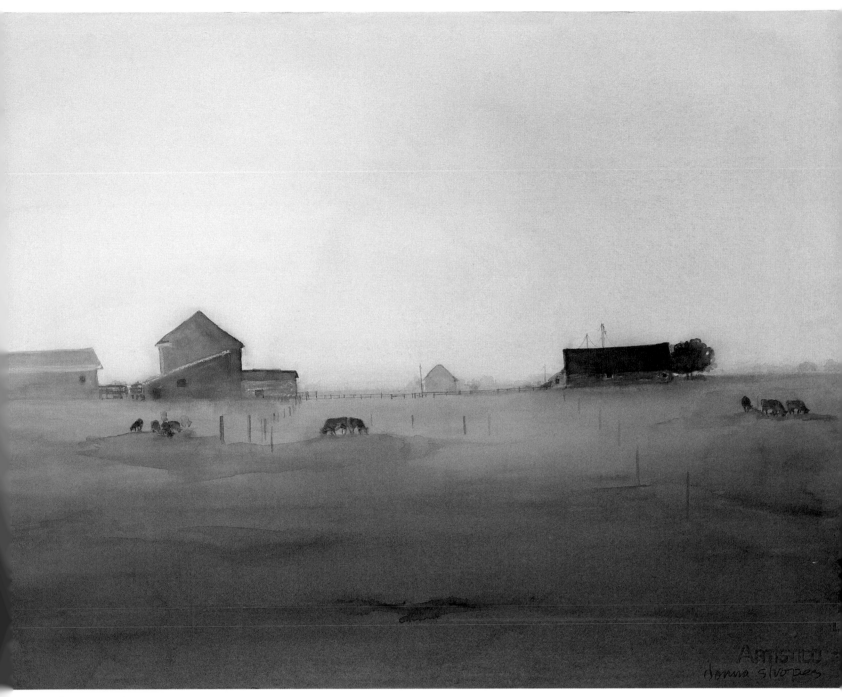

Overdo It Sometimes

I paint landscapes on Fabriano 300-lb (640gsm) paper because of its smooth surface and how well it takes the many glazes I use. I wet the entire paper, pour the paint, pick up the paper and roll the wet paint around to disperse the color. I blot extra water around the edges and always let each glaze dry completely. The first few glazes set the tonal base for the painting. In *Ferndale Gold*, I wanted to keep the sky very transparent and glowing; the sun was setting and ocean mist was in the atmosphere. After painting the foreground with a 2-inch (51mm) brush, I used many variations of Juane Brilliant, Naples Yellow, Hansa Yellow, Quinacridone Coral and Quinacridone Gold in light washes to build up the overall glow. To keep the left side lighter, I then pre-wet the entire paper, poured paint to the right, and let it flow down over the buildings and foreground, softening and diffusing them. Then I used light glazes of Juane Brilliant below the structures to show reflected light from the sun and dew on the ground.

Ferndale Gold Donna Stropes
23" x 30" (58cm x 76cm)

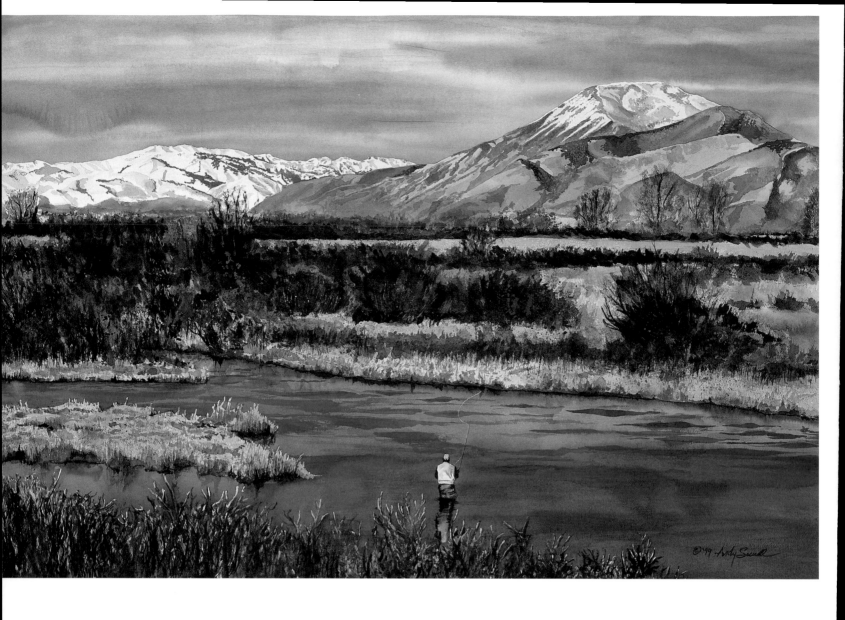

Capture the Mood of the Season

In *Late Season Silvercreek*, I wanted to capture the crisp freshness of the color, beauty and majesty of the early winter months. As I approached this painting, I purposely over saturated some of the shrubs, grass and water with color to emphasize the clarity of the air. One of the things that I felt turned out very successfully was actually kind of an accident. Finishing up this painting one afternoon, I realized I needed to get it to my photographer before 5 p.m. that day, so I was under pressure. As I painted the red and brownish shrubbery in the middle of the painting, I did not have time to get meticulous. I started to get loose and abstract, applying the paint almost carelessly with a big brush. It brought a loose freshness to the painting. I have since begun to paint more and more loosely and I like the results.

Late Season Silvercreek Andy Sewell
30" x 40" (76cm x 102cm)

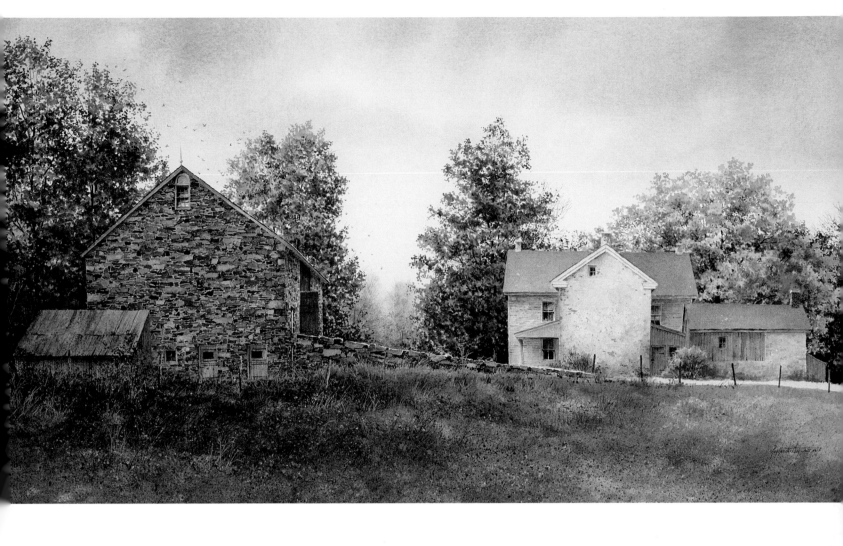

Use Unconventional Tools for Classic Results

Much of my work begins traditionally with soft color and value blending using loose, wet-into-wet washes and soft sable brushes. This establishes my composition and provides a base for a variety of not-so-traditional watercolor techniques. After my initial washes are completely dry, I switch to hog bristled oil painting brushes almost exclusively. The bristle fan brush is my favorite. This brush can produce so many different textures depending on how you hold it and how you touch the paper with the bristles. In *Autumn Roost*, I made ragged-edged clouds using the flat of the brush and a scrubbing motion, taking advantage of the splaying bristles. I accomplished many of the leaf formations by holding the brush upright and applying paint in a jabbing motion. I painted the foreground textures using the flat of the brush and an up-and-down patting motion. Watercolor painting needs not be restricted by using only watercolor brushes. Experiment with unconventional tools, open up new possibilities and make your watercolors unique.

WHY DO YOU PAINT?

"I paint because it makes me happy. The discipline and challenge keep my mind engaged."

—Robin Purcell

Autumn Roost Ray Hendershot
22" x 40" (56cm x 102cm)

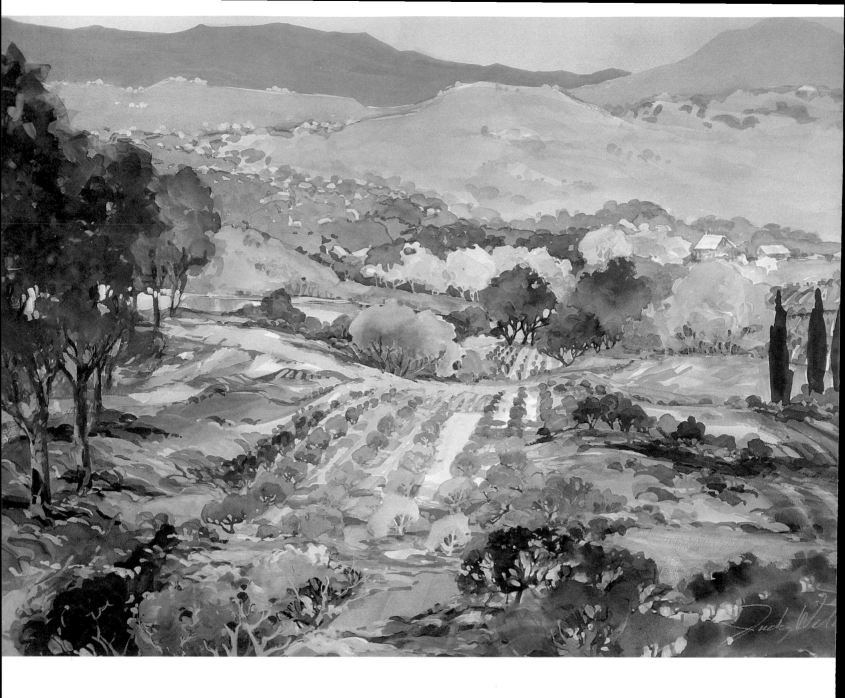

Don't Rely on Your Imagination

The reality involved in plein air painting provides more ideas and images than I could ever summon from my imagination. But still, I push the reality I see by exaggerating color and placing complements next to each other. First, I sketch elements on scratch paper to figure out what is important to focus on. Then, I sketch directly onto watercolor paper using a small brush and a diluted solution of Cobalt Blue. If the sketch becomes obvious, I can lift this blue easily. Then, I use transparent watercolor, starting with the large shapes. I build my composition by breaking down those shapes while increasing the intensity of pigment. I recently experimented with a Daler-Rowney product called Pro White. You can use it to paint over areas that are dull or too dark, let it dry, then overlay it with color. You must use the opaque white sparingly, or the painting will lose its luminosity. Seldom do I finish a plein air painting finished on-site. A feeling of dissatisfaction tells me that I must work on the composition in my studio.

Hot Flashes on Cool Contours Judy Welsh
22" x 30" (56cm x 76cm)

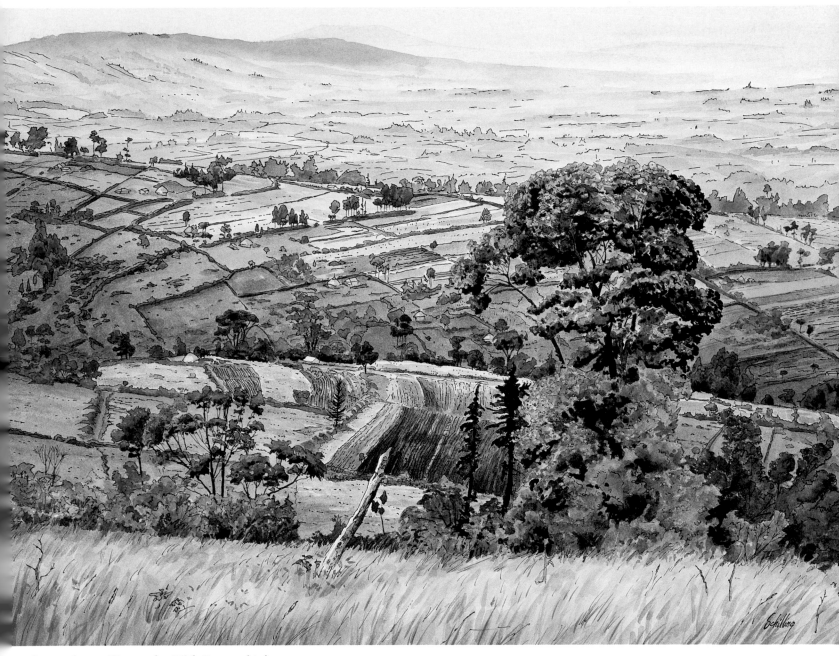

Strengthen a Watercolor With Pen and Ink

Use this technique when you want to separate subtle changes in color or value. I also like to use it for works that require a great deal of definition, such as paintings containing interesting architectural detail. I used only a linear drawing done with waterproof ink to strengthen the watercolor washes that are to come in this painting. I was working as a volunteer at Tenwek Hospital in the remote highlands of Kenya. One Sunday afternoon, I climbed to the top of Matigo, the highest hilltop in the region, with my sketchbook to survey the countryside. A sketchbook is my constant companion on such outings. I made several watercolor sketches, but the problem was how to separate the many nuances of green in this verdant landscape. After I returned home, I took a full sheet of cold-pressed watercolor paper and sketched the landscape in ink with a Pilot VBall pen. I outlined the numerous four-acre plots that the African people farm, then laid in washes of different shades of green. I enjoyed finishing the picture by defining the patchwork acres and the trees in the foreground.

WHY DO YOU PAINT?

"A painting is a note in a bottle dropped into the sea of time, a way to share with others some of the wonderful things we've noticed and loved in our lifetimes."

—Jerry McGrew

Green Hills of Africa Richard Schilling
18" x 25½" (46cm x 65cm)

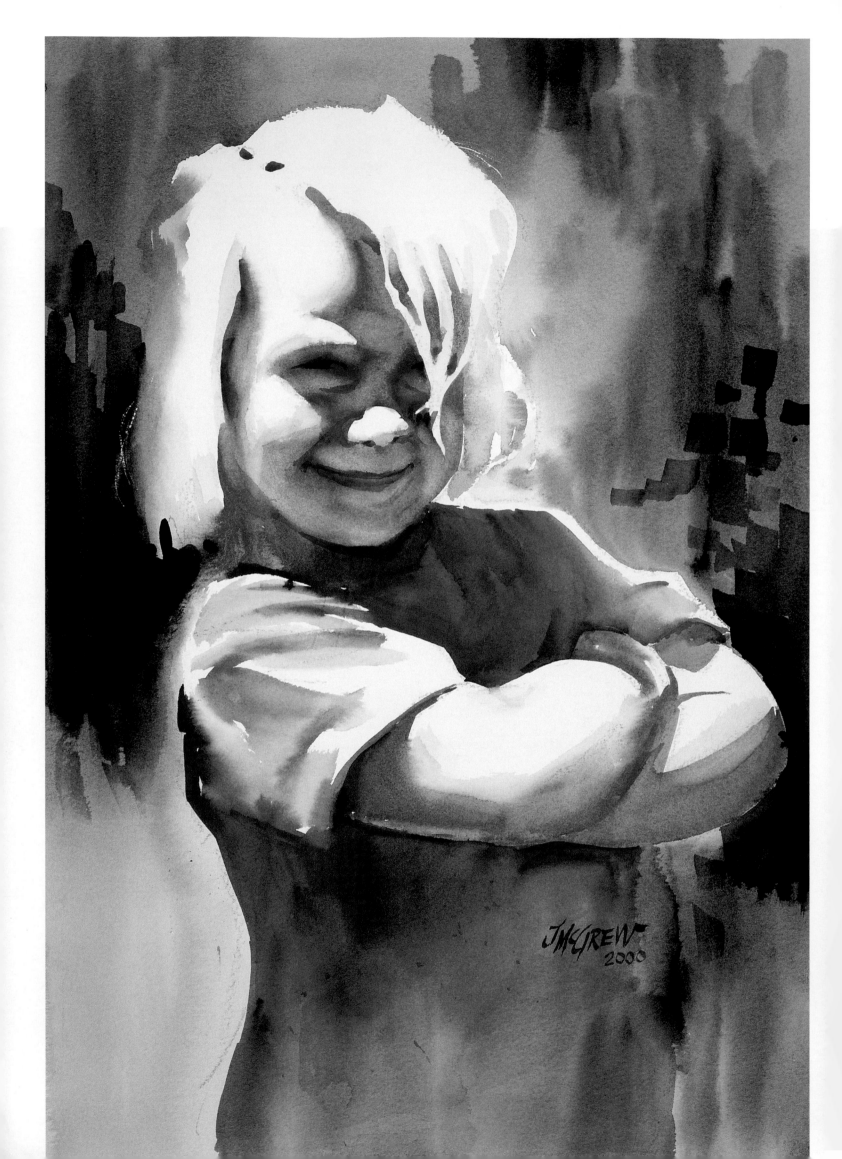

I once edited a book called *The Best of Portrait Painting.*

In judging the art for that book, one of my criteria was that the paintings be not just a technical rendering of a person, no matter how good, but that they have a living, breathing quality to the portrait. The same goes for pet portraits and animal painting in general. The artists in this chapter have met my standards. I wanted to know what, for them, goes into capturing a soul on paper, whether human or canine.

Rachel

Don't Make Children Smile Perpetually

This young lady was independent and determined from birth. Her body language, shown here when she was five, tells a lot about her personality and contributes much to her accurate likeness. On a half-sheet of 140-lb. (300gsm) paper, I drew a careful pencil sketch, including lines around the shadow areas, then soaked the paper in cold water in the bathtub for 20 seconds. I placed the wet paper on a Plexiglas sheet and blotted it back to damp with a bath towel. I applied a beginning indication of the background color, then tipped the painting 45 degrees. I added the main shapes, then wet a 1-inch (25mm) sponge brush to soften and lose the edges. Once dry, I chiseled out the features to develop a good likeness. When completely dry, I soaked the paper for 20 seconds again in cold water, put it back on the Plexiglas support, and patted it back to damp again. I severely tilted the Plexiglas and paper and watched for flowing shapes. I added strokes where needed. When all the soft shapes satisfied me, I laid the painting flat to dry.

The Attitude Jerry McGrew
19" × 14" (48cm × 36cm)
Collection of Mr. and Mrs. Russell Morgan

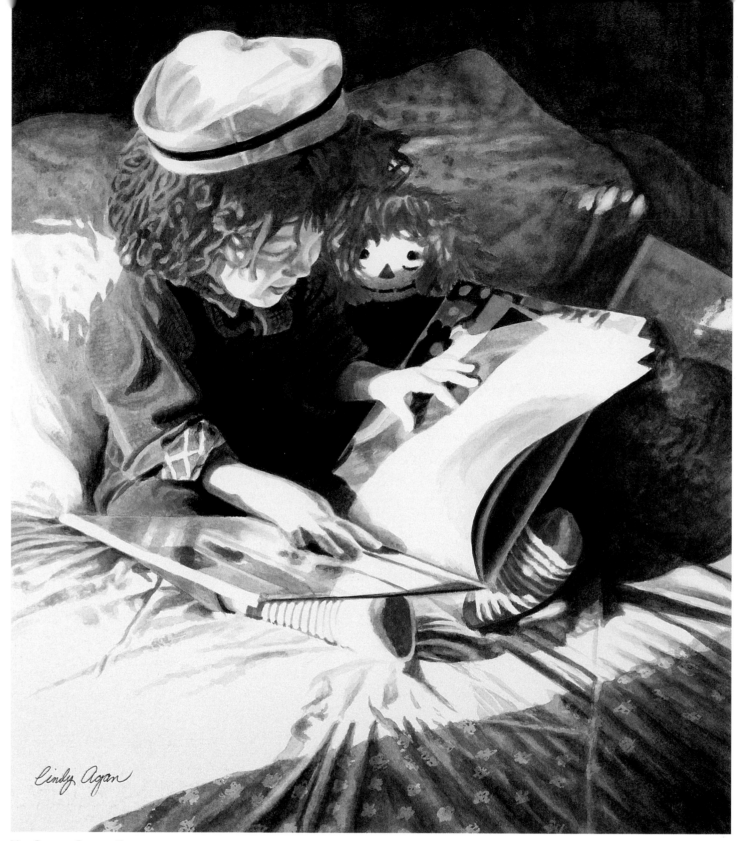

Use Proper Proportion

When painting children, create a composition that is proportionately correct as well as charming, to draw the viewer in for a closer look. Just the late-day sun lights this room as the child reads to his "friend." As luck would have it, a tiny rainbow reflected warmth onto the pillow. I wanted this painting to have a cozy, intimate feeling, as if the viewers were eavesdropping on this sweet, quiet moment. Because my subjects have a tendency to *walk off*, I prefer to work from photographs. I begin with a detailed drawing and apply several light glazes of color, letting everything dry completely between glazes. I used a graded wash and damp cotton swabs to soften the edges of the fabric folds.

WHY DO YOU PAINT?

"Painting provides me tremendous joy, challenges to overcome, and throughout my life has satisfied a deep desire in me to be creative and capture the beauty in life."

—Cindy Agan

A Quiet Moment Cindy Agan
16¾" × 14¼" (43cm × 36cm)

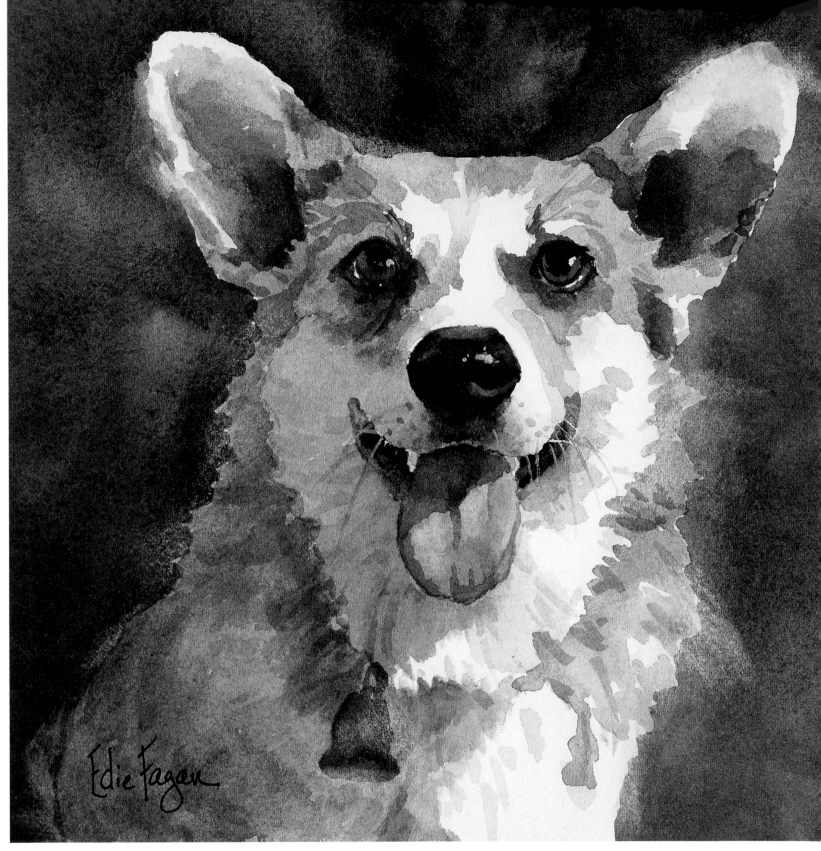

Set Up Your Photograph Well

No matter what my subject, even if it's a friend's dog, I keep in mind the basic elements that make an engaging painting. First is good composition. I look for varied negative spaces and linked lights and darks so the viewer's eye will travel through and around the subject. To capture Ben's likeness and friendly attitude, I started with an outstanding photograph, situating him in the sun (never use a flash) and on my level. I cropped the photo aggressively and made an accurate drawing. Then I painted with a limited palette, carefully but loosely. I preserved most of the whites by painting around them but added a touch of gouache for the highlights on the eyes, nose and a few whiskers. Once dry, I gently scrubbed some edges here and there with a small, damp toothbrush to make Ben look furry and ready to play fetch!

Ben Edie Fagan
7" × 7" (18cm × 18cm)

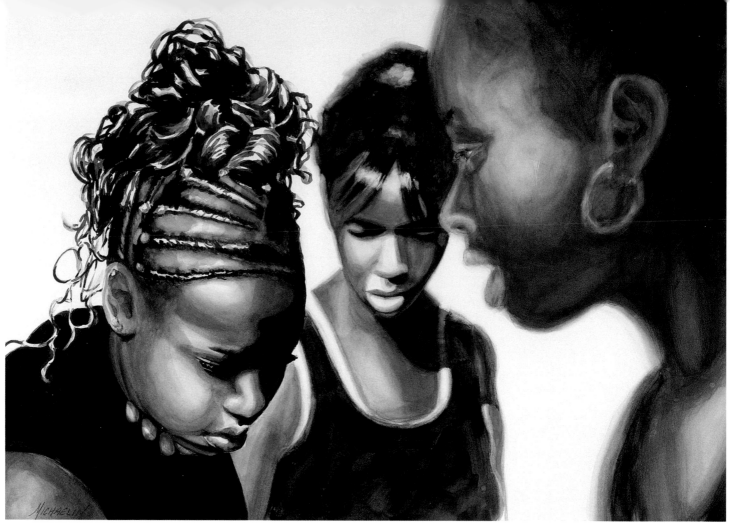

Let Human Subjects Tell a Story

Nothing is more exciting than watching wet watercolor swirl and dance around on a hot-pressed surface. Strathmore 500 Series Bristol Heavyweight Vellum Watercolor Board enables me to achieve rich, vibrant color that doesn't fade when it dries. It also is easy to lift, so I can soften edges after the paint is dry using a soft damp brush. Figures and faces are my favorite subject. I try to get the viewer's attention with large light and dark shapes then use the figures to tell a story. In *Sisters*, averting the subjects' gazes downward makes the viewer wonder what they are looking at. The proximity of the figures evokes a feeling of camaraderie between the girls. I used Burnt Sienna and Carmine for the basic skin tone; I mixed Burnt Sienna and Ultramarine Deep for the darks. Then I added opaque turquoise last for a cool accent.

WHY DO YOU PAINT?

"Painting is my passion, but, actually, I paint because I have to. I could not survive without it. It is a better escape than going to Disneyland, and much cheaper than therapy. Capturing a bit of someone's soul on paper is an indescribable thrill."

—Michaelin Otis

Use People as Integral Pieces of the Composition

Old Maxwell is a street west of Chicago's Loop where merchants sell their goods and services. My impression of this area was striking; I used light and subject matter to evoke this emotion. Note that the brilliant midafternoon sun obliterates a main principle of color: warm highlights and cool shadows. I immediately knew that the white of the paper would represent the planes that are perpendicular to the light source. The degree to which I added other objects was determined by compositional importance, local value, character of light and the reflective quality of the object. I began by sculpting in the figures' highlight halftones with direct linear brushstrokes. To capture the standing figure's movement, I used the fullest extension of his gestural actions. I expressed the inviting nudge of the seated foreground figure by using brushwork following the contour of his shoulder, softly disturbing the pigment behind him. I conveyed the compositional eye movement through the strong diagonal line formed by the cast shadow of the shelters eave through the seated figure's leg, over the steps, and down to the standing figures' shoe.

Sisters Michaelin Otis
20" × 30" (51cm × 76cm) (ABOVE)
Collection of the artist

Old Maxwell John Howard
28½" × 21½" (72cm × 55cm) (RIGHT)
Collection of Bob Paetow

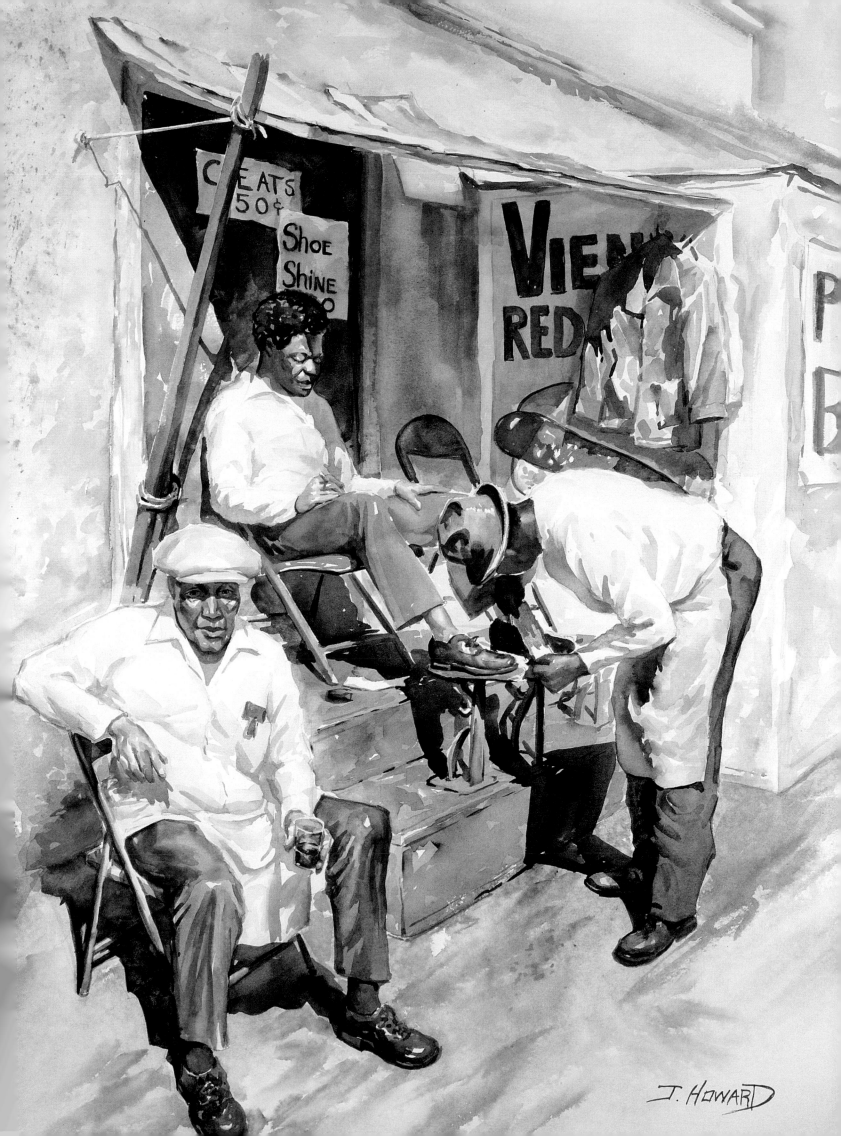

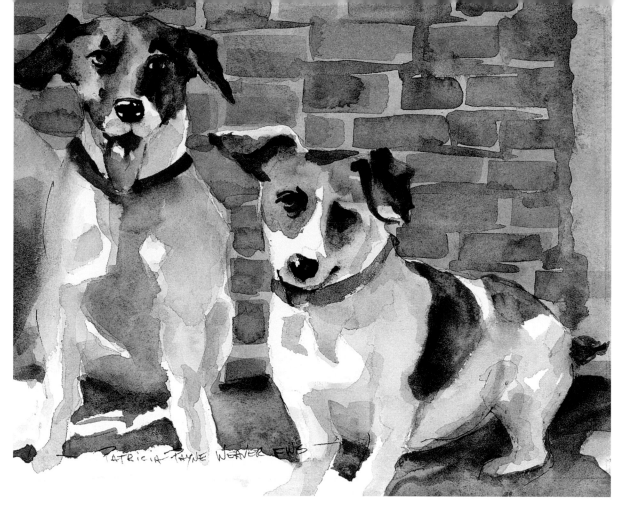

Follow Five Keys

Painting animals is a joyful experience, especially in watercolor. Capturing the personality and likeness of the animal is extremely important. My five keys to bringing animals to life: good drawing, color temperature, limited palette, value hierarchy and center of interest. Though my style is loose, I start with a pencil drawing. Good drawing is vital to good painting; don't skip over this crucial element, even if you paint loosely. Once you choose your subject and format, decide on a temperature and palette for each painting. For *Two Jacks*, I chose a warm palette with cool accents. I always limit my palette to no more than five tube colors in any one painting. Here, I used three warm colors and one cool color. Notice three distinct values in unequal proportion in the painting. I refer to these as Papa Bear, Mama Bear and Baby Bear. The biggest percentage is mid-value, the next is white paper, and the smallest is darks. The Jack Russell terrier on the right is the center of interest. I have placed his face near but not quite at the center of the painting.

WHY DO YOU PAINT?

"As I have pondered this question, my conclusion is that I inherited the gift to see beauty in this world, possessed the desire to commit many years to the study of watercolor and found that the life of an artist affords me the privilege of making my avocation my vocation."

—Geraldine McKeown

Look for Gestures That Reflect Animals' Personalities

Growing up on a farm, I have always been drawn to farm animals. To best convey the attitudes of these simple creatures, observe them closely to understand their specific nature and temperament. Roosters, in particular, seem to have been hatched with an attitude! They are curious, pompous and somewhat aloof compared to the quieter, gentler hens. Dominiques have the distinction of being America's first chickens and are an endangered breed. To convey this significance, I placed the regal rooster in an authoritative stance over the timid hen. Strong composition enhances this expression. The diagonals in the shadows, fence rails and siding on the coop take your eye to the center of interest—the chickens—which is accentuated by the contrast of lights and darks and the bright red combs.

Two Jacks Pat Weaver
8½" × 9½" (22cm × 24cm) (ABOVE)
Collection of the artist

Dominiques—A Rare Pair
Geraldine McKeown
24¾" × 17¾" (63cm × 45cm) (RIGHT)

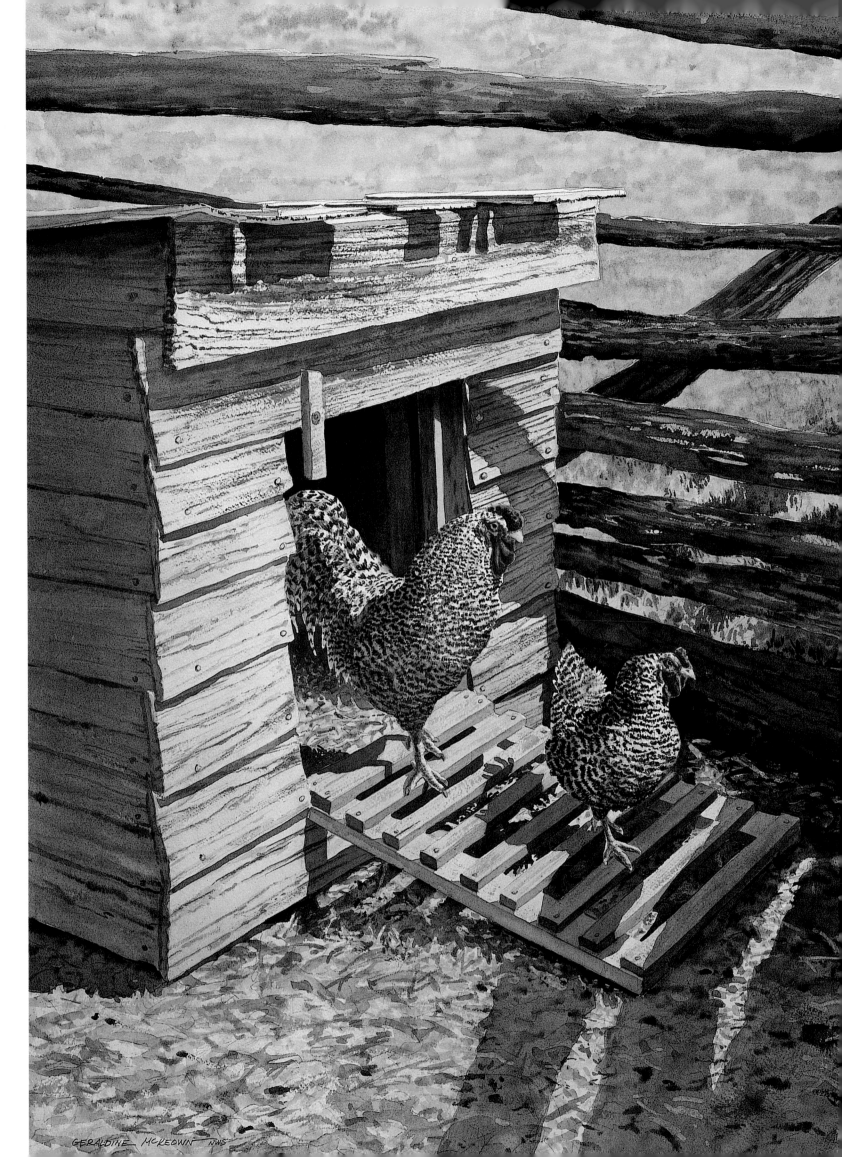

GERALDINE McKEOWN NWS

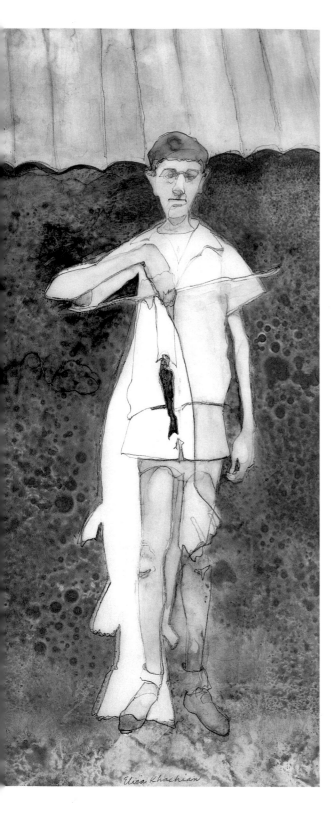

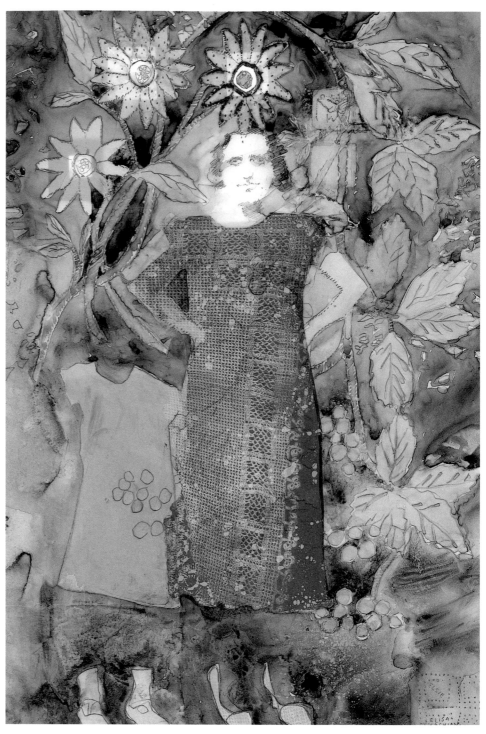

Paint Family History

I carefully select and edit photos to tell a story, always with a happy ending. Mylar, a semitransparent paper, is a wonderful drawing surface. I use many layers and draw and paint on both sides. The many surfaces become a multilayered story, a weaving together of history with the mood of an old photo album. I use a personal color code and symbolism and paint only people I know or care about. I do not trace the photos, but draw randomly from them as if they were live models.

In *Mother*, I printed the lace collar onto acetate, shaped it to her dress and then glued to the reverse side. I set white squares of paper for her face and flowers over her head and glued on the second layer of paper. The numbers and placements of these details are significant to the story. In *Big Fish Story*, I give the little boy (my husband) a happier ending with a bigger catch. I cut a stencil for the central figure, painted dark around it, rolled it with a foam brayer to give a bubbly texture. This dark shape helped to focus on the little fish. For *Friends*, drawing and simplification were important. I used color for the living—blue for special people— and darks for the deceased. This personal, flexible color code helps me make many artistic decisions.

Big Fish Story Elisa Khachian
16½" × 9¼" (42cm × 24cm) (LEFT)

Mother Elisa Khachian
15½" × 10½" (39cm × 27cm) (RIGHT)

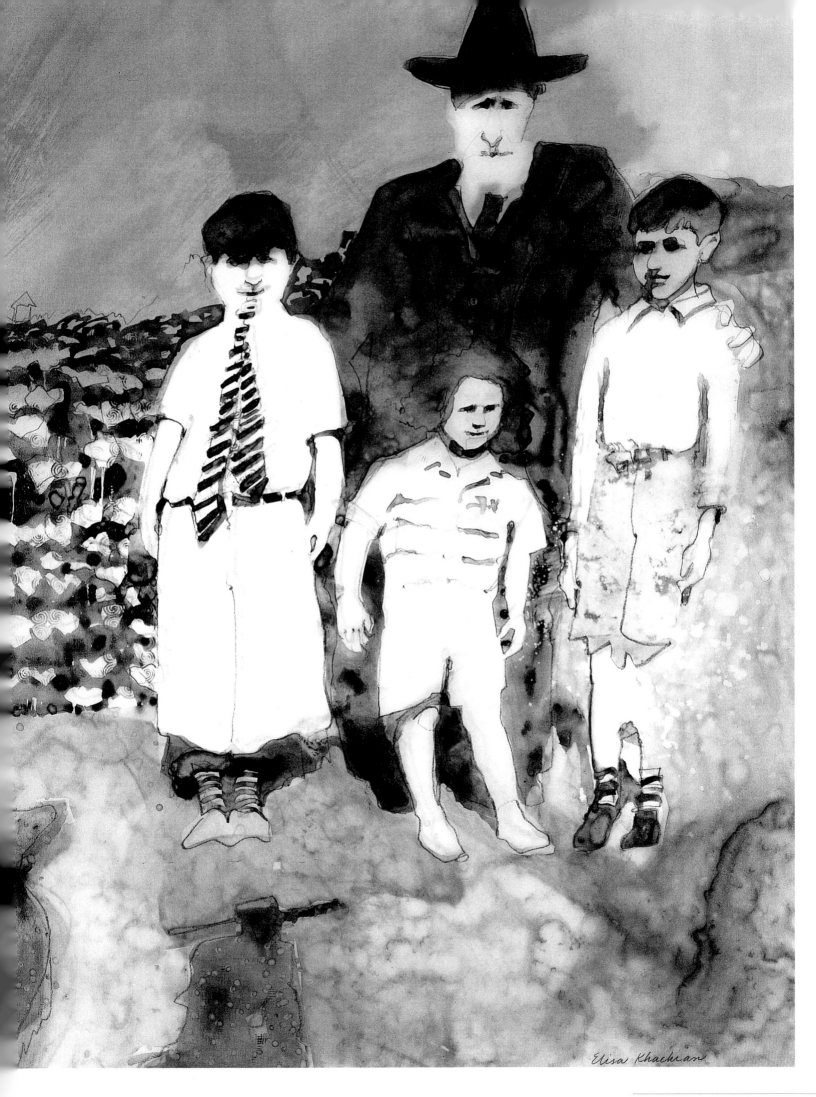

Friends Elisa Khachian
17" × 13" (43cm × 33cm)

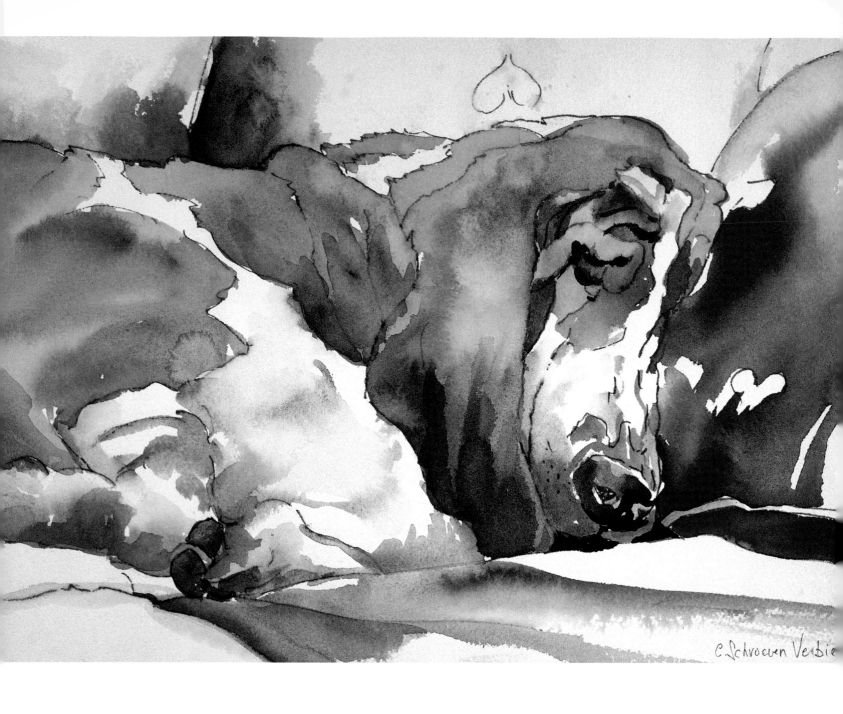

Cherish Unexpected Circumstances

Inclement weather during a painting trip drove me to look for inspiration inside the hotel. Oscar, one of the five dogs who had the run of the place, was taking a nap on the lobby's red couch. I decided to capture his unwittingly droll and nonchalant personality in a quick, expressive drawing using an ink marker on watercolor paper. Without waiting for the ink to fully dry, I applied a few bold washes of primary colors, leaving a lot of the white paper exposed. When I was done, I noticed that the painting, besides being fresh and whimsical, had a somewhat cubist look, as all of its parts were treated with the same fluid brushstrokes, colors and value gradations. This integration fragments the image so that from a distance there is little visual distinction between the dog and his environment. It is only upon closer study of the image, in trying to make sense of the back-and-forth movement between lights and darks, that Oscar's face emerges from the jumble of positive and negative shapes.

WHY DO YOU PAINT?
"I paint because I must."

—*Claire Schroeven Verbiest*

Oscar, Napping Claire Schroeven Verbiest
9¼" × 13¼" (24cm × 34cm)
Collection of Constance Jordan

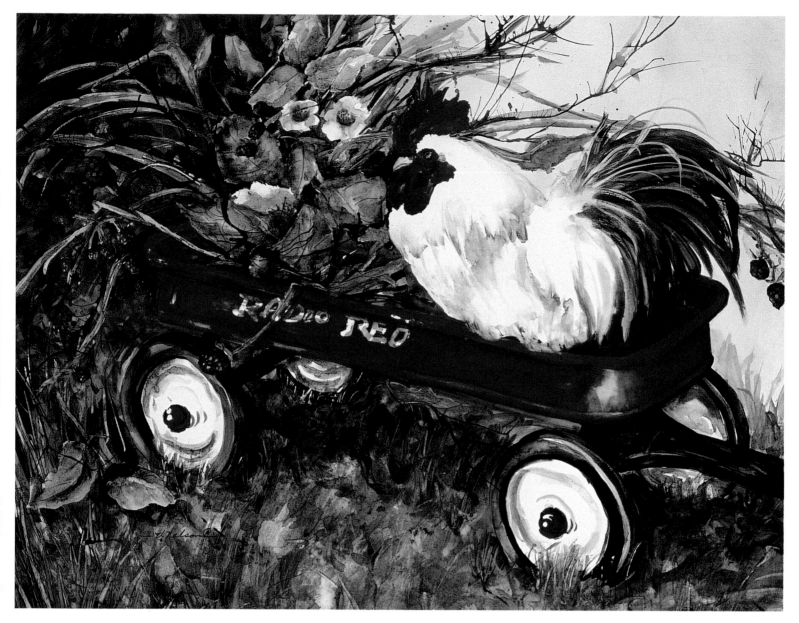

Take Lots of Pictures

This approach provides me a big selection of photos to use as resources. The wagon in *Radio Red* was nestled among an overgrowth of blackberry vines, and Red, the rooster, had chosen the wagon for his roost. It was a painting waiting to happen. Seldom does this occur. I usually combine photos to get my inspiration and just-right combinations. Roosters are proud and strong, so bold primary colors seem to fit this theme, especially the dominant red. I paint mostly with transparent watercolor and never use white or black. I mixed the blacks you see from French Ultramarine and Burnt Sienna, or Winsor Green and Alizarin Crimson. I masked the tail feathers, then softened them after I removed the masking fluid. Red's body and the wheels use the white of the paper. I created the dark twigs by blowing through a straw; I put the "black" mixture directly on the paper, pointed the straw in the direction I wanted the twig to go, then blew.

Radio Red Vickie Nelson
18" × 22" (46cm × 56m)
Collection of Virginia Kostner

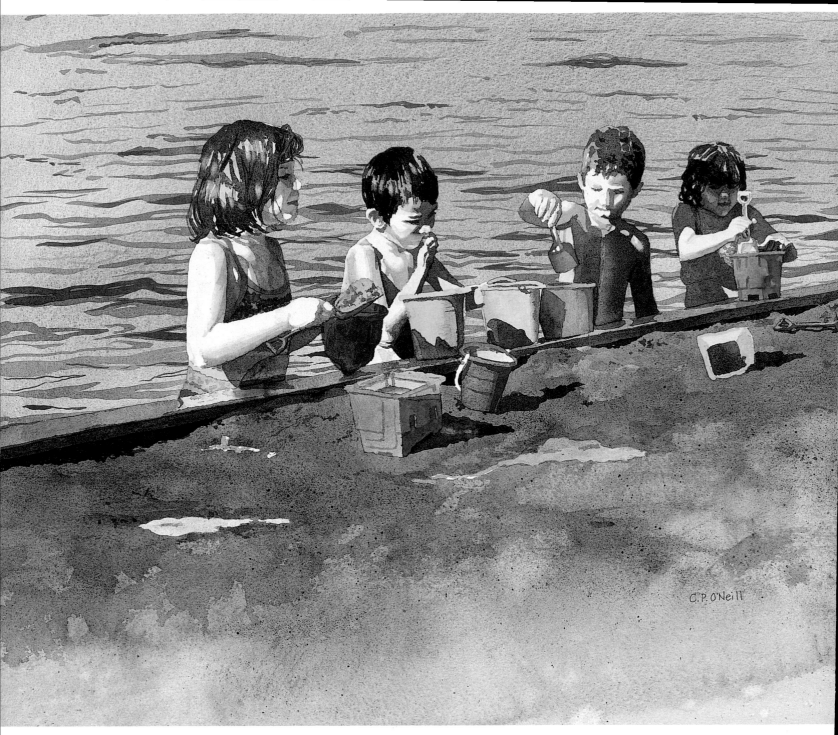

Collect Subject Matter Everyday

Sand Soup arose while watching my daughter and her cousins play on the shore of our favorite Adirondack lake. The bright sunshine, colorful swimsuits, shovels and pails combined with the children's intense expressions and industrious movements to appeal to me. They were in fact preparing sand soup for their adult customers on the beach. My four children and extended family have provided endless material and inspiration for my painting. Taking lots of photographs enables me to capture these fleeting moments.

WHY DO YOU PAINT?
"Through painting, I can tell stories without using words."
—Cathy P. O'Neill

Sand Soup Catherine P. O'Neill
15" × 20¼" (38cm × 51cm)

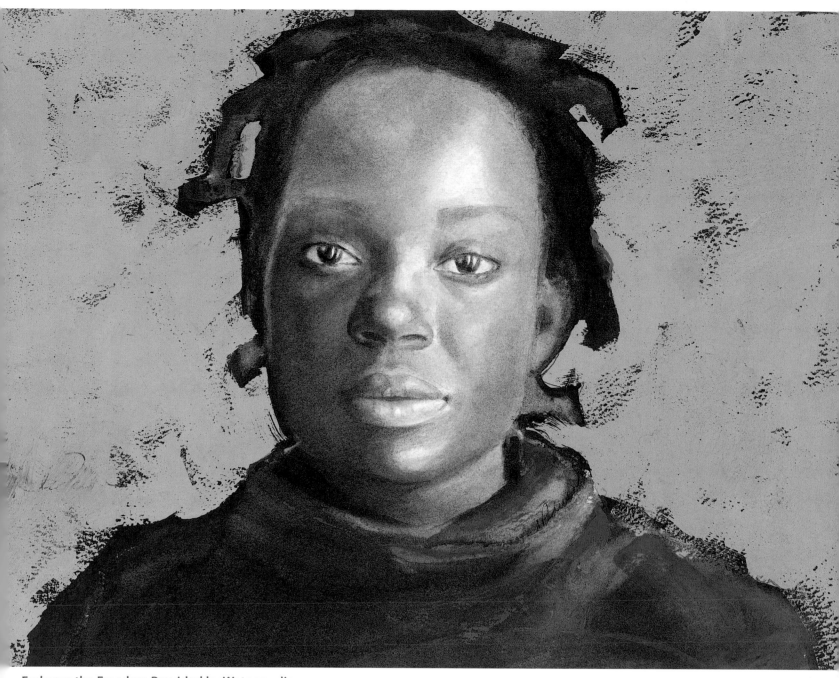

Embrace the Freedom Provided by Watermedia

I like to take risks and try new combinations of watermedia, always thinking of new ways to push mediums and concepts. I don't like to paint portrait commissions, but I love to paint people I know. I am drawn to people who have a spirit about them that is interesting or intriguing. Susan is part of a Ugandan family I have befriended. Despite the severe difficulties they lived through in Uganda, they have retained a noticeable gentleness. I worked from the live model to do the drawing, and I added color later. I began *Transfixed* by layering transparent watercolors onto wet paper. I work all over the paper, back and forth from subject to background. When I felt that I had pushed the transparents as far as they could go, I introduced gouache. When you incorporate more than one medium, balance is required. Consider balance of color, value, surface finish (flat or shiny) and surface moisture (wet, damp or dry).

WHY DO YOU PAINT?

"Painting is something I need to do; there is an internal pull or longing that leads me to the paint and paper. When I don't paint, my spirit is negatively affected. But, if it were easy, there would be no reason to continue painting."

—Jean Pederson

Transfixed Jean Pederson
11¼" × 15" (29cm × 38cm)

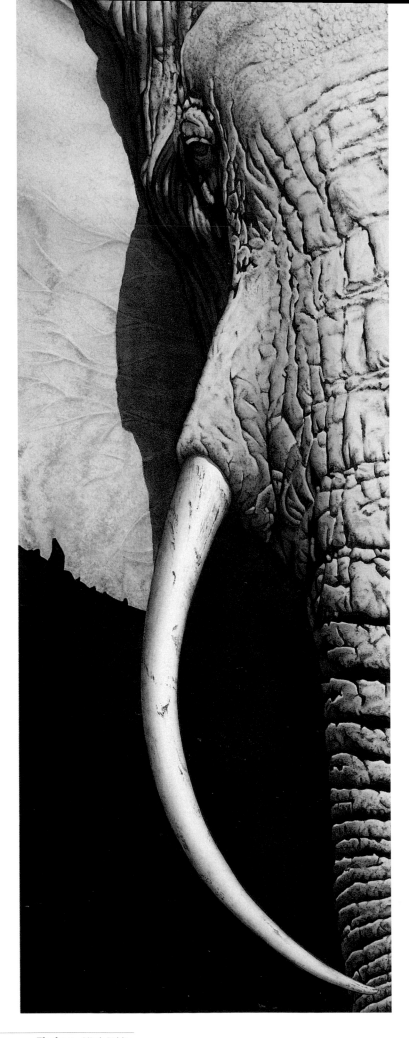

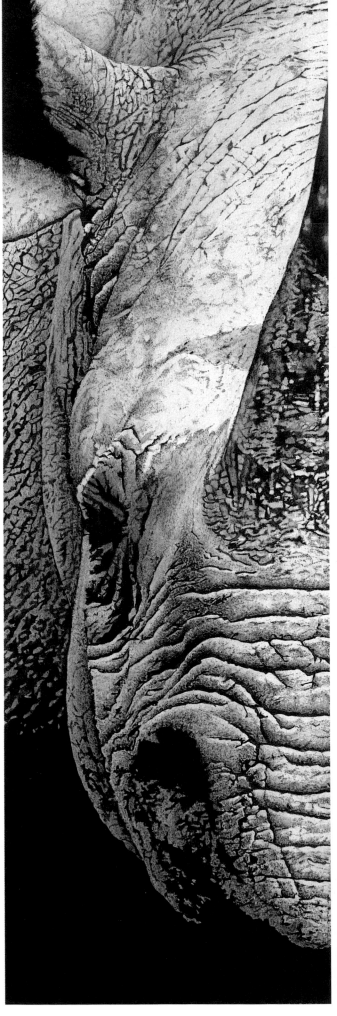

Elephant Mitch Ridder
23" × 8" (58cm × 20cm) (LEFT)
Collection of Nancy Daudistel

Rhino Mitch Ridder
24" × 7" (61cm × 18cm) (RIGHT)
Collection of Christine Shaw

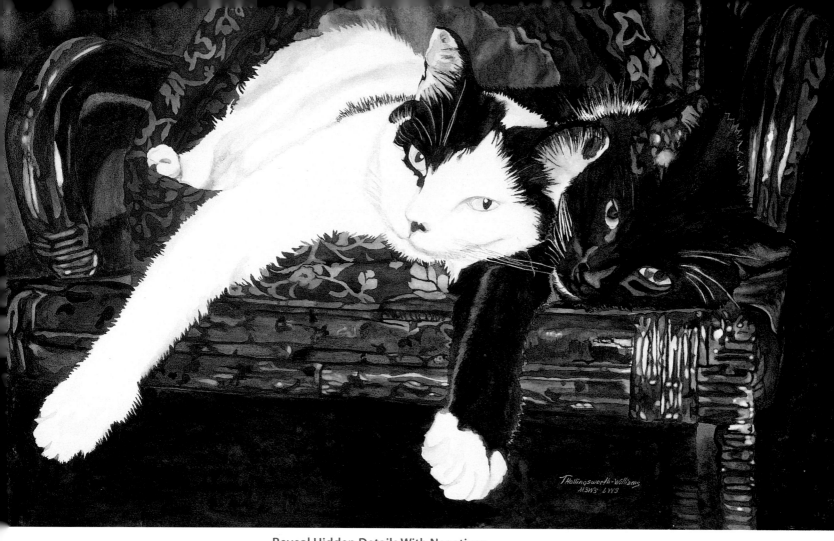

Reveal Hidden Details With Negatives

Painting other people's cats is difficult because their "people" will know if the cat's expression is wrong. When a patron asked me to paint her cats, I was smitten by the first pictures I saw of Peggy, the white cat, and Paul, the black one. However, I could not see the facial features on the photos, so I had to use the negatives to see the details in the black-and-white areas. To begin a painting, I record the following information in an Aquabee sketchbook: a title for the painting, the colors/hues I plan to use and sample swatches of paint mixtures. After deciding how to crop the photograph and what to omit, I start the drawing. I put the negative into a slide frame and project the image onto a sheet of 300-lb. (640gsm) Arches watercolor paper. I adjust the image to fit my guidelines on the paper and draw an enlarged, simple contour. Referring to the photograph, I complete the drawing and then paint the background. I paint my dark areas first, letting the white paper help me determine where the light and middle values should be.

Use Extreme Cropping

This gives *Elephant* and *Rhino* their unique looks and power and lifelike mystiques. These tight compositions reveal detail and texture you otherwise would miss completely. To emphasize their characteristic textures, I use a dramatic light angle to produce a mixture of bright sunlit areas and rich cast shadows. This high contrast carves out textures, and creates more depth and excitement, a quality that prompted one viewer to describe my paintings as "animal landscapes."

WHY DO YOU PAINT?

"I believe it was that right brain/left brain, process-of-elimination thing. When I was in school I always hated math but loved art, and I definitely couldn't sing or dance, so Broadway was out. But when I painted, I found I could 'get lost' for several hours while never having to stop and ask for directions."

—Mitch Ridder

Hanging Out Together
Tommie Hollingsworth-Williams
22" × 30" (56cm × 76cm)
Collection of Jerry and Anne Veazey

133

Capture Human Interaction

My painting reflects my deep passion for human interaction. I am a psychologist by training, so I have learned to focus and paint using close observation of the world around me. I search for interesting "happenings" in my paintings that lead to new ways of working. To create the texture of *School Break*, I washed and coated 140-lb. (300gsm) cold-pressed watercolor paper with Golden Acrylic Gel Medium. This creates a smooth, nonporous surface and causes the watersoluble pigment to stay on the surface. Then I let the paper dry overnight. I started the painting with a wet-into-wet technique laying the vibrant watercolors down generously and letting them blend freely. The treated paper allows me to remove or add paint anytime, so I painted *School Break* as far as I could with watercolor. After it dried, I applied dark gouache to connect all the figures and shapes and used lighter, opaque gouache for the background and some darker areas. I saved the transparent watercolor in some important areas.

WHY DO YOU PAINT?

"My reason for painting is to satisfy my addiction to the act of creating visual images. And painting models of different cultures from life seems to make me aware of the basic integrity of all people."

—William Rogers

Paint a Luminous Figure

Here are my secrets: Taking extra time to draw and position the figure, allowing frequent breaks for the model, setting the easel about 7 to 8 feet (2 to 2½ meters) away, detaching mentally to look at the figure abstractly, and treating the painting as an experiment. For this painting, the model sat comfortably with a selected background near a window that provided indirect daylight that would avoid changing shadows. Painting vertically on dry paper allows the color to mix by gravity, resulting in luminosity and variety in the washes. Starting the shadow areas first, along with some of the connecting background, I used both hard and soft edges and worked all over the sheet, avoiding detail and keeping my mind on the overall design. I used sable blend brushes, mainly a no. 16 round, with a limited palette of Raw Sienna, Burnt Sienna, Alizarin Crimson, as well as Cobalt Blue, Cerulean Blue and Utramarine Blue. My aim was to apply a single wash with minimal glazing. Repeating color helped achieve unity, and simplifying the complex sweater pattern allowed the face to dominate.

School Break May Lu
21" × 29" (53cm × 74cm) (ABOVE)

Thoughts of Nigeria William Rogers
29" × 21" (74cm × 53cm) (RIGHT)
Collection of the artist

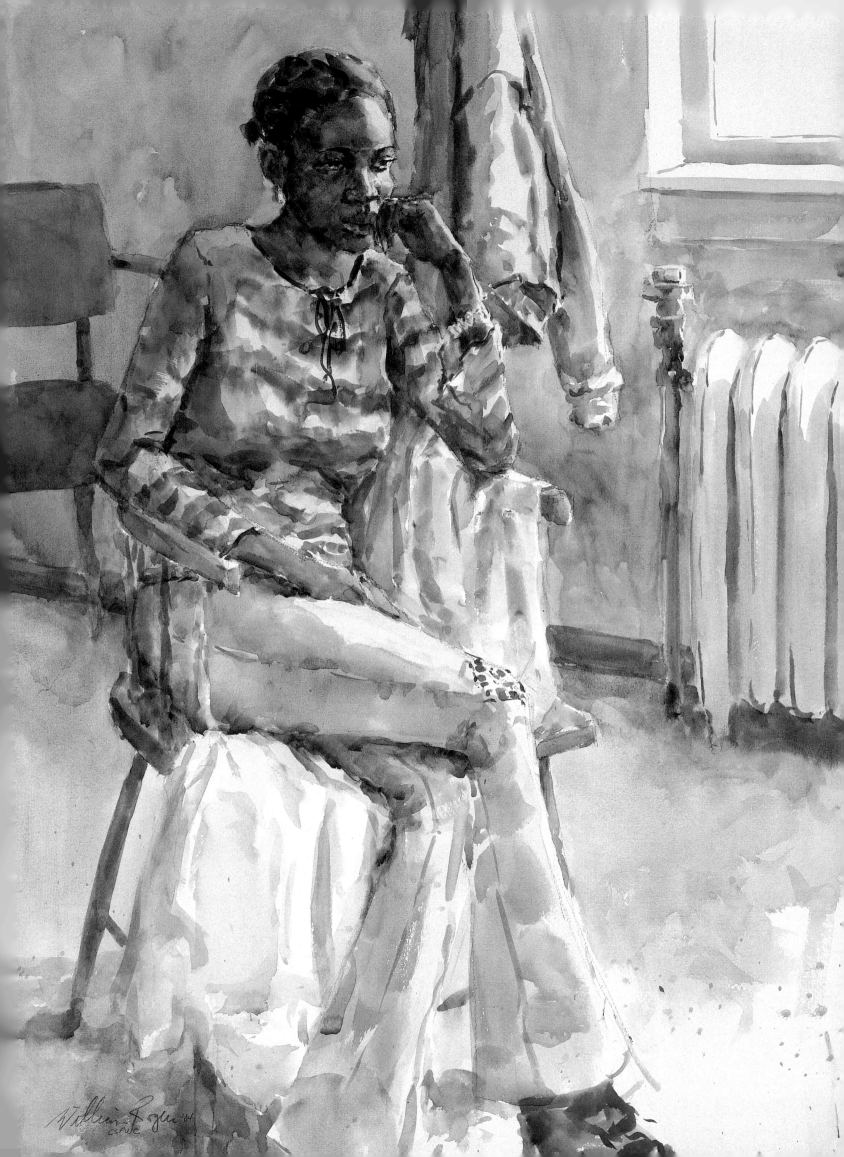

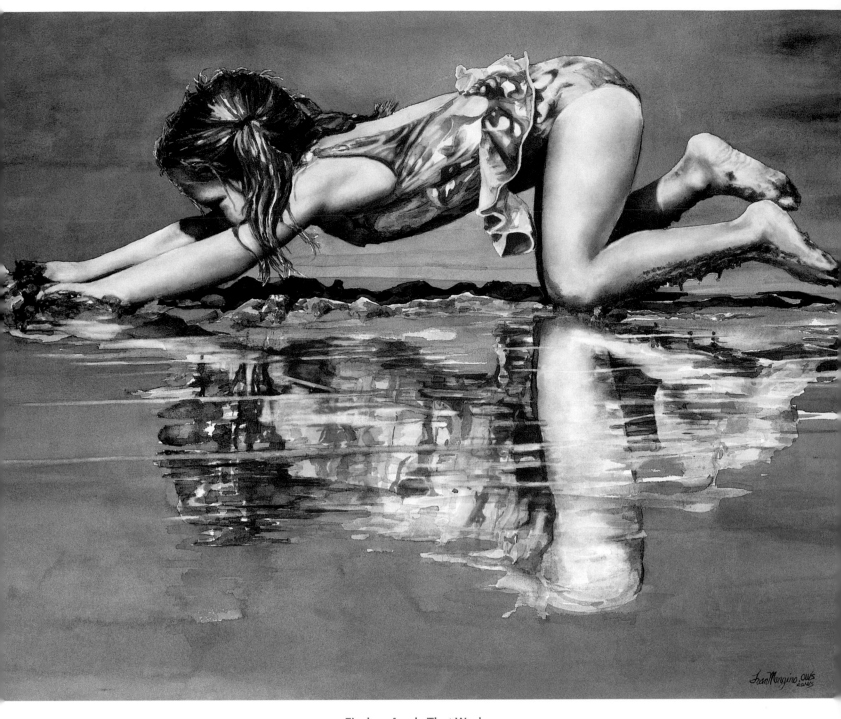

Find an Angle That Works

When I took the photo for *Pushing Sand*, I got down to the child's level. Lying on the sand was a good angle to give depth to the painting and to capture the child's reflection. I built the rich colors of the bathing suit and the reflected light skimming over the sand with several glazes of clear transparent colors. Using a large flat brush, I quickly painted the water with a soupy mix of Antwerp Blue. When I needed a second coat, I remasked the child, quickly re-wet the area with water, and repainted the ocean water. Because Antwerp Blue is a staining color, re-wetting helped the colors flow, created a better transition between layers and saved the transparent quality.

Pushing Sand Fran Mangino
22" × 30" (56cm × 76cm)
Collection of Barbara Steele

CONTRIBUTOR INFORMATION

Neil H. Adamson
5529 1st Avenue N.
St. Petersburg FL 33710
(727) 347-3555
nadamson@tampabay.rr.com
p. 104 *Roadside Treasures*
p. 105 *Soaring the Canyon*

Cindy Agan
1201 Belmont Avenue
South Bend IN 46615
(574) 233-7950
cindyaganart@hotmail.com
www.cindyaganart.com
p. 120 *A Quiet Moment*

Cynthia Allman
4135 Sierra Circle
Medina OH 44256
(330) 725-1709
allmanstudios@zoominternet.net
p. 30 *Peaches With Creamers*

Sue Archer
10138 Dahlia Avenue
Palm Beach Gardens FL 33410
sue@archerville.com
www.archerville.com
p. 93 *Cantalope-x-ing #3*

Mary Weinstein-Backer
1359 Sea Pines Drive
Banning CA 92220
(951) 845-5131
mary@bodaciousimages.com
www.bodaciousimages.com
p. 48 *Kaleidoscope*

Wendy Dawn Barnhill-Hill
1502 E. Shamrock Street
Gilbert AZ 85296
(480) 963-7533
hillartaz@aol.com
p. 79 *Is the NASDAQ Up Today?*

Terrece Beesley
1202 N. 3125 East
Layton UT 84040
Terrece@aol.com
www.terrecebeesley.com

p. 76 *Bad Year for the Dragon*
p. 76 *War-Torn Reflections*

Robin Berry
5429 Park Avenue South
Minneapolis MN 55417
(612) 824-5488
tberystudio@mn.rr.com
www.natureartists.com/robin_berry.asp
www.originalbirdart.com/berry.htm
p. 46 *Grooming Snowy*

Judi Betts
P.O. Box 3676
Baton Rouge LA 70821
(225) 926-4220
judiortombetts@peoplepc.com
p. 32 *Good Morning Glory*

Cindy Brabec-King
712 Ivanhoe Way
Grand Junction CO 81502
(970) 242-9504
p. 55 *French Paper Dolls and Perfume*

David Broad
100 Golden Hinde Boulevard
San Rafael CA 94903
415-479-5505
sndbroad@neteze.com
p. 93 *Ichabod Crane*

Dana Brown
1423 Pratt Avenue
Huntsville AL 35801
(256) 776-8996
www.danabrown.net
p. 69 *One Thing Leads To Another*

Daryl Bryant
1136 Fremont Avenue, #101
South Pasadena CA 91030
(626) 799 0921
p. 1 *Sunny Flowers*

Hazel Camp
2 Bayberry Drive
Newport News VA 23601
p. 82 *Washington Rain*

Laurel Covington-Vogl
333 Northeast Circle
Durango CO 81301
(970) 247-0205
laurelvogl@durango.net
p. 67 *Betty's Glass, Wally's Goblets*

Sandy Delehanty
P.O. Box 130
Penryn CA 95663
www.sandydelehanty.com
p. 88 *An Evening in May*

Gail Delger
540 E. New Hope Road
McKinney TX 75071
(972) 542-2956
adelger@waymark.net
www.gaildelger.com
p. 72 *Full of Holes*

Lois deMontegre
12210 Headquarters Farm Road
Charlotte NC 28262
(704) 510-0530
larrylois@earthlink.net
www.yellowwoodfineart.com
p. 100 *Fan Palm*

Mark de Mos
7 Richlyn Court
Morristown NJ 07960
(973) 267-4363
demosart@juno.com
p. 10 *Green Grocer*
p. 33 *Comfortable Elegance*

Margaret Dwyer
P.O. Box 519
New London NH 03257
dwyerdavis@hotmail.com
p. 60 *Glass Symphony*

Edie Fagan
106 S. Interlachen Avenue, Apt. 219
Winter Park FL 32789
(407) 644-2899
ediefagan@aol.com
www.ediefagan.com
p. 121 *Ben*

Tom Francesconi
2925 Birch Road
Homewood IL 60430
p. 83 *Timeless*

Ming Shu Franz
1753 Valpico Drive
San Jose CA 95124
(408) 466-6607
mingfranz11@yahoo.com
www.mingfranzstudio.com
p. 106 *Waterfall*
p. 107 *Kwei - Lin, China*

Jane Freeman
P.O. Box 1451
Bemidji MN 56619
(218) 243-3333
jane@janefreeman.com
www.janefreeman.com
p. 52 *Sundaes on Padre*
p. 53 *Bananas Fostoria*

Ann Gaechter
P.O. Box 285
Woody Creek CO 81656
agpaints@hotmail.com
www.anngaechter.com
p. 36 *Rampant Reflections*

Betty Ganley
713 Forest Park Road
(703) 759-4678
bettyganley@hotmail.com
www.bettyganley.com
p. 5 *The Crab Basket*

Carla Gauthier
902 Plum Falls Court
Houston TX 77062
(281) 461-6865
carla.gauthier@earthlink.net
www.carlagauthier-watercolors.com
p. 14 *Returning Home*

Leslie Gerstman
1927 Westwood Circle
St. Paul MN 55113
(651) 633-2109
lesliegerstman@mac.com
http://homepage.mac.com/lesliegerstman
p. 50 *Peruvian Passion*
p. 51 *Chiapin Weavings*

Janet Gilliland
17862-38 Avenida Cordillera
San Diego CA 92128
(858) 485-8597
jr16paws@msn.com
p. 34 *Afternoon Peace*

David B. Goldstein
GIC
3686 King Street #165
Alexandria VA 22302
(703) 354-5347
dgold@gic.net
www.davidbgoldstein.com
p. 12 *Red Bus*

Elizabeth Groves
2430 Alamo Glen Drive
Alamo CA 94507
(925) 837-4968
tgr6146000@aol.com
p. 58 *Windrush Blue*
p. 59 *Entropy*

Nava Grünfeld
116 Pleasant Street, Ste. #21
Easthampton MA 01027
art@navagrunfeld.com
www.navagrunfeld.com
p. 86 *Watermelon*
p. 87 *Dragonfly Bowl*

Linda S. Gunn
5209 Hanbury Street
Long Beach CA 90808
(532) 425-0134
lindasanartist@aol.com
www.lindagunn.com
p. 78 *Mr. Bear's Birthday Party*

Laurel J. Hart
laureljhart@comcast.net
www.laurelhart.com
p. 44 *Maybe He's Just Late*

Tanya L. Haynes
11408 E. Baltic Place
Aurora CO 80014
(303) 671-0306
tanya@h2oscapes.com
www.h2oscapes.com
p. 95 *Spinnaker Flying*

Cathy Hegman
505 Avondale Drive
Yazoo City MS 39194
Hegmanart@aol.com
www.cathyhegman.com
p. 96 *Preen*
p. 97 *Retreat*

Ray Hendershot
1007 Lakeview Terrace
Pennsburg PA 18073
rayjoan@netcarrier.com
www.rayhendershot.com
p. 115 *Autumn Roost*

Reiko Hervin
11 Norton Lane
Wellington NV 89444
(775) 465-1163
dreamart-mue@juno.com
p. 89 *When Time Stands Still—Iris*

Dianne Hickerson
231 Hollybrook Road
Brockport NY 14420
(585) 637-2695
diannehickerson@aol.com
www.diannehickerson.com
p. 13 *47th and Broadway*

Mike Hill
445 W. Powell Boulevard
Gresham OR 97030
(503) 661-6000
mikehillwatercolors@mac.com
www.mikehillwatercolors.com
p. 17 *Occidental Oasis*
p. 16 *Bodies and Souls*
p. 17 *The Last Waltz*
p. 16 *Christmas on Main St.*

Sharon Hinckley
5666 La Jolla Boulevard, #200
La Jolla CA 92037
(858) 456-1083
sharonyogart@san.rr.com
http://homepage.mac.com/yogart/index.htm
p. 35 *Portal II*

Gwen Talbot Hodges
321 Gramercy Court
Shreveport LA 71106
(318) 797-1913

gthartist@aol.com
p. 38 *Sallie's Satsuma*
p. 39 *Seeing Through*

Tommie Hollingsworth-Williams
3014 Magnolia Place
Hattiesburg MS 39402
(601) 268-3784
hollingsworthwms@earthlink.net
http://home.earthlink.net/~hollingsworthwms
p. 18 *Valley of Invention*
p. 133 *Hanging Out Together*

John Howard
12809 S. Carriage Lane
Crestwood IL 60445
(703) 385-6797
m.plantinga@comcast.net
p. 123 *Old Maxwell*

Tis Huberth
29623 47th Avenue South
Auburn WA 98001
(253) 839-5623
tiswatercolorsetc@yahoo.com
p. 77 *Primordial Patterns*

Bill James
15840 S.W. 79th Court
Palmetto Bay FL 33157
billjames@bellsouth.net
www.artistbilljames.com
p. 42 *The Rally*
p. 43 *The Red Quilt*

Russell Jewell
116 Deer Creek Court
Easley SC 29642
(864) 855-1251
jewellart@charter.net
p. 37 *Sun and Daughter*

Bev Jozwiak
315 W. 23rd Street
Vancouver WA 98660
paintingjoz@hotmail.com
www.bevjozwiak.com
p. 7 *Unspoken Friendship*

Elise Khachian
213 Hollydale Road
Fairfield CT 06824

(203) 255-6003
khachian8@aol.com
p. 126 *Big Fish Story*
p. 126 *Mother*
p. 127 *Friends*

Ann Kromer
40 Beechwood Lane
Ridgefield CT 06877
ackromer@yahoo.com
p. 112 *Go West*
p. 112 *The Harvest*

Estelle Lavin
6674 Hawaiian Avenue
Boynton Beach FL 33437
(561) 369-3219
estellelavin@adelphia.net
p. 19 *Beware the Dog*

Fealing Lin
1720 Ramiro Road
San Marino CA 91108
(626) 799-7022
fealinglin@hotmail.com
www.fealingwatercolor.com
p. 20 *Corner of the Alley*
p. 21 *Lady in Red*

May Lu
2912 Ella Lee Lane
Houston TX 77019
(713) 868-9177
shiaojiao@sbcglobal.net
p. 134 *School Break*

David Neil Mack
2650 Secor Road
Toledo OH 43606
(419) 531-7610
dnmack@prodigy.net
www.davidnmack.com
p. 56 *The Fabled Farewell*

Guy Magallanes
2625 Broadway, Studio 206
Redwood City CA 94063
(650) 556-1967
gvm414@sbcglobal.net
www.guymagallanes.com
p. 66 *Fiesta*

Fran Mangino
1180 Smoke Burr Drive
Westerville OH 43081
midlifemama@hotmail.com
www.midlifeseries.com
p. 136 *Pushing Sand*

Susan Mansell
2718 FM 382
Ballinger TX 76821
(325) 365-3642
susanmansell@hotmail.com
www.susanmansell.com
p. 101 *Yellow Rose*

Diane Maxey
7540 N. Lakeside Lane
Paradise Valley AZ 85253
(480) 951-2723
dmaxey.watercolor@worldnet.att.net
www.dianemaxey.com
p. 40 *Summer Bouquet*
p. 41 *Poppy Parade*

Mike Mazer
7 Holly Woods Road
Mattapoisett MA 02739
msmmassmedorg@comcast.net
www.mazer.myexpose.com
p. 25 *Fairhaven Shipyard*

Laurin McCracken
604 Monteigne Boulevard
Memphis TN 38103
(901) 277-0742
lauringallery@aol.com
www.lauringallery.com
p. 62 *White Lightnin'*
p. 62 *White Roses*
p. 63 *Winter Rose*
p. 64 *Fermentations*
p. 65 *Pears With Silver Plate*
p. 65 *Pears and Rose*
p. 68 *Ottoman Still Life*

Jerry McGrew
2805 Woods Lane
Garland TX 75044
(972) 495-0911
lostedge@aol.com
p. 118 *The Attitude*

Geraldine McKeown
227 Gallaher Road
Elkton MD 21921
(410) 398-5447
geraldine@mckeownart.com
www.mckeownart.com
p. 125 *Dominiques—A Rare Pair*

Esther Melton
201 Oakmist Way
Blythewood SC 29016
esthermelton@yahoo.com
www.esthermelton.com
p. 70 *Marbles I*
p. 71 *Shadow Play*

David Milton
31682 Farview Road
Laguna Beach CA 92651
(949) 415-0155
dmiltonart@cox.net
www.davidmiltonstudio.com
p. 84 *In the Big Apple*

Judy Morris
2404 E. Main Street
Medford OR 97504
(541) 779-5306
judy@judymorris-art.com
www.judymorris-art.com
p. 8 *Chinatown: San Francisco*

Milind Mulick
7, rachana classic, gulmohar park, Aundh
Pune 411007
India
91-20-25881778
milindmulick@yahoo.com
www.milindmulick.com
p. 24 *Cycle in the puddle*
p. 24 *Night Lamp*

Vickie Nelson
722 S.E. 200th Place
Camas WA 98607
vickienelsonstudios@comcast.net
www.vickienelson.com
p. 129 *Radio Red*

Ruth Newquist
6 Phyllis Lane
Newtown CT 06470
(203) 426-6654
www.ruthnewquist.com
p. 26 *Waiting*

Robert O'Brien
2811 Weathersfield Center Road
Perkinsville VT 05151
(802) 263-9394
rjoartist@yahoo.com
www.robertjobrien.com
p. 94 *Low Tide*

Catherine P. O'Neill
34 Marengo Avenue
Hamburg NY 14075
(716) 648-4852
kconeill@adelphia.net
p. 81 *Meg Underwater*
p. 130 *Sand Soup*

Michaelin Otis
2152 Third Street
White Bear Lake MN 55110
(651) 429-4489
michaelin@avalonartsgallery.com
www.avalonartsgallery.com
p. 122 *Sisters*

Kris Parins
16025 County Road T
Townsend WI 54175
(715) 276-9476
dkparins@ez-net.com
www.krisparins.com
p. 31 *Hard Rock Café*

Niki Lawrence Parsons
635-A Hogan Branch Road
Hendersonville TN 37075
(615) 714-2513
nikilawrenceparsons@yahoo.com
www.parsonstudios.com
p. 45 *The Red Apple*

Lynda Pattee
15 Pine Mountain Road
Redding CT 06896
(203) 544-8246
lpattee@optonline.net
p. 74 *The Flower Sellers*

Donald Patterson
441 Cardinal Court North
New Hope PA 18938
donpattart@mailstation.com
www.travisgallery.com
p. 108 *Resplendent Autumn*
p. 109 *Still Water*

Jean Pederson
4039 Comanche Road N.W.
Calgary AB
T2L 0N9 Canada
(403) 289-6106
artform@telus.net
p. 131 *Transfixed*

Donna Phillips Roberts
5015 Crestwood Avenue
Central Point OR 97502
(541) 664-2908
phillipsroberts@charter.net
p. 90 *Home, Sweet Home*
p. 91 *The Big Apple ... We Will Never Forget*

Robin Purcell
409 Triomphe Court
Danville CA 94506
(925) 648-0971
robinj20@aol.com
p. 102 *Summit From Southgate*

Patricia Rapoport
5529 Gentry Lane
Williamsburg VA 23188
(757) 565-0568
patriciarapo@cox.net
www.patriciarapoport.com
p. 75 *Copenhagen No. 3*

Robert Reynolds
rgreynolds@charter.net
www.robertreynoldsart.com
p. 28 *Vineyard Radiance*

Lee Ricks
126 Hayden Road
Pleasanton TX 78064
(830) 569-2481
leericks2@sbcglobal.net
p. 27 *San Francisco Shadows*

Mitch Ridder
P.O. Box 4673
Laguna Beach CA 92652
(949) 494-6457
rwatercolors@netzero.com
www.ridderwatercolors.com
p. 132 *Elephant*
p. 132 *Rhino*

William Rogers
4 Carter Crescent
Antigonish NS
B2G 2S8 Canada
(902) 863-6797
billrogers@eastlink.ca
www.gapacc.ns.ca/williamrogers
p. 135 *Thoughts of Nigeria*

Irena Roman
www.irenaroman.com
p. 98 *Sunflower*
p. 98 *Dahlia*
p. 98 *Bearded Iris*
p. 99 *Iris*

Richard Schilling
wwwatercolorist@aol.com
www.worldwidewatercolorist.com
p. 117 *Green Hills of Africa*

Andy Sewell
930 N.W. Fisk Street
Pullman WA 99163
(509) 332-1751
andy@finewatercolors.com
www.finewatercolors.com
p. 114 *Late Season Silvercreek*

Jean Smith
10903 Innisbrooke Lane
Fishers IN 46038
(317) 570-9570
lputtjr@msn.com
p. 15 *Venice—Bridge*

Patsy Smith
61 S. Lakeview Road
Brady NE 69123
(308) 594-3379
love2create@msn.com
p. 80 *Construction*

Susanna Spann
1729 8th Avenue West
Bradenton FL 34205
(941) 747-8496
luvartspan@aol.com
www.susannaspann.com
p. 47 *Scarlet Ladies*

David L. Stickel
1201 Hatch Road
Chapel Hill NC 27516
(919) 942-3900
dlstickel@juno.com
www.davidstickel.com
p. 57 *Cycle of Color*

Donna Stropes
23851 Sherwood Road
Willits CA 95490
(707) 459-1642
whiteros@concentric.net
www.donnastropes.com
p. 113 *Ferndale Gold*

Paul Sullivan
6602 N. 82nd Way
Scottsdale AZ 85250
(480) 948-9097
sully1251@cox.net
p. 22 *Piazza del Duomo, Milan*
p. 22 *Risorgimento, Caffé, Rome*
p. 23 *Cathedral Steps, Sienna*

James Toogood
920 Park Drive
Cherry Hill NJ 08002
jtoogood@snip.net
p. 61 *1700*
p. 110 *Goyt Valley*
p. 111 *High Point*
p. 110 *Meadows Near Buxton*

Claire Schroeven Verbiest
aquatel@aol.com
p. 128 *Oscar, Napping*

Debi Watson
916 Forest Road
Lancaster PA 17601
(717) 481-7526
debiwatson@comcast.net
p. 54 *The Human Touch*

Pat Weaver
P.O. Box 1246
Dade City FL 33526
(352) 567-6392
ivel2@aol.com
www.watercolorplace.com
p. 124 *Two Jacks*

Judy Welsh
963 Wallace Drive
San Jose CA 95120
(408) 268-6501
kandjwelsh@aol.com
p. 116 *Hot Flashes on Cool Contours*

Tom White
3538 Eastview Drive
Lafayette CA 94549
(925) 283-1073
p. 11 *Palazzo Vendramin*

Rhoda Yanow
12 Korwell Circle
West Orange NJ 07052
(973) 736-3343
alrhoyanow@aol.com
www.louisamelroseartcraft.com
p. 4 *Street Scene*

INDEX

Abstraction, 44
Acrylic matte medium, 49, 75, 77, 80
Acrylics, 23, 49, 73, 79, 104
American flag, 90-91
Animals, 46, 66, 96-97, 124-125, 128-129, 132-133

Backlighting, 25, 29-30, 34
Backruns, 93
Balance, 55
Blacks, mixing, 129
Boards, 42, 75, 104, 122
Boats, 94-95
Bridge, 18
Brushes, 54
 bamboo, 88
 filament, 93
 flat, 20
 hog-bristled, 115
 mop, 30
 ox hair, 82
 rigger, 5, 17, 93
 round, 63, 86, 93, 103
 sable, 14, 88, 115
 Soft Scrubber, 39
 sponge, 119
Brushstrokes, 11, 33, 76, 83
Buildings, 26, 56, 61, 104
Burnishing, 46

Center of interest, 12, 69, 124
 See also Focal point
Charging, 103
Children, 37, 118-120, 130, 136
Children's book illustration, 78
Chinese ink techniques, 106
Chrome, 57
Cityscapes, 2, 8-24, 26-27, 75, 82, 84-85
Clouds, 115
Color code, 126
Color intensity, 54
Color key, 36
Color study, 26
Color temperature, 18, 29-30, 39, 100, 122, 124
 and backlighting, 34
 juxtaposing, 36, 40, 103

Colors
 blowing, 129
 bright, 20, 30, 60
 complementary, 5, 33, 54, 80, 97, 116
 depth of, 85
 dropping, 77
 intense, 51
 lifting, 51
 local, 27, 34, 49
 mixing, 76, 93-94
 primary, 14, 30, 75, 107, 128
 pushing, 44, 57, 59, 76
 reflected, 30, 39, 63
 refracted, 39, 63
 saturated, 86
 sedimentary, 11
 staining, 93, 136
Contour drawing, 74
Contrast, 12, 14, 18, 70, 83, 97, 133
 See also Value contrast
Crayons, 75, 79
Crystal, 39, 52, 62-63
 See also Glass

Depth, 18, 69, 77, 85, 93-94, 111
Detail, 18, 29, 52, 54-55, 63
Drama, 29, 93-94
Drawings, 14, 44, 60, 63, 124, 128
 detailed, 85
 perspective, 23
Drybrush, 17, 20, 23, 44, 55-57, 69, 94, 98
Dutch painting, 63

Easel, 103
Edges, 29, 51, 55-56, 119-120
 lost and found, 24
 varying, 30, 69
Exaggeration, 33, 55, 66, 96, 103, 116

Fabric, 68
Figurative work, 42-44
 See also Children; People
Flowers, 1, 34-36, 39-41, 58-59, 63, 88-89, 98-99, 101
 See also Leaves; Nature

Focal point, 33, 40, 46, 80, 94
 See also Center of interest
Foreshortening, 94
Fruit, 38-39, 54, 86-87, 93

Gesso, 42, 73, 106
Gesture, 42, 74
Glass, 44, 60, 66-67
 See also Crystal
Glazes, 24, 42, 47, 55-56, 60, 104, 113
 crayon, 79
 diluted, 88, 108
 gradated, 77
Gouache, 17, 42, 75
 over watercolor, 96, 131, 134
Granulation technique, 88
Grays, 63
Greens, 35
Gum arabic, 79

Highlights, 55, 60

Industrial scene, 92
Ink, 79, 82, 96, 106, 117
 pouring, 107

Lace, 52
Landscapes, 31, 102-117
Leaves, 29, 34, 59, 100-101, 108, 115
Light, 29-48
 ambient, 30
 overcast, 111
 reflected, 33, 39, 56
 refracted, 39
 strong, 66-68
 See also Backlighting; Sun
Lines, 11, 25, 46, 76, 82
Location painting. See Plein air

Masking fluid, applying, 39, 56, 108
Memorials, 90-91
Metaphor, 76
Model, drawing from a, 134
Mood, 11, 17, 33, 40, 44, 55, 59, 79, 114
Movement, 12, 40, 51, 83, 122, 128

Nature, 28, 32, 34-35, 58, 100, 106
 See also Flowers; Leaves

Painting
 drive-by, 112
 planning a, 81
Palette colors, arranging, 40
 by color temperature, 124
Palettes
 limited, 52, 54, 121
 color, pale, 59
 color, pure, 93
Paper
 Aquarius II, 77
 Arches, 97, 133
 Bockingford, 82
 cold-pressed, 27, 30, 46, 64, 78, 94, 98, 112, 117, 134
 large-format, 85
 Mylar, 126
 newsprint, 107
 rice, 106
 rough, 88, 94
 smooth, 113
 watercolor, 20, 42, 73, 101, 103, 116, 128
Patterns, 51
 color, 49, 70
 complex, 86
 light, 47
 light and shadow, 20, 27
 reflected, 61
 repetitive, 68, 80
 value, 27
Pears, 64-65
Pencils, 14, 79
People, 2, 7, 42-44, 122-123, 126-127, 131, 134-135
 in cityscapes, 23, 26-27
 outdoors, 74, 79
 See also Children
Perspective, 93-94
 See also Viewpoint
Photographs, 24, 66, 81-82, 121, 130, 133
 for cityscapes, 26-27
 combining, 9, 129
 cropping, 51, 63, 133
 editing, 57, 126

enlarging, 52
 for florals, 47
 travel, recording, 18
Plastic wrap, 11
Plein air, 33, 35, 74, 103, 116
Portraiture, 119-136

Razor blade, 20, 55, 104
Realism, 17, 25, 44, 47, 116
References, visual, 78
 See also Photographs
Reflections, 5, 12, 14, 57, 82, 107, 136
Rhythm, 40, 80
Rocks, 83, 104

Salt, 17
Scrubbing, 33, 46
Scumbling, 42, 96
Sense of place, 11
Series, painting a, 75-76, 98-99
Shadows, 30, 36
Shapes, 12, 24-25, 59, 70, 76, 103-104
 lifting, 29
 positive and negative, 59, 74, 128
 and viewpoint, 96
Sheen, 63
Silver, 62-63
Sketches, 75, 88, 116, 119
 value, 27, 33
 watercolor, 117
Skies, 17-18, 100, 113
Snow, 30
Space, negative, 93, 121
Splash ink painting, 106
Splattering, 55, 106
Sponges, 104
Spotlight effect, 46
Still lifes, 30, 40, 50-55, 60, 62-65, 67-68, 70-71, 86-87
Story, telling a, 42, 90, 122, 126
Sun, setting, 111, 113
Sun-drying, 107
Sunlight, 29-30, 36, 101

Tea bags, 79

Texture, 14, 17, 55, 73, 77, 93, 115
 contrasting, 68
 dramatic, 96
 levels of, 80
Tints, 49, 73
Tools, unconventional, 115
Translucency, 34
Travel painting, 14-15, 18-24, 27, 74-75, 112

Underpainting, 14, 33, 49, 60, 63, 79, 111
Unity, 14, 25, 40, 54, 57, 80, 97, 134

Value, 34, 66, 81, 88, 93, 124
 contrast, 36, 39
Value sketches, 27, 33, 47
Viewer's eye, directing the, 40, 70, 76, 93, 100, 121, 124
Viewpoint, 54, 85, 90, 93-97, 100-101

Washes
 color temperature in, 111
 gouache, 42
 graded, 5, 11
 layering, 24, 30, 42
 transparent, 30, 116, 129
 variegated, 11, 33
Water, 5, 12, 83
Watercolors, 73, 85, 108
 and acrylics, combining, 49, 79
 and Chinese ink techniques, 106
 pencil drawing on, 112
Watermark, 107
Wet-into-wet, 11-12, 20, 27, 30, 56, 64, 86, 93, 96, 98, 115
Wet-onto-dry, 47, 93
Whites, 17, 24, 36, 51, 106, 116
Wood grain, 97

Yellows, 75, 101

The Best in Painting Instruction and Inspiration is from North Light Books!

Dramatic Light:
Paint eye-catching art in watercolor and oil

by Patrick Howe
ISBN-13: 978-1-58180-658-8
ISBN-10: 1-58180-658-2
Hardcover, 128 pages, #33253

Light appears as reflection, glow and atmosphere. In painting, success hinges on your ability to capture light's subtleties, whether bright and bold or soft and shadowed. Dramatic Light demystifies this difficult aspect of painting with 25 step-by-step demonstrations in both watercolor and oil that show you how to see and paint light in its many forms.

The Watercolorist's Essential Notebook:
Landscapes

by Gordon MacKenzie
ISBN-13: 978-1-58180-660-1
ISBN-10: 1-58180-660-4
Hardcover, 144 pages, #33255

Painting with watercolors gives you endless opportunities to create the world you want. You choose whether to let the sun blaze or the rain pour, to move a maple tree here or make the trail wind over there, to subdue a hillside with quiet greens or make a forest glow with dazzling golds and reds. It's not only a matter of what to paint, but how to go about painting it. Let this reliable collection of tips, techniques, ideas and lessons be your companion on a sure path to creative fulfillment and better watercolor landscapes.

Vibrant Flowers in Watercolor

by Soon Warren
ISBN-13: 978-1-58180-707-3
ISBN-10: 1-58180-707-4
Hardcover, 128 pages, #33373

You can paint watercolors that capture the beauty and personality of roses, peonies, zinnias and many more brilliant blooms—and achieve color more vivid than you ever dreamed possible. From first washes to final touches, Soon Y. Warren will teach you her extraordinarily effective techniques for painting spectacular flowers.

These books and other fine North Light titles are available at your local fine art retailer, bookstore and online suppliers. Or visit **www.artistsnetwork.com**.